GW00367309

Emil Nolde and German Expressionism
A Prophet in His Own Land

Studies in the Fine Arts:
The Avant-Garde, No. 52

Stephen C. Foster, Series Editor

Associate Professor of Art History
University of Iowa

Other Titles in This Series

Emil Nolde and German Expressionism
A Prophet in His Own Land

by
William S. Bradley

UMI Research Press

Ann Arbor, Michigan

Copyright © 1986, 1981
William Steven Bradley
All rights reserved

Produced and distributed by
UMI Research Press
an imprint of
University Microfilms Inc.
Ann Arbor, Michigan 48106

Library of Congress Cataloging in Publication Data

Bradley, William S. (William Steven), 1949-
Emil Nolde and German expressionism.

(Studies in the fine arts. The Avant-garde ; no. 52)
Revision of thesis (Ph.D.)—Northwestern University,
1981.
Bibliography: p.
Includes index.
1. Nolde, Emil, 1867-1956—Criticism and interpre-
tation. 2. Expressionism (Art)—Germany. I. Title.
II. Series: Studies in the fine arts. Avant-garde ;
no. 52.
N6888.N6B73 1986 760'.092'4 85-21008
ISBN 0-8357-1919-7 (pbk.)

To the memory of my mother
Jane Gebhart Bradley

Contents

List of Figures

Acknowledgments

Professor Frederick S. Levine of the Department of Art at Colorado State University provided invaluable counsel during the research stage of this project at Northwestern University; his criticisms served to sharpen my own perceptions and critical evaluations of Nolde's art. For all this and much more I am very grateful.

Thanks are also due the Graduate School of Northwestern University and the German Academic Exchange Service for grants which allowed me to pursue my research in the United States and in Germany.

When I had occasion to work with the Stiftung Ada und Emil Nolde in Seebüll, the Foundation's director, Dr. Martin Urban, was always willing to put the facilities and his own expertise and insight at my disposal. I have profited greatly from my conversations with him and his assistant, Manfred Reuther.

For insightful and enthusiastic reading of this manuscript or portions of it, I must also thank Professors David Van Zanten and Kathy Harms of the Art History and German Departments, respectively, at Northwestern University, and Professor Peter Guenther of the Art Department at the University of Houston.

Finally, my most personal expression of gratitude must go to my wife Kathryn for her support throughout this project.

Introduction:
Frenzy and Prophecy

Within a general discussion of the development of German art in the years just before the First World War, the figure of Emil Nolde and his art have always seemed to represent the archetype of the Expressionist painter and his creation. In style and emotional impulse, a painting such as *Candle Dancers* (1912) (fig. 1) conforms to the expectations of an Expressionism conceived as "the search for expressiveness of style by means of exaggerations and distortions of line and color" and "a deliberate abandon of naturalism . . . in favor of a simplified style which should carry far greater emotional impact."[1] The painting is quite literally "expressive"—the brushwork is large, obvious and undisguised, the result of a loaded brush applied to the canvas in considerable haste; its pattern is seemingly random and haphazard, controlled not by any rational scheme, but purely by the emotions of the artist, emotions whose intensity and directness are transmitted with an immediacy and accuracy that are often discomforting to the "civilized" viewer. The choice and use of colors, too, are "expressive," emotional rather than rational in origin and effect; the fervor and abandon of the two female figures is associated implicitly and explicitly through their colors with the candles beneath them and the incandescent background from which they seem to emerge as throbbing, glowing coals; the red and orange of the background is absorbed by the cheeks, breasts and thighs of the dancers resulting in an extremely effective combination of ritual and eroticism. When compared with Henri Matisse's *Dance* (1909), a painting of a similar theme representing a dominant contemporary strain in French art, *Candle Dancers* exhibits the more overtly aggressive qualities usually associated with Expressionist art: extreme antibourgeois eroticism directed toward a deliberate upheaval of accepted moral values and a wild, uncontrollable approach toward the act of painting itself in what seems to be an equally deliberate attempt to destroy any sense of formal composition or planning.[2]

Though dealing with a similar subject, Matisse's *Dance* presents a totally different concept of this activity: the figures join hands to form a circle suggesting continuous movement to a gentle strain of violins rather than the ecstatic drumbeat which sets the rhythm for *Candle Dancers*. In the tradition of Nicolas Poussin's *Dance to the Music of Time* (1638–40) and other such mythical depictions,

Matisse's figures seem to sway to the tones of cosmic harmony, while Nolde's dancers pulsate to a more subterranean force, "a glowing fire in the bowels of the earth" of which the artist himself spoke, in a conception that recalls Friedrich Nietzsche's description of Dionysiac rapture where "the infliction of pain was experienced as joy while a sense of supreme triumph elicited cries of anguish from the heart."[3]

In fact, the whole tenor of this dance ritual as Nolde presents it seems inspired by Nietzschean concepts of the ancient Dionysiac ritual. The exaggerated rhythmic gestures of the two dancers and the sense of total self-abandon suggested by the dissolution of the dancers' forms which almost melt into the background seem to illustrate passages where Nietzsche describes the intoxicated state of the Dionysiac reveler who "becomes not only reconciled to his fellow [man] but actually at one with him—as though the veil of Maya had been torn apart and there remained only shreds floating before the vision of mystical Oneness" so that the participant "now expresses himself through . . . dance as the member of a higher community."[4]

Nolde's ability to achieve such a convincing ecstatic expression in this and other works may establish him as an archetypal Expressionist personality in more recent interpretations of modern art, but this very quality was often perceived by the artist's contemporaries as something which set him apart from other Expressionists during the first decades of this century. One art critic and admirer of Nolde's art, Rudolf Probst, sought to describe the uniqueness of expression of Nolde's paintings by likening the "great pulsating movement" which runs through each of them to the heavy cadence of a primitive dance ritual "animated by a blood-rhythm, by an alternation of intense activity and elemental calm. . . . This one essential phenomenon, coursing through the realms of the vegetable, animal and the human psyche—that is what the interaction of colors and forms in Nolde's paintings calls forth."[5]

According to Probst, the source of this forceful expression is the artist's intimate contact with the formative powers of nature and his monumental struggle with "the glowing masses of essential matter" in the midst of the creative process. The effect of this contact with elemental life is the elimination of all traces of strictly individual expression and the achievement of "a power and purity of voice" which are "free from sentimental pathos and problematic speculation."[6] Derived from this experience, Nolde's art attains a visionary quality that is not found in the art of other Expressionists who likewise embrace the chaos of elemental life out of genuine aversion to the materialistic orientation of modern society, but "without feeling inside themselves the degree of passion and the certainty of the primal order of things" that Nolde feels.[7]

Nolde's acquaintances among the young German artists of his generation also perceived him as somewhat of an outsider. In a letter to her family recounting her meeting with Nolde in the spring of 1900, Paula Modersohn-Becker described the curious personality of this "Schleswig farmboy" and the solemn intensity of

his presence. She concluded by remarking, "Moreover, he is extremely intro-
verted, as are all the people of the North."[8] Several years later after Nolde's
artistic reputation was more firmly established, Franz Marc confessed in a letter
to August Macke that he really did not know what to make of Nolde.[9]

In his art and in his personality, Nolde shares only some of the qualities
which historians of the movement have analyzed as integral to the Expressionist
generation and its artistic expression. In the area of literature, Walter Sokel has
outlined several themes prevalent in Expressionist writing which correspond to
certain attitudes and qualities common to the Expressionist artist. He examines
two pairs of opposing tendencies which he sees operating within the proponents
of the movement and their expression: a vitalism which attempts to counteract
an innate self-awareness and social perceptiveness that plague the young gener-
ation (what he terms the "thorn of intellect") and an ethically idealistic, "com-
munionistic" longing (to be part of a community as a worthwhile contributor)
that is weighed down by an "impotence of the Heart," i.e., feelings of narcissism
and emotional isolation.[10] More recently, Frederick Levine has convincingly
argued for the predominance of themes of regression and of apocalypse in both
the visual arts and the literature of the Expressionist generation.[11] Both Sokel
and Levine, and indeed almost all scholars of Expressionism, agree that German
Expressionism was an art "born of intense psychological despair," and that "the
Expressionist generation, quite unlike any generation before it, was compelled
into an acute awareness of the fundamental contradictions inherent in human
existence."[12]

The outward manifestations of this state of despair and tension in which
the Expressionist artist suffered created a strong sense of metaphysical anxiety
readily observable in various individuals: in the almost schizoid vacillation be-
tween intense joy and paralyzing gloom in the poetry of Georg Trakl, in the
longings for deliverance evident in the letters of Georg Heym and Franz Marc
or in shocking confessions of emotional, sexual and artistic impotence such as
Ernst Ludwig Kirchner's *Self-Portrait as a Soldier* (1914). Indeed, the expression
of this anxiety would seem to be the hallmark of Expressionist art and literature.

Nolde was not immune to states of despair and inner tension, but at least
publicly and to an extent in his own self-image he sought to project a statement
of strong, unbending conviction and certainty concerning the purposes of his
artistic expression. His decision to resign from the *Brücke* and his later attacks
on the ruling factions of the Berlin Secession were motivated in part by this
desire to pursue the singular vision of his art. Similarly, Nolde's lithographic
Self-Portrait with Pipe (fig. 2) of 1907 presents the viewer with the image of a
personality formed by absolute values and the sheer force of inner conviction.
There is no hint of anxiety or even self-examination that we might find for
instance in a self-portrait by Edvard Munch or Kirchner. Instead we are confronted
with a disquieting sense of certainty in the strong, set jaw and the suspicious,
but steadily defiant eye peering out from the shadow of Nolde's wide-brimmed
hat.

This same sense of steady, forceful insistence pervades many of Nolde's landscapes. Especially in the period just before and during World War I, when apocalyptic outbursts are so prevalent and pronounced in the work of other Expressionist painters, Nolde's increasingly frequent landscapes exhibit none of the destructive elements found in landscapes by Kirchner, Marc or Vasily Kandinsky. In contrast to the works of most other German artists at this time, Nolde's paintings of this period make little or no reference to the actual political situation in Europe. An oil painting from 1916, *Marsh Landscape,* now in Basel (fig. 3), presents a view of nature that seems far removed from a world at war, but is nevertheless not a simple, idyllic scene that Nolde might have conjured up in reaction to the wartime situation. Nolde's marsh landscape seems to be charged with a dynamic force which sets all of its elements in motion, but the force seems less destructive than the apocalyptic landscapes of Marc or Kandinsky; the movement in *Marsh Landscape* is more seething, chaotic and directionless. In the context of the war and the strongly felt apocalyptic longings of so many individuals, Nolde seems to be looking beyond the immediate reality into a world after the crisis—a primitive utopia seemingly devoid of higher life forms, where primal forces of nature actively manifest themselves.

This dynamic feeling for nature sets Nolde apart from other figures of the Expressionist movement, just as his actual physical situation, his close contact with his homeland, Schleswig-Holstein, kept him isolated and separate from many of the events and interactions of Expressionist artists and writers after 1912. Nolde always retained a strong sense of his peasant background as the son of a farmer raised in the region along the present-day border between Germany and Denmark, and this background was evident in his artistic expression throughout his long career. By the second decade of this century, he seemed to find a definite focus for these feelings in an attraction to and expression of what is now termed Volkish thought in his art.

The history of the development of Volkish thought has been the subject of several recent studies of German intellectual history of the late nineteenth and early twentieth centuries, but the influence of this loosely organized ideology on the vanguard movements in the German art and literature of this period has yet to be fully explored.[13] A central tenet of this system of ideas as it relates to Nolde's developing artistic vision is the role Volkish thinkers attributed to the landscape of a given region in determining the character of its inhabitants. In their use of the term 'character', these writers were referring to a 'spiritual essence'; the term 'soul' was frequently substituted for the term 'character' in discussing the nature of a *Volk,* that is, a culturally and racially unified people.

As the inheritors of German Romanticism, the Volkish thinkers adopted the Romantic concept of a nature with its own soul that offered points of correspondence and mystical revelation to the soul of the individual and the *Volk* which inhabited and lived in close contact with a specific corner of nature, a specific regional landscape. Speculations on the ramifications of this bond between man and nature revolved mostly around discussions of the German character and the

German landscape, though the conclusions were applied in a more global scope to all peoples (*Völker*) and their native landscapes, as well as in a more restricted sense in descriptions of geographic regions within the German-speaking lands. As a member of a *Volk* closest to the countryside, the peasant is continually brought forth in Volkish writing as the embodiment of the soul of that *Volk,* the segment of the *Volk* that exists in rapport with the forces of nature.

In this concern with the peasant as the true repository of German character, the proponents of Volkish thought created an ideology with strongly mystic-Romantic, rural overtones, which they intentionally opposed to what they perceived to be the un-Romantic, materialistic, urban culture of Germany in the last quarter of the nineteenth century, the *Gründerzeit.*

As it developed from certain trends in German Romanticism, Volkish thinking was a politically and culturally conservative (or reactionary) ideology in its admiration of a preindustrial German state with a culture based on an agrarian economy and a reverent, pantheistic attitude toward nature. In the decade of the 1890s and thereafter, the tone of Volkish statements became less nostalgic and its emphasis less backward-looking. Various Volkish writers began to propose that this ideal could be and indeed had to be realized in the immediate future to ensure the salvation of the German character, threatened by the increasing preponderance of industrialization, urbanization, liberalism, and a host of other evils. In a society overwhelmed by the diversity, the confusion, the uncertainty, by the freedom of the modern world, the Volkish solutions offered a sense of certainty, simplicity and purpose.

These solutions engendered both real, tangible manifestations such as the various "back-to-nature" movements of the period immediately preceding World War I, as well as prophetic, intellectual expressions. Among the latter group, foremost in the degree of its influence and reception by a large audience (including Nolde), was the call by Julius Langbehn and other critics for a rebirth of German art from Volkish origins. As Fritz Stern has noted, "The right kind of 'populistic' (*völkisch*) art loomed as the only remaining means of spiritually ennobling life. It could fuse religion and philosophy, truth and beauty, and become the incarnation of national genius."[14]

Nolde's own often repeated description of his art as a "new German art" must be understood in this context. The differences between the emphasis of his art and the art of other German Expressionists—the sense of resoluteness and purpose already mentioned—can be better defined by taking into account Nolde's attraction to certain aspects of Volkish thought. He explained his break with the other artists in the *Brücke* group as they attempted to form a "New Secession" in 1912 by writing, "Perhaps none of them was so obsessed with a belief in the future as I was. . . . It may be that the *Brücke* artists did not recognize the 'New Secession' as a visible sign of the division between past and future, foreign and German."[15]

Around this time the tenor of Nolde's art began to diverge from that of his younger compatriots. Visually, his paintings became more forceful during these years through the use of large areas of intense colors; what had earlier been only vague longings and tentative expressions take on the appearance of certainty and purpose. Although Nolde presents himself in a soft light of humility in the autobiographical passages which describe this period, his paintings at the time reveal a significant concern with prophecy and mission—he was perhaps beginning to see himself as a creator of Volkish art, expressing eternal truths of nature and the German *Volk*. Nolde makes only a single reference to the Volkish movement and its relationship to him, but it is a telling statement. Referring again to his work in the years 1910 to 1912, Nolde wrote, "My course of attack (*Sturmlauf*) found a parallel in the establishment of the German-Volkish student organizations. I did not know it at the time."[16]

The concepts of prophecy and mission mentioned above are important considerations in understanding Nolde's intentions in his art. They suggest an aspect of Nolde's character that is decisive for the direction his art will take after 1912—a tendency to identify his art with a prophetic function and to see himself as a vehicle of some revelatory insight, not necessarily within the boundaries of accepted religions. Nolde was by no means the only German artist in his generation to experience such prophetic yearnings: Paul Klee, Franz Marc and Vasily Kandinsky and many other artists and writers of Expressionism all produced prescient statements at some point before 1914. Indeed, numerous critics and historians of German intellectual life from 1848 to 1933 have cited this tendency as a hallmark of the literary output of this period. Comparing German writers with their English contemporaries, Michael Hamburger has stated:

> More often than not these German writers assumed prophetic or priest-like functions which very few English writers have assumed in modern times. . . . In an age of cultural pluralism, they claimed or assumed that their work was of exemplary importance as a source of spiritual or moral leadership. The claim or assumption goes back to a time when secular literature and philosophy took over functions which had formerly been the prerogative of the clergy—to the eighteenth-century Enlightenment and Weimar classicism.[17]

By the late nineteenth century, this phenomenon was so established that Hamburger can only describe the literary climate of the time as "a proliferation of prophets." This climate, so receptive to prophecy—and to self-fulfilling prophecy, at that—was created from a variety of sources peculiar to German culture, not the least important of which was its educational system. As the historian Ralf Dahrendorf has pointed out, "Until recently, one of the basic assumptions of German educational thinking was that the school is supposed to build up a 'spiritual world' in the child besides and even against the 'real world'. . . ."[18] And in discussing the kinship between the prophetic expressions of Friedrich Nietzsche and Heinrich Heine, J. P. Stern has theorized how this 'spiritual world' instilled from childhood in the average German reacts to cultural

prophecy: "The 'prophet' hovers above his society. But what happens to prophecy if that common soil itself is unstable, if society itself . . . is unsure of its proprieties: what if significance, 'reality' itself, is felt to rest in intellectual and artistic experience, 'in the mind alone'? Then indeed prophecy has more than its usual chance of coming true."[19]

These observations are no less true for Nolde's generation than for the preceding generation of Germans, nor are they any less applicable to those Germans attracted to or professing Volkish ideology. This was their prophecy and it vied for acceptance by the German 'spiritual world' with as much potential for success as the philosophy of Nietzsche, the doctrines of aestheticism professed by the poet Stefan George and his followers, or any number of other concurrent programs. Actually, the potential for successful reception in terms of sheer numbers was far greater for the proponents of Volkish thought than for many competing systems of ideas, because of the broad range of ideas encompassed by the Volkish ideology and the popular basis of most of those ideas.

By the beginning of the twentieth century the pattern of artistic prophecy was so ingrained in German culture that an individual of Nolde's personality would have found it difficult to avoid subconsciously perceiving his artistic longings as expressions of some profound inner truths. His introduction to Volkish thinking was bound to provide him sooner or later with a focus and an audience (however imaginary) for these expressions to which he was spiritually connected by the common bond to their native soil. This study will examine the aspects of Volkish thought to which the artist was attracted—ideas of a mystique of the soil, of invisible powers within nature, of the irrational, mystical development of character, and of communal or racial consciousness—and determine how these beliefs were manifested in his art.

1

Man and Nature in Wilhelmine Germany

The Wilhelmine Era (1871–1914) into which Emil Nolde was born was a period of German history that witnessed profound and rapid changes in the structure of society, in the national economy and in political institutions. For centuries prior to 1871, the German nation had consisted of a loose confederation of smaller political states held together by the memory of their former participation in the Holy Roman Empire and by a common language and culture. The economy of this region of Europe remained predominantly agricultural well into the nineteenth century and the majority of the German population lived in the countryside. There was also little increase in the size of the German population prior to the nineteenth century, and towns and cities in 1850 still retained much of the traditional charm and appearance of an earlier age.

After 1871 Germany achieved the political unification it had long sought, but many Germans of the *Gründerzeit* felt the accompanying transformations created more problems than benefits for their society. A tremendous increase in industrialization took place during this period of political realignment, and the two developments tended to complement and strengthen each other. This process began to change the face of Germany. The older capital cities started to grow rapidly to become the new centers of business and commerce. Large numbers of people moved from the country to the larger cities attracted by the financial opportunities they offered; traditional bonds with a regional homeland were severed and replaced by a system of values based on the acquisition of material goods and the market value of products and services.

Germany at this time entered into a period of economic prosperity that would have been unimaginable even a generation earlier, but the materialistic culture which arose soon began to alienate many of the intellectuals of the age. Toward the end of the Wilhelmine Era, the economist Werner Sombart expressed his generation's condemnation of the modern German state. Concluding his study of the economic developments in Germany during the nineteenth century, he turned to the broader issue of the national state of mind, writing,

> The great ideals which inspired our fathers and grandfathers have faded; the national idea is exhausted after the Reich has been established with a great burst of enthusiasm. What we are offered today as nationalism is a pale second brew which nobody can warm up. Empty phrases

serve to cover up the spiritual void. The same is true of the great political ideas for which our forefathers died. . . . The younger generation smiles knowingly when it reads about the struggle for political freedom, and celebrations in honour of the great age of enthusiasm turn into ridiculous farces.[1]

At times the younger generation may have smiled knowingly at the situation, but often behind the smile there lurked a deep sense of despair over the loss of traditional ideals. The expression of this loss took many forms. One such expression of dissatisfaction looked with nostalgia and even bitterness at the changing relationship between the individual and his immediate environment. As an increasingly urban culture replaced the former rural culture, the strong emotional attraction of the individual to the natural environment began to deteriorate. To many of the generation of Germans born during the first years of the *Gründerzeit,* especially to those with artistic inclinations, this separation from nature became quite important and regrettable thirty years later as they came to maturity and looked back in a critical manner at the course of their own lives and the recent developments of society. This feeling of separation was not only a reaction to the transformation of a basically rural society and the displacement of large segments of the population, but the image of separation came to symbolize the plight of the modern German: alone, isolated, and divorced from the collective past of the culture. In the introduction to his essay on the Worpswede landscape painters in 1902, the poet Rainer Maria Rilke expressed the sentiments of many of his generation when he wrote:

Let us frankly admit it—for us, the landscape is a stranger and one is frightfully alone among trees that bloom and brooks that flow past us. Being alone with a dead person, one feels far and away not so abandoned as being alone with trees. For as mysterious as death may seem, even more mysterious is a life that is not our life, that does not participate in our life and, without giving any notice to us, celebrates its own festivities, which we observe with a certain embarrassment, like guests who have arrived by accident and speak another language.[2]

Even without knowing the exact context of the passage by Rilke, the reader can sense in it a definite tone of regret and longing for a spiritual state which no longer exists. To Rilke, as a representative (or perhaps as a victim) of modern sentiments, nature is "the other"—but not "the enemy"; modern man contemplating the landscape does not see in it something to be tamed and molded by his hand in some grand struggle any more than he perceives in the natural scene before him an expression of divine order and omniscience of which he is but a small part. The experience of nature only forces the individual to realize his own isolation from anything that does not directly affect him or "participate in his life"; it implies an alienation not only from nature, but from the past (traditions, family history), the future and its ideals, both personal and social, and from all of society outside the immediate family.[3]

How utterly different is this sense of estrangement from nature that Rilke describes from sentiments expressed by the poet Eduard Mörike seventy-five years earlier. In the poem *Besuch in Urach* (*Visit to Urach*) written in 1827, Mörike relates his experience of communion with nature:

> Almost as in a dream I found myself
> Wandering back in this beloved valley.
> What I can see is not a miracle,
> But the ground shifts, air and bushes whirl,
> From green and countless mirrors bygone time
> Now seems to move and smiles, bewildering me;
> Here truth itself becomes a very poem,
> A strange and lovely vision of my own image.
>
> .
>
> Here any bush or blade of grass becomes
> A noose to snare me in sweet meditation;
> No tiny bank of earth, no piece of wood
> Too small for me to look upon with sadness;
> Each speaks to me of half-forgotten things;
> Feeling how pain and joy press back the tears
> Which hesitate, I do not stop but hasten
> Onward and undecided, full and thirsting.[4]

For Mörike, nature is something approachable and sympathetic, a mirror to the past and a friend of the heart. Nature is filled with movement and life, but its forces are not hidden from man. Rather, they seem almost to react to their visitor's presence, welcoming him into intimate surroundings. The natural experience expands the individual psyche for Mörike, whereas for Rilke the experience merely serves to underline the extreme limitations of the individual.

This contrast between the artistic expression of the early nineteenth century and that of the first generation of twentieth-century modernism should not be that unfamiliar to the reader. The same pattern exists as a general tendency in most Western art and literature; one could set up a similar comparison using the examples of Wordsworth and Eliot, for instance. The situation in Germany at this time, however, took on the most extreme proportions. Nowhere else was the contrast between man's present estrangement from his surroundings and his former spiritual attachment to it so keenly felt or was an actual desire to overcome the estrangement and emptiness of modern life and return to a state of mystical harmony with nature so developed and widespread. Volkish thought was one such attempt to negate the present age. Its "program" sought to reinstate in its audience a sense of intimacy and awe before nature comparable to the Romantic feelings expressed by Mörike.

The physical features of modern Germany, its geographic, political and economic structure, were transformed irrevocably after 1871 and with a rapidity which made the changes seem almost to occur overnight. The first major change

was the creation of a unified German state, the new German Empire, under the dominant leadership of Prussia and its chancellor, Bismarck. Forged in the wake of the Franco-Prussian War from the overwhelming patriotic sentiments and practical political necessities engendered by that brief conflict, this German Empire was, as it was termed at the time, in many respects the "second Reich." It was perceived as the first lasting and stable unification of German states under a single political structure since the demise of the first Reich of Charlemagne and his successors five centuries earlier. Moreover, this new German state was the culmination of more than a century of unsuccessful attempts at political unification. By 1871 the German mind had been so conditioned by the series of failed attempts to create a unified German state that the desired goal of a single sovereign nation took on the qualities of a dreamlike ideal rather than an achievable reality.

The development of this curious attitude began almost a century earlier in response to the profound political and psychological changes wrought by the French Revolution and the Napoleonic campaigns and also by the equally oppressive domination of European art and literature by French culture. To ward off foreign domination and regain a secure position within European history, many Germans around the turn of the nineteenth century began a concentrated effort to bring about a political and cultural unification of German-speaking peoples. In part because of the extremely repressive nature of the German Confederation under Metternich which quickly and severely punished any political activities outside its own sphere, but also in keeping with the tendency already mentioned to perceive a separate "spiritual reality" above and beyond everyday pragmatic reality, much of the new nationalistic interest in Germany was either couched in or actually and intentionally expressed in poetic or philosophical and scholarly argument.

Gradually, more and more of the best German thinkers lost interest in any political efforts to create a sovereign constitutional state, and the leading intellectuals turned their attentions instead to the cultural concerns such as the examinations of newly discovered folklore and popular poetry. In this respect, a collection of folk songs like *Des Knaben Wunderhorn*, Jakob Grimm's *Teutonic Mythology*, Joseph von Eichendorff's nature poetry, or Goethe's *Faust* were more influential in creating a sense of national pride and destiny than any speeches by Friedrich Christoph Dahlmann or Heinrich von Gagern before the National Assembly in the Paulskirche in 1848.

By 1870 in the minds of many Germans the desired image of a national union had become a cultural ideal rather than a political possibility. When the German Empire was proclaimed in 1871, by its very nature it failed to meet the expectations of a large segment of the German population, and in the succeeding decades the Empire further alienated these individuals, as the second major change of the period, a rapid and all-encompassing industrialization, began to transform German society.

This industrialization of Germany was achieved with phenomenal speed and commercial success after 1871. By the end of the decade, German industrial production had overtaken that of France, and by the turn of the century it was equal to that of England with only the United States producing more industrialized goods. Necessary for this process was an equally swift exodus of large masses of the population from the countryside to the large urban centers in Germany. In 1830, eighty percent of the population lived in the country and earned a living in agriculture; seventy years later less than twenty percent of the population was rural.

As a result of this process, German society in the last quarter of the nineteenth century, even to those individuals most closely associated with the changes, was seen as moving toward an uncertain future. Golo Mann relates the following incident concerning Bismarck:

> In his old age, visiting the port of Hamburg, he looked down on the mass of ships and crane and workers and shuddered as he murmered to himself: "This is a new age"—which indeed it was. For someone who in his youth had attended the balls at the court of Frederick William III it must have been a strange, sinister and ultimately incomprehensible age. Although new ages do not come about from one day to the next this one took only a few decades to arrive, starting gradually and then quickening its tempo until it almost resembled an explosion.[5]

Not only was Germany moving toward uncertainty, but to the basically conservative personalities who became the strongest voices of Volkish criticism, the nation and its culture were moving ever further from a certain, secure past. To those Germans who envisioned a new German Reich based on the spiritual ideals of a past German age rather than on a materialistic, individualistic and essentially "un-German" present, the only link between them and that past was very literally their land—the German countryside. The Volkish writers offered just such an ideal to conservative-minded Germans. The focus of many Volkish ideas was an appeal to this segment of the population, to the irrational fears and frustrations such persons felt concerning the present course of German society and to the xenophobic sentiments prevalent among this minority. The Volkish writers confirmed this reactionary mentality in their condemnation of modern German society. More importantly, the attention of German conservatives and nationalists was captured by the Volkish allegiance to the ideals of the German past, especially in the homage Volkish thought paid to the German landscape and to the intimate relationship between the land and its history.

The landscape in most parts of Germany had remained virtually unchanged since late medieval times, these individuals believed; at least the manmade aspects of the landscape—farmhouses, roads—all appeared in the early nineteenth century as they had in the fifteenth century and one could experience the past through these objects in the landscape. In 1797 the German Romantic poet Wilhelm Heinrich Wackenroder praised the town of Nuremberg with its still extant medieval buildings. His description of the town exemplifies this

manner of perceiving the German landscape and expresses the strong desire to
gain renewed contact with the spirit of the German past which was so widespread
at the time.

> Nuremberg! you once world-famous town! How I liked to wander through your crooked
> streets; with what childlike love I looked at your ancestral houses and churches which bear
> the firm traces of our old paternal art! How deeply I love the forms of those times, that speak
> such a rough, strong and true language! How they draw me back to that grey century, when
> you, Nuremberg, were the lovely, swarming school of national art and a truly faithful,
> exuberant spirit of art dwelt and stirred in your wall.[6]

As the century proceeded these sentiments increased. In 1896 the essayist
Friedrich Ratzel evaluated these Romantic attitudes toward the native German
landscape as "a sign of a growing intimacy with our countryside, that is, with
ourselves as a *Volk*. For how can one divorce the participation of the soil from
the essence of a *Volk,* which has lived, worked and suffered on that same soil
for fifteen hundred years?" In addition to the inspiration of historic architecture
and ancient cities, Ratzel saw an intimate bond between the *Volk* and the land.
"A people impresses its spiritual essence, its fate on a landscape, just as it does
on its cities and houses."[7]

Most often this bond between the *Volk* and the land was expressed by writers
discussing the phenomenon in terms of "roots," for example, the "rootedness"
of the *Volk* to its native soil. This image implies not only an exchange which
proceeds from the inhabitant to the soil, like Ratzel's imprint of a "spiritual
essence" on the landscape, but also an extraction of certain "qualities" from the
soil.[8] Repeatedly, one finds examples of the belief that certain creative charac-
teristics and powers of the individual are in some invisible, intangible, but
nevertheless undeniable fashion the direct result of contact with the soil which
the individual and his forefathers have inhabited. Such a belief led the Volkish
critic Julius Langbehn to call for the creation of a new discipline: "German
spiritual geography (*Geistesgeographie*)—namely a scientific tracing of the in-
dividual personalities of German spiritual life back to the respective characteristics
of the native landscape and clan (*Stamm*)."[9]

Although few members of Wilhelmine society would have felt it necessary
to go to the extremes Langbehn suggests here, by the last quarter of the century
this belief in an undefinable connection between the German people and the
native landscape was widely held at the public level, and many Germans were
distressed at the results of industrialization. To these anxious observers industriali-
zation was not only "uprooting" large segments of the traditional social structure
by drawing the rural population into the big cities and their unnatural urban life,
full of toil and "rootless," but the land itself, the countryside, was being trans-
formed by factories, railways and new roads and towns that had no real historical
or "natural" bond with the landscape. Many Germans began to envision the
ultimate desecration of the German countryside and the elimination of those

individuals who retained the best and truest qualities of the *Volk* by virtue of
their intimate and traditional connection with the land. The term "Americaniza-
tion" was frequently used in discussions of the changes which German society
was undergoing, to point out the predominance of materialism, mechanization,
commercialism and mass society, but also to make veiled reference to a nation
with no sense of history and no spiritual bond with its soil, in short, a nation
that was not a *Volk*.[10] Thus, when Rilke describes the landscape as "a stranger"
and something which has nothing in common with its human observer, he is
speaking as a child of Wilhelmine Germany, a Germany whose landscape had
been transformed from what it was a thousand, one hundred and even fifty years
before and whose "roots" with that landscape and its traditions had been severed.

In the late nineteenth century the German province of Schleswig-Holstein had
no large urban centers, and industrialization on any noticeable scale did not
begin in this region until well after the *Gründerzeit*. Perhaps more than any other
German province, Schleswig-Holstein retained the essentially rural character of
an earlier age. Nevertheless, the German residents of Schleswig-Holstein experi-
enced a national "identity crisis" with an intensity equal to that felt by Germans
elsewhere because of the precarious political situation of their homeland as a
border province. The various avenues which were pursued in search of a national
identity in more politically secure regions were received by the intelligentsia of
Schleswig-Holstein with more than a trace of enthusiasm. Seeing themselves as
pawns at the mercy of larger, more powerful states and unable to control effec-
tively their own political situation, many Germans in Schleswig-Holstein turned
to their history, their culture and the land that spawned them as a source of
stability and identity.

 From the Middle Ages until the middle of the nineteenth century both
duchies, Schleswig and Holstein, had been under Danish rule. The political
allegiance and stability of the duchies weakened after 1848 as pro-German sen-
timents surfaced among the German-speaking populations of these regions. Pro-
German nationalism intensified in Schleswig and Holstein during the 1850s, and
numerous appeals were made to Prussia and other powerful German states to
support the aspirations of their German brethren in these northern provinces.
Finally, in 1866, Prussia responded to these pleas by annexing Schleswig-Holstein
after a brief military campaign against Denmark.[11]

 This incorporation of Schleswig-Holstein into the Prussian political system
was crucial for the political, economic and especially cultural development of
the northern province in the latter nineteenth century. To ensure the allegiance
of the region and secure a power base, the Prussian state invaded Schleswig-Hol-
stein with its well-known efficiency and bureaucracy, chiefly in the area of public
education.

 For North Schleswig—that is, the regions just north of the present-day
Danish border (and Nolde's homeland)—1866 did not bring immediate stability
and unification with either Prussia or Denmark. It was forced to exist in a state

of political limbo for another dozen years until a referendum could be organized in the northernmost districts to decide upon the exact location of the border. Because of the nature of the situation in North Schleswig and the kinds of provision made for its settlement, an atmosphere of Danish activism began to surface to combat the already powerful elements of German nationalism that were operating in the area. A state of cultural tension continued throughout the border region for the next fifty years.

Anticipating the eventual referendum and seeking to ensure an outcome favorable to her cause, Prussia began to institute a program of German *Sprachpolitik* through educational reforms in areas previously under Danish control. Prussian *Sprachpolitik* involved not only instruction in the language per se, but also the use of German texts for instruction in other subjects. Such texts were disseminated with characteristic Prussian efficiency to large numbers of school-aged children, not only in North Schleswig but throughout the Prussian Empire.

As early as the 1840s, the nationalist struggle was fought not only in the political arena but through the press. Various publications extolled the German character of Schleswig-Holstein as revealed in its history and its cultural expression. These publications fall into two broad groups: one type follows the format of the travelogue and the other is a collection of various entries (*Lesebuch*) dealing with matters pertaining to the history, behavior and character of the *Volk* or to folklore. In the historical development of the Volkish ideology, these types of publication, especially the travelogues written around the middle of the century, provide a direct link between the nationalistic strain of German Romanticism represented in the figures of *Turnvater* Jahn, Ernst Moritz Arndt and J. G. Fichte in the first two decades of the nineteenth century and the Volkish propaganda of Paul de Lagarde, Julius Langbehn and others at the turn of the twentieth century.[12] In some cases these publications anticipated the political struggles in Schleswig-Holstein, and in other publications a direct reaction to the situation was evident. All of them, however, were explicitly or implicitly intended as a contribution to the nationalist cause. In the latter part of the nineteenth century, when Emil Nolde was growing up and maturing, these books are as important in an intellectual dimension as the actual political events which affected the territory.

Theodor Mügge's *Streifzüge in Schleswig-Holstein und im Norden der Elbe* (*Excursions in Schleswig-Holstein and North of the Elbe River*), published in 1846, is typical of the travelogue category. Following the format that would later be raised to the level of literature by Theodor Fontane in his *Wanderungen durch die Mark Brandenburg* (*Ramblings through Brandenburg, 1862–82*), Mügge describes the history, architecture and local customs of the land and provides a first-person narrative account of the landscape through which he passes as he rides the train from Berlin to Hamburg and then journeys up into the province itself. The factual and descriptive passages are frequently interrupted

by patriotic *excursa,* and Mügge makes no attempt to disguise his purpose in writing the book, which is, as he states in the preface, to show the German nation at large just how much a part of that nation and its cultural heritage Schleswig-Holstein is.[13]

Instead of political argument or reasoning to advance his cause, the author relies on description of the sheer beauty of the landscape and its emotional effect on him and accounts of the life and customs of the region's inhabitants, especially those aspects which will seem familiar to the reading audience and similar to their own customs and heritage.

The method employed by Mügge, which combines direct observation with historical evidence and study and then a transformation into a resulting patriotic panegyric, was a frequently used form of expression of nationalist sentiment in Germany around the middle nineteenth century. In the decade of the 1850s this approach was codified and widely publicized by Wilhelm Heinrich Riehl, a professor at the University of Munich. Riehl's many widely read publications became the standard texts for the developing discipline of *Volkskunde* (folklore with overtones of cultural anthropology), especially to the Volkish writers of the next generations.[14]

Riehl's most important contribution to the developing Volkish movement was the infusion of an attitude into the study of the *Volk* that was politically conservative and antimodern. For him, any contact with the *Volk* and the natural order of things would result in the inevitable conclusion that democracy and urbanization, the children of the Enlightenment and the nineteenth century, were directly opposed to the needs and desires of the *Volk*.[15]

After the appearance of Riehl's works, almost all publications that attempted to describe or examine a *Volk* carried this tendency of political conservatism and antimodernity as part of their intellectual baggage. A Schleswig-Holstein travelogue from 1858, A. U. Hansen's *Characterbildern aus den Herzogthümern Schleswig, Holstein und Lauenburg (Character Sketches from the Duchies of Schleswig, Holstein and Lauenburg),* is a case in point. Written after the political turmoil which followed the 1848 revolutions in this territory, Hansen's book is much more militant in its expressed purpose than Mügge's *Streifzüge* of twelve years earlier.[16]

In relating the history of the province, Hansen includes an exposition of the heathen altars and grave sites to be found throughout Schleswig-Holstein and a discussion of the ancient Nordic gods.[17] This point recurs with increasing frequency in Volkish writings around the turn of the century, as these writers attempt to create a link between their aspirations for the future and the earliest historical period of the German people as described by Tacitus, when the fierce Germanic warriors defended their land against foreign (Roman) intervention.[18]

Increasingly in the latter half of the nineteenth century, the rural scenes praised in these travelogues and other literature in Germany were presented not as a part of the modern world, but as something opposed to it and threatened

by it. Some writers, like Mügge, continued to perceive this threat as something inevitable and irreversible, and their attraction to the simple, rural life of the peasant was strongly colored by nostalgia. But others began to conceive of this situation as a struggle with profound spiritual, political and cultural overtones, whose outcome was by no means predetermined.[19]

The second category of books published on aspects of Schleswig-Holstein in the period from 1840 through 1860, the *Lesebücher* or collections of various materials, contains examples whose purposes seem far less overtly patriotic than the representative works of travel literature just discussed. One of the most widely read and quoted of these publications, Claus Harms' *Schleswig-Holsteinischer Gnomon. Ein allgemeines Lesebuch (The Schleswig-Holstein Gnomon. A Common Reader,* 1843), contains almost two hundred entries culled from various sources on a wide range of subjects including languages, art, geography, antiquities, anatomy, economics, history, games and festivities. Some of the sections are germane to Schleswig-Holstein although others are not and the tone of the book is, on the whole, very cosmopolitan. Nonetheless, there are certain entries such as "Die Deutschen" (number 53), which would have instilled in the reader a definite pride in his German heritage and contributed to the self-image of Germans as "spiritual beings." The passage proclaims that

> the German is born to dwell in the world of the spirit; his life is completely inward-oriented, his heart and his mind are more developed than his senses [for contemplation], his greatest pleasures are those of sentiment and of thought. . . . His happiness does not spring from material things; he is hardly affected by that which goes on around him. . . . His freedom does not exist in political institutions, but rather much more in the undisturbed pursuit of free ideas.[20]

The next section is entitled "Man in relation to nature" and is equally important in its appeal to Romantic-Volkish view of character development: "The effect of nature on the individual changes from land to land, for the earth consists of regions, each of which has its own particular character and differing influence on its inhabitants. Every landscape has its own people (*Volk*)."[21] The Harms reader was widely used in the public schools in Schleswig-Holstein during the final decades of the nineteenth century and its influence thus lies in the mental state of the self-image it fosters, an image of Germans as inhabitants of a "spiritual world" whose only connection with the real world is their mystic bond with the native landscape.[22]

Karl Müllenhoff's collection, *Sagen, Märchen und Lieder der Herzogtümer Schleswig, Holstein und Lauenburg (Legends, Fairy Tales and Folksongs from the Duchies of Schleswig, Holstein and Lauenburg,* 1845), is somewhat more focused in its intentions. Inspired by the efforts of the historian Theodor Mommsen and the novelist Theodor Storm, both prominent figures in Schleswig-Holstein who supported the recording and dissemination of local histories and folklore within the province, Müllenhoff states in the introduction to his collection

that it was arranged with the idea "of the great whole to which we belong" (i.e., the German nation), but meant to focus on the regional character of each specific tale.

The struggle to define the German character within the Schleswig-Holstein heritage and to retain intact the soil which nurtured that simple, traditional existence was carried on in many other books and pamphlets, in articles in scholarly journals and weekly newspapers and in the classrooms of the province throughout the latter half of the century. Almost all the major exponents of the Volkish cause at the turn of the twentieth century had been born and raised in that climate.

The profound dissatisfaction with the cultural climate of the Wilhelmine era, the persistent longing for a national identity which extended beyond a mere political structure and the recurrent tendency to seek the roots of this desired "spiritual nation" in the ideal German past and the various other ideas which circulated within these central points were gathered up, organized and advanced in the writings of two Germans in the last two decades of the nineteenth century, Paul de Lagarde and Julius Langbehn. From the testimony of later Volkish activists and the credence given to the ideas put forth in the two authors' writings, Lagarde and Langbehn were the most influential figures within the developing Volkish movement at this time. The majority of Volkish ideas and concepts found in Nolde's writings and in his art were originally expressed by Lagarde and Langbehn.

Paul de Lagarde (1827–91) was a frustrated academic, an Old Testament scholar and Oriental philologist.[23] Born into an old Saxon family whose sons had for generations entered the Protestant ministry, Lagarde decided instead to pursue an academic career. Unable to secure a university appointment until 1869, he spent the first fifteen years of his professional life teaching at *Gymnasien* (secondary schools), feeling himself to be exiled from his true calling as the result of a conspiracy by frightened and jealous colleagues. Lagarde's failure was, however, mostly of his own doing. After he submitted several texts for publication without editorial correction or explanation, publishers began to refuse his works. He also included in several scholarly articles grandly irrational, unverifiable conclusions concerning the spiritual potential of his subject. Colleagues reacted to such speculations with outrage, and Lagarde quickly gained a reputation as rash and unreliable. Lagarde's professional frustration was mirrored in the personal frustration he felt as a resident of Bismarck's Empire, but that in turn was almost a part of his nature. He seemed a man determined not to fit in. "One thing I know," he wrote, "I belong not in this time nor in this world. My fatherland has to be bigger."[24]

From this stance, Lagarde wrote the searing, penetrating criticisms of imperial Germany and the current state of German culture that were published as a

series of essays entitled *Deutsche Schriften* (*German Writings*) in 1878. A second volume was released three years later, and Lagarde sent copies to members of the Prussian court including Prince Wilhelm and Bismarck himself.

The basis of Lagarde's despair and his vision of cultural decay was his assumption of a basic frailty in man. He believed the German character would languish in the material comforts of the Wilhelmine Era, for it had nothing to challenge it, nothing toward which to strive. "We shall sink into nothingness," he wrote in 1881, "for the capital resources of our intellectual life, which we possessed in 1870, have been nearly exhausted in this last period of our history and we are face to face with bankruptcy."[25] Man is weak and threatened in this situation, Lagarde felt, but his present plight is so utterly deplorable because within him there exists so much potential for nobility.

> Everything depends on the human being, and Germany lacks nothing so much as men; there is nothing toward which Germany with its adoration of the State, of public opinion, of *Kultur*, and of success, directs so much hostility as toward the individual, who alone can bring it life and honor.[26]

When Lagarde refers here to the individual and elsewhere to the "free intellectual and spiritual development of man," he is not writing within the context of a modern humanistic and politically liberal view of man.[27] Rather, the free development of the individual which Lagarde desires must take place within a greater spiritual construct which controls and directs this development — a faith which liberates through its chains. This is the crux of Lagarde's Volkish system. "I want to bind and liberate my people," he wrote. The term "bind" recurs as frequently as "rooted" in Volkish writings and carries the connotations of a bond that gives strength and sustenance.[28]

Beyond the caustic critiques of Prussian society, Lagarde's most important contribution to the Volkish movement was this call for a new faith, a Germanic Christianity, which could revitalize the German spirit and reform the nation. This Germanic faith was based on a rejection of traditional Christianity, which Lagarde felt had been perverted by the infusion of Jewish, Greek and Roman elements. Foremost among these debilitating influences were those of Jewish origins. Lagarde blamed St. Paul for covering the original Gospel "which is an exposition by a religious genius of the laws of the life of the spirit" with the veil of Hebrew law.[29] To create his "religion of the future," Lagarde sought to strip away these Jewish elements and reach the original doctrine of the Gospel, which would be fused with the "national characteristics of the Germans" — "the independence of intellect, the love of loneliness, and the peculiar selfhood of the individual."[30] And these "national characteristics" necessary for the creation of the new faith could be found only in the peasant and lower, uneducated classes, which still retained these qualities from an earlier heroic age. The Germanic faith would not be a system of worship but a spiritual and political

realignment—a new way of life. "The basic principle of the new community must be that religion is the consciousness of the plan and purpose of the education of the individual, of peoples and of humanity."[31]

Julius Langbehn (1851–1907) was an even more eccentric personality than Lagarde. He was born in the town of Hadersleben on the Baltic Sea in North Schleswig (now part of Denmark), situated about fifty kilometers north of the present-day German-Danish border. Being of German descent and loyalty, his family was caught up in the political intrigues of the period. Three months after Julius' birth, his father was dismissed from his post as assistant principal of a local *Gymnasium* by Danish authorities for refusing to adopt Danish as the official language in his school. Forced to move in search of work, the Langbehn family traveled south into more politically stable Holstein, eventually settling in Kiel, where Julius grew up.[32]

Like Lagarde, Langbehn was trained as an academic; he held a doctorate in art history and archeology. Unlike his mentor, however, he did not seek an academic career. In fact, shortly after his promotion, Langbehn decided against pursuing any sort of established career. "I shall now cease to study the past, instead I shall construct the future," he wrote to a friend in 1880.[33] The major cornerstone of the future that Langbehn sought to construct was the book he composed during the next decade, *Rembrandt als Erzieher. Von Einem Deutschen* (*Rembrandt as Educator. By a German*), published anonymously by C. L. Hirschfeld in 1890.

The "Rembrandt book," as it was commonly termed, was only nominally concerned with the historical figure of Rembrandt or with education as a discipline. Fritz Stern has aptly described it as "a shrill cry against the hothouse intellectualism of modern Germany which threatened to stifle the creative life, a cry for the irrational energies of the folk, buried for so long under layers of civilization."[34] The book, thoroughly unorganized and illogical in its argument, was the product of at least ten years' work. Several sources record Langbehn collecting information on a variety of seemingly unrelated subjects during the 1880s and corresponding with authorities on all sorts of technical matters, much of which must have gone into the Rembrandt book.[35] The prophetic style of the book was also a direct expression of Langbehn's undisciplined personality and the profound discontent he directed toward modern society. As an example of his discontent, one of his poems reads:

> Among pillars
> Fallen,
> Among temples
> Desecrated,
> Among people
> Cultivated,
> Among girls
> Corrupted,
> I walk and find no rest.[36]

For all the quirkiness of his character, Langbehn was not alone in the sense of unrest and dissatisfaction he felt. Large segments of the German population in the 1890s, especially the younger generation, seemed to share these feelings and the unprecedented and unexpected success of the Rembrandt book was due in large measure to this phenomenon. In 1890, sixty thousand copies of the book were sold. By the end of 1891, it had gone through forty printings. Sales declined slowly through the next decade, but soared again in the 1920s. Its retail success was comparable to the reception of Oswald Spengler's *Decline of the West* after the First World War.[37]

Not only was the Rembrandt book read, it was read and discussed seriously — at German universities, in art schools and by the leading critics and intellectuals of Germany. Ferdinand Avenarius, later one of the founders of the German *Werkbund,* expressed the admiration of much of his generation when he praised the book.

> The chief significance of this work lies in the fact that the author molded in his heart a coherent *Weltanschauung* out of the diverse elements of his thought, a *Weltanschauung* which, new as it is, becomes at once typical of a *Weltanschauung* of hundreds, even thousands of Germans. In this sense *Rembrandt als Erzieher* is truly a work of deliverance.[38]

The art historian Cornelius Gurlitt went so far in his enthusiastic support of Langbehn's book as to suggest that it, along with Lagarde's writings, should be required annual reading for public school teachers.[39] The anonymity of the book lent to its appeal and to its cultlike following in many quarters. The author became known simply as "the Rembrandt-German" and many of his supporters adopted the accolade. Fritz Stern writes, "Before the First World War, to proclaim oneself a 'Rembrandtdeutscher' was to attest a noble commitment of the heart, a longing for a better and more artistic national future."[40]

Lagarde had called for a new Germanic faith that would combine the qualities of original Christianity with the strongest national characteristic of the German *Volk.* Langbehn accepted this notion and reinterpreted the personality and art of Rembrandt in this light. Langbehn's Rembrandt became the ideal of Germanic Christianity and the model for the spiritual revival of Germany. The following description of Rembrandt reveals just how closely Langbehn's hero conformed to Lagarde's ideal faith:

> His inwardness runs deep. One might say that in some of his paintings he is more prophet than poet; he chooses to seek the spirit on the dark side rather than the bright side of existence. Peculiar to him is a genuine religiosity, this deeply German quality, which he exhibits to a great and as yet unsurpassed degree. He presents the biblical scenes to us just as we once imagined them as children; he is the mouthpiece of the *Volk* in artistic matters; and what artist can or should be more than this? . . . the netherlandish painter has undoubtedly . . . found the objective spirit of original Christianity (*Urchristentum*).[41]

In this passage, Langbehn's argument takes a leap, and it is difficult to follow his logic when he writes of Rembrandt's Volkish tendencies and concludes

that the artist therefore exhibits the "spirit of *Urchristentum*." To Langbehn's way of thinking, this association is unavoidable due to his understanding of Germanic Christianity. Whereas Lagarde conceived of this new faith as the product of an intense, passionate study of the Gospels from a Volkish point of view, Langbehn saw the source of this religiosity residing entirely in the *Volk*. "A strong personality develops only from a strong tribal spirit (*Stammesgeist*) and this in turn only from a strong Volkish spirit."[42] Implicit in this "strong personality" is the spirit of *Urchristentum*, "this deeply German quality."

Langbehn is returning here to a basic but nonetheless previously unexpressed belief long held by many Volkish-oriented minds. The belief is in a spiritual symbiosis between the individual member of the *Volk* and his native soil, a belief which itself developed out of early Romantic notions. Langbehn saw a complete correspondence between "a uniform summary of dimensions, that is the inner symmetry of natural phenomena" and "a uniform summary of emotional inter-relationships, that is the inner rhythm of human life."[43] In other words, nature and the soul are analogous. The concept of a divinity which conceived this analogy and is in turn revealed through it is implicit in this belief. Langbehn writes elsewhere, "seen from the point of view of human consciousness, the individual is only an eternity which has been reversed and turned inward; eternity, likewise in human terms, is only an individual personality, turned outward, directing itself toward infinity. God, man and world are concepts which are contained each within the other."[44] To know God and to know one's own soul, one only has to understand nature properly; it is a matter of the proper state of mind. This concept is taken from the theosophical system of Emanuel Sweden-borg, the eighteenth-century Swedish mystic. George Mosse points out that Swedenborg's influence on the developing Volkish movement went far beyond Langbehn's acknowledged debt, because Swedenborg's view "that every man has a microcosm containing within himself a world or a heaven tended to portray the individual in the terms of Volkish ideology."[45]

If this process was to be applied to the situation in Germany, if the soul of the German *Volk* was to be recognized and expressed in a new art form, then, according to Langbehn, a practice of "localism of art" must be instituted.

> A modern art can only flourish, if it carries within itself the balance of lasting, stable, necessary, innate, eternal elements. . . . And this can only be achieved through a concentration on the specific, local character of the individual regions of Germany.[46]

In Langbehn's terminology, the truly German painter must be a local painter. He must exhibit the quality of *Volkstümlichkeit*—"belonging to, expressing, yet transcending his people and its traditions."[47] This is the lesson of Rembrandt; more than any other artist Rembrandt had this quality. "He remained true to the soil from which he sprang."[48] The cultivation of *Volkstümlichkeit* in German life and art is the road to salvation for modern Germany.

Rembrandt is exactly the same for Holland and in a broader sense for Germany as Phidias is for Greece and what the German artist—of the future—shall be for Germany: the highest and purest, the freest and finest expression of the popular (*volkstümlichen*) German spirit. His experience is rooted in the spirit of Lower Germany (*im niederdeutschen Geiste*) and his vision rises to the fullest heights of individuality.[49]

This image of the individual member of the *Volk* rooted to the soil but interacting with the heavens recurs throughout the Rembrandt book. For example: "The genuine artist acts in this manner; his foot is firmly attached to the earth, but his gaze is directed toward the heavens."[50] This notion of the human element as a "spiritual intermediary" linking the earth (symbolizing the past) with the cosmic forces is found in many Volkish writings around the turn of the century, especially in popular peasant novels where the peasant fills this role. The image will reappear in a somewhat disguised form in certain of Nolde's landscapes.

The phenomenon of *Niederdeutschland* is central to Langbehn's vision of the new Germany and its Volkish art. Geographically, *Niederdeutschland* or Lower Germany comprised the lowlands along the Baltic and North Seas from Denmark down through Holland. Rembrandt was a *Niederdeutscher,* as was anyone whose ancestors had resided in this region—for Langbehn the list included such diverse figures as Shakespeare, Bismarck, even Johnny Appleseed, and of course Langbehn himself.[51] *Niederdeutschland* was the last refuge of the idealized peasant population which retained the noblest spiritual attributes of the German *Volk.* Consequently, this region would be the birthplace of the new German art and spirit, Langbehn hoped. To give credence to this theory, Langbehn conceived of a "migration of the energy of the *Volk*" from southern to northern Germany— the age of chivalry and the *Minnesang* had flourished in southern Germany, the Reformation and the written German language originated in central Germany, the age of art had therefore to blossom in the north.

The specific region of *Niederdeutschland* which attracted Langbehn's attention was—not surprisingly—Schleswig-Holstein. In this manner, the Rembrandt book takes a place within the categories of literature on Schleswig-Holstein discussed previously. Whereas the earlier examples had attempted to demonstrate the Schleswig-Holstein should be included in the greater German nation on political and cultural grounds, Langbehn's intentions in the Rembrandt book are far more grandiose—Schleswig-Holstein should not be considered just a part of the German nation; it should be viewed as the sole source of salvation for that nation. In a passage that comes the closest in the entire book to a sustained logical argument, Langbehn presents his case for this view of his homeland.

First of all, Schleswig-Holstein has always been at the forefront of German history. It provided a backdrop for the entrance of the first Germans, the Teutons and the Cimbri, onto the stage of world history. It is the homeland of Shakespeare's ancestors, the Anglo-Saxons. More recently, Schleswig-Holstein played a cardinal role in the creation of the new political state of Germany, as it captured

and intensified the spirit of the *Volk* in 1848 and later.[52] Secondly, just as Schleswig-Holstein has historically provided a source of synthesis and unification in political matters, in the spiritual realm this province can achieve the same results. "Thus, it seems especially well suited to call a halt to the dissolute tendencies that have held sway over German education up to this point. Unifica-- tion, in the realm of the spirit, is construction."[53]

Schleswig-Holstein is also the only part of Germany which had any direct artistic contact with Rembrandt—by sending students to him and by employing his students.[54] In the Volkish mysticism Langbehn employs, such a contact is significant. A demonstration that the spirit of Rembrandt actually touched Schleswig-Holstein soil is a convincing argument. Finally, the province is a land where the spirit of aggressive attack, in both a political and a spiritual sense, is and always has been held as the highest virtue. Schleswig-Holstein and its inhabitants can provide the perfect example for the rest of Germany in political, military, moral and religious matters. Like Rembrandt, Schleswig-Holstein can "educate."[55] What Holland was in the past and as a sovereign state, Schleswig-Holstein will probably be for the future and as an integral part of the German empire: "the focal point for a free and further development of German spiritual life."[56]

Considering the popularity of the Rembrandt book and its wide reception, Langbehn did more to place Schleswig-Holstein in the mind of the German public than any earlier writer had been able to do.[57] More importantly, the image of Schleswig-Holstein that Langbehn presented to the public was a very special one—a "New Holland," the seat of a spiritual rebirth of the German *Volk,* the homeland of a new Rembrandt. One can almost imagine the eyes of Volkish-minded Germans turning northward, anxiously awaiting the arrival of this artist-hero who never appeared or came somehow unnoticed.

In the concluding paragraphs of the Rembrandt book, Langbehn returns once more to this image of Schleswig-Holstein and places it in conjunction with all the major points he has raised in the book, the individual components which must be combined to create the new world.

> The cradle of the Aryan state of mind is the entire Germanic northwest, that is, *Niederdeutsch-land;* from this fact arises the necessity that renewal of German national feeling must take place in conjunction with *Niederdeutschland;* only there where a *Volk* was born can it be reborn. What is born or reborn is a child; and the childlike state is, as noted, Christianity; this, as likewise emphasized, is in its noblest form—mankind.[58]

As important to Langbehn's argument in the Rembrandt book and to its remarkable influence as the messianic ideal of Rembrandt and the image of Schleswig-Holstein was the author's appeal to a specific segment of German society, the youth of Germany coming of age in the 1890s, to take up the cause of the book. The vision of the future and the hope Langbehn placed in this transformation was not intended as a distant ideal. It could and indeed should be realized within one generation.

> Each year's vine carries a new wine; so it is with the German vine; and this "new wine" cannot be distilled in old skins. In other words plainly spoken: the new spiritual life of the Germans is not a matter for professors; it is a matter for the German youth, especially the uncorrupted, un-miseducated, uninhibited German youth. Right is on its side.[59]

More than any other Volkish critic, Langbehn appealed to Nolde and Nolde's generation.

One final cultural critic must be mentioned before this examination of a developing cultural crisis in the last decades of the nineteenth century in Germany is concluded: Friedrich Nietzsche. Nietzsche was not a Volkish critic. This point must be emphasized, because he is repeatedly discussed in that context despite the many differences between his intentions and those of Lagarde, Langbehn and their followers. Nietzsche was not a nationalist; the Volkish critics were— often to an extreme. More importantly, as Fritz Stern points out,

> Nietzsche was a philosopher, a great and self-critical writer, to whom the search for truth and reality was a measure of his own integrity. Half-truths and the comforts of unreason he loathed. His style was experimental without being precious; witty without being trivial; profound without being ponderous. The reverse held true for the Germanic critics—proof again that style is the man.[60]

The overwhelming force with which Nietzsche attacked the cultural Philistinism of his day did, however, attract even the Volkish critics to his writings. Certain of Nietzsche's concepts were taken out of context and appropriated by the generation of Volkish writers that followed Langbehn. Langbehn tried even to appropriate the philosopher himself. In the winter of 1889–90, Langbehn attempted to gain legal guardianship of the failing Nietzsche, feeling that he alone could "save" him. Only the successful intervention of Nietzsche's friends Peter Gast and Franz Overbeck served to avert a situation that undoubtedly would have ended in a tragicomical farce.

The aspect of Nietzsche's philosophy that is most germane to the present discussion is his concept of Dionysiac rapture—an expression of irrationality that contains the potential for spiritual deliverance and rejuvenation. This concept was fully explored by Nietzsche in his early study, *The Birth of Tragedy from the Spirit of Music* (1872), and expanded and repeated in later writings, especially in *Thus Spoke Zarathustra,* whose protagonist Nietzsche called "that Dionysiac monster." Nietzsche's understanding of Dionysiac rapture, "whose closest analogy is furnished by physical intoxication," arose from his reinterpretation of Greek culture. This experience, Nietzsche believed, was the true source of myth and provided the participant with the fullest possible image of the truth of life, "as though the veil of Maya had been torn apart and there remained only shreds floating before the vision of mystical Oneness."[61] To the artist, access to such an experience was of supreme importance—"the productive power of the whole universe is now manifest in his transport, to the glorious satisfaction of the primordial One."[62]

Although Nietzsche recognized the powers of irrationality in Greek culture, he saw their existence and redeeming capacity in all ages, including the present one. "And if the German should despond in his endeavor to find his way back to his lost homeland, whose familiar paths he has forgotten, he has only to listen to the call of the Dionysiac bird, which hovers above his head and will show him the way."[63]

Nietzsche's emphasis on an art and a way of life rooted in the Dionysiac experience was understood by many of his contemporaries as a call for the establishment of a Dionysiac culture in the present age to combat the stifling, overcivilized, "Apollonian" influence of modernity. This aspect of Nietzsche's philosophy lent itself particularly well to Volkish interpretation. The Dionysiac experience could be "nationalized" to explain the assumed interaction of the individual member of the *Volk* and the natural forces of the native landscape.[64] The image of the peasant "rooted" to his native soil could be redefined so that the peasant actually reacted to or perhaps acted in accordance with the mystical forces of nature. For example, in Hermann Löns' *Der Wehrwolf* (*The Werewolf*, 1910), the most famous German peasant novel of the period, one of the protagonists speaks this almost Nietzschean line: "What is culture, what meaning does civilization have? A thin veneer underneath which nature courses, waiting until a crack appears and it can burst into the open."[65] After Nietzsche, the subjectivity which had always been a prime attribute of the Volkish hero in literary discussion was transformed from a quiet, but resolute mysticism to an irrationality characterized by a fascination with brute force and by ecstatic, uncontrollable behavior.

Though to a lesser extent than in the preceding example, a Dionysiac spirit is also evident in Langbehn's image of Rembrandt. Langbehn presents the artist as willful, defiantly individualistic and totally spontaneous and subjective in his creativity, controlled only by an inner vision. His art lacks totally the Apollonian qualities of clarity, symmetry and equilibrium; instead, it exhibits boldness, power and an abundance of formal and symbolic associations.[66] Finally, there is considerable evidence of the influence of this aspect of Nietzsche's thought on Nolde and his art.[67] Certain periods of creative outpourings which Nolde describes in terms of an intoxicated state cannot be fully appreciated without reference to Nietzschean theory.

2

The Roots of the Man:
Nolde's Youth and Education

Nolde, the primeval soul, the earth-bound, is easier to imagine as a man of flesh and blood than other [artists]. And when one sees him, he is hardly disappointed: a genuine Nolde, as he is, must be and will remain.

In their distance of escape from earth, abstractionists sometimes forget that Nolde exists. Not so I, not even on my furthest flights, from which I always find my way back to earth in order to recuperate in newly won gravity.

Nolde is more than just earth-bound, he is also the demon of this region. Even residing elsewhere, one is always aware of him as a cousin there in the depths, a kindred spirit. . . .

With Nolde a human hand is at work; a hand not without heaviness and a writing not without flaws. The mysterious full-blooded hand of the lower depths.

Each region forms and colors its mysteries and the hands that bring them forth differ much, each according to the region in which their master resides. Still the heart of creation beats for all of them and nourishes these regions.[1]

This is how Paul Klee saw Nolde in 1927, when the "primeval soul" was sixty years old (and Klee himself was forty-eight). Of all the artists associated with German painting and the Expressionist movement of the first two decades of the twentieth century, Klee probably had a better understanding than any of his contemporaries of Nolde and his art—at least of the image Nolde sought to present and of the intentions which formed his art. Nolde recognized this fact and took some comfort in it. For almost fifteen years, in keeping with his solitary, brooding nature, Nolde had made little effort to explain himself and defend his art before the general public. He felt the course of modern art had run in directions far from the origins of his artistic expression. Only a handful of friends and patrons continued to show appreciation for his "strong, nordic art."[2] It is from this perspective that Nolde began to compose and publish his autobiography in the 1930s.

The first two volumes of his autobiography, *Das eigene Leben. 1867–1902* (*One's Own Life*), and *Jahre der Kämpfe. 1902–1914* (*Years of Struggle*), were published in 1931 and 1934, respectively. A third volume, *Welt und Heimat.*

Die Südseereise. 1913–1918 (*World and Homeland. The South Sea Journey*), was completed in manuscript form by 1936, but by that time sale of the first two volumes had been banned by the Nazi government, so that publication of this and the final volume, *Reisen. Ächtung. Befreiung. 1919–1946* (*Travels. Condemnation. Liberation*) was postponed until after the artist's death.[3]

The four volumes combine candid yet often naive accounts of trivial matters with a rather calculated effort to present a definite image of the artist to the reading public, an image not always consistent with actual facts. One can only guess at Nolde's motivations in desiring to place himself in the public eye after almost twenty years of seclusion and once again to defend his art. He may well have felt the particular climate of Germany in the 1930s conducive to a more positive appreciation and understanding of his work and his desires to create a "new German art." One must also consider the very human motivation to look back over an artistic career that had spanned almost forty years and reconsider it from the enlightenment of advanced age. Despite the strong, unbending posture which he sought to project, a strain of doubt and self-examination runs through much of Nolde's art. Nolde tried on occasions to suppress this tendency, but it persisted and its very existence lent his art a seriousness and profoundness it would not have had otherwise. As we shall see, it continually led him back to his homeland and to a contemplation of the origins of his art.

Emil Nolde was born Emil Hansen on the seventh of August, 1867, the fourth son of Niels and Christine Hansen, in the village of Nolde in North Frisia, the northwestern region of Schleswig. The land on which Nolde was born had been farmed by his family for nine generations.

His father, Niels, "likeable, shrewd, thorough and strict," supervised the daily operations of the family homestead and held several local offices. Niels was of Frisian stock and was strongly patriotic in matters of German interest. The young Emil seems to have had a genuine respect for his father, but his relationship with him was somewhat strained, a situation that was almost emblematic of so many of the writers and artists of the Expressionist generation.[4]

Nolde held a deep affection for his mother and was able to express that warmth and affection to her. Christine Hansen was of Schleswig-Danish heritage. Because an aunt carried out most of the household duties, Christine was free to pursue her own devices, and much of her time was taken up with her beloved flower gardening. Nolde quite often mentions his mother in conjunction with flowers and from an early point in his career he had formed a strong and conscious association between the memory of his mother and the images of home and of flower gardens.

Each of Nolde's brothers seems to have had a personality as highly individualistic as that of Emil. The oldest, Hans, ran the family farm under his father's supervision and his stern, religious character seems close to that of his father. Nolde records that Hans read much—history, language studies, local

history (*Heimatkunde*), but no novels—"only the truth."[5] Much of what Hans might have read would have had implicit or explicit Volkish overtones during this period. Although it cannot be proven with any certainty, it would appear likely that his oldest brother was one of the sources of introduction to Volkish ideas for the young Nolde. The second brother, Nikolai, was a lighthearted, joking type and seems to have had no great driving ambition. Leonhard, the third brother, was closest to Nolde in age and in personality. As Nolde describes him, Leonhard was imaginative and romantic in temperament and was an avid reader of novels. He was his father's favorite, according to Nolde, and he seems also to have been young Emil's best friend. Nolde also had a younger sister, Cathrine, but he writes little of her, only that she was a good, domestic type.

Nolde's childhood was spent in a manner that must have been typical for a child growing up in a rural area of Germany during the last quarter of the nineteenth century—observing the workings of the farm and the feeding and slaughtering of livestock, listening to the farmhands tell of their experiences and recount ghost stories and local tales like the kind recorded in Müllenhoff's collection. According to Nolde, he displayed an early interest in art and in learning to paint and draw. He admired Albrecht Dürer and other early German artists and recalled that a painted panel in the "old German" style depicting the life of Christ was displayed in his household once a year.

Nolde's public school education was also characteristic of that administered by the Prussian state after 1866. According to the artist, all instruction was given in High German, except religion which was taught in High Danish. The actual records of what was taught in the schools Nolde might have attended are no longer extant, as is the case throughout the Prussian system at this time. However, a recent study by Ernst Weymar of social science texts used in the teacher's colleges for training purposes and in many secondary schools (*Realschulen* and *Gymnasien*) during the course of the nineteenth century in Germany gives an indication of the kind of instruction Nolde most likely received, especially in terms of the implicit political and philosophical assumptions contained in these texts.

Weymar's research turned up evidence of widespread acceptance of Volkish ideas in these texts in the last half of the century.

> The individuality and the biological-spiritual-religious unity of the *Volk* were overemphasized, the qualities of individualism in a proper sense, the individual man and the particular occurrence in the past and the present, became insignificant before the concepts of the *Volk* and its God. For the instructor, the capacity to differentiate had been in large measure forfeited. Phrases and slogans formed an essential component of this theory of historical education, which was meant to be a sort of national education.[6]

Weymar observed the following tendencies in many of the texts of various disciplines that contributed to the prevalence of this attitude: (1) an overdeveloped fascination with the ancient Germanic tribes and their culture, evident in the

increased interest taken in Germanic and Nordic mythology (e.g., Grimm), in the descriptions of ancient Germans by Tacitus and in the barely disguised call for a rejection of modern customs by present-day Germans in favor of a return to the tribal virtues of their ancestors; (2) a reverence for the Old Testament that centered around the concept of a chosen people, a people separated from all other races and peoples on biological, cultural and religious grounds. This concept was transferred to the German people as the chosen people of the Christian era; (3) a totally uncritical worship of the ideal of Luther as the embodiment of the "German mission," that is, the concerted and calculated effort to reform (and re-form) the world around an inwardly oriented, deeply spiritual, essentially German focal point.[7]

The important consideration here is that these attitudes were indoctrinated with surprising success into the teaching body trained at German universities and teachers' colleges during the latter part of the century, so that young instructors fresh from their formal training were a major source for the espousal and dissemination of these ideas of antimodernity and the supremacy of the German spirit in history. As Nolde recounts in his autobiography, one such instructor taught young Emil.[8]

A brief glance at the texts for one discipline, geography, that were most widely used in the Prussian school system after 1870 will illustrate how these ideas were communicated. Hermann Adalbert Daniel's *Lehrbuch der Geographie für höhere Unterrichtsanstalten* (*Geography Textbook for Institutions of Higher Learning,* 1845) and his *Leitfaden für den Unterricht in der Geographie* (*Manual for Geography Instruction,* 1850) were used in more than three hundred Prussian schools after 1880 and a three-volume *Handbuch der Geographie* (*Handbook of Geography,* 1859–62) carried the points covered in the earlier writings to a much larger audience.[9] The appeal of Daniel's writings lay in part in the broad range of subjects encompassed by his "geography instruction" (actual landscape description interspersed with character sketches of various peoples and statistical tables), drawn not only from contemporary scientific research, but also from popular journals. In Daniel's description of the "German character" from the *Handbook* (a shortened version appeared in the *Textbook*), the popular phrases and catchword characterizations which Weymar noted in many other texts are evident. For instance, "Homesickness (*Heimweh*) is a German word and above all *a German sentiment.*" In seeking the major qualities that define the German character, Daniel turns to the image of the ancient Germanic tribesman described by Tacitus, whose "*furor teutonicus*" was redirected toward spiritual matters through the influence of Christianity.

> Seriousness and depth [of feeling] characterized the German tribes of these earliest periods in contrast to the Celts. What still appears today as [spiritual] illumination in the German character has been retained from this ancient period in a Christian transformation, as a break in the shadows allowing a glimpse into the ancient tribal character.[10]

This image of the ideal German character is surprisingly close to Lagarde's concept of Germanic Christianity of twenty years later. If Lagarde was familiar with Daniel's writings, this passage may have influenced the Volkish writer in the formation of his ideas.

Although Daniel cannot properly be considered a Volkish writer since his writings do not take the form of a criticism of modernity and a call for the reform of German character and society through the embracement of Volkish principles, he does employ many of the sources (e.g., Arndt, Jahn) used by early Volkish writers in his discussions and descriptions of the nature of the German people and the German landscape.[11] As Weymar has concluded, when the Daniel type of geography instruction was combined with a program of history instruction of similar orientation, even though the two areas together made up only a few hours of the weekly instruction in public schools, by focusing on more contemporary and accessible matters, they probably exercised more lasting influence on the minds of the young students than the fifteen plus hours per week which were spent studying classical languages.[12]

When Lagarde began to compose the essays in his *German Writings,* which attacked the current state of education in the Prussian system, he seems to have been curiously unaware of the new voices in that system like Daniel and others. Most probably Lagarde's own discipline, classical philology, did not allow him contact with these new developments in other areas. At any rate, his criticism of Prussian education was focused on this very point: that the *Gymnasium* placed too much emphasis on the study of the classical world and not enough on more pertinent subjects that would prepare the student to comprehend the situation of modern Germany.[13] The strength of Lagarde's complaint and his effort to have a system of national education instituted based on his new "faith" of Germanic Christianity most certainly helped create a climate in the public schools favorable to the increased use of texts by Daniel and other like-minded educators.[14]

In his autobiography, Nolde gives little indication of what he was taught as a youth in school or of how he felt about what he was taught. However, this brief examination of certain aspects of the instruction in the Prussian school system should suggest ideas and attitudes Nolde would have encountered in the classroom from around 1875 until his graduation in 1883—the image of the German *Volk* as a special people within the European community whose misunderstanding by foreigners was merely an indication of the superiority of the German spirit; an understanding of the German character formed by innate religious feelings and by a Romantic, almost pantheistic relationship to nature; and finally, a vision of the German land itself as the source of German culture and a focus for national pride.[15]

We cannot say for sure to what extent Nolde would have been conscious of these concepts and their implications at this time in his life. Still, like so many young minds of his generation, Nolde's adolescent mind must have been primed by his classroom experience as well as his own family background to

receive Volkish-inspired notions as respectable and even self-evident beliefs later in his life. In fact, a passage from his autobiography describing his feelings upon finishing his secondary schooling indicates just how strongly Nolde experienced these concepts on a barely conscious level:

> In a high cornfield, where no one else could see, I lay down flat on my back with eyes closed and arms stretched out and then I thought: "This is how your Savior Jesus Christ lay as men and women brought him from the cross" and then I turned over, dreaming in the vague belief that the entire, great, round, wonderful earth was my lover.[16]

This passage is an example of Nolde's calculated efforts to present a cohesive image of his character to the reader. The event may or may not have happened, but it stands out in this section of his autobiography as one of the few passages described with such detail and obvious purpose.

In the summer of 1884, Nolde left his family and his small village and traveled across Schleswig to Flensburg on the east coast of the province. In Flensburg he began an apprenticeship in the Sauermann woodcarving factory. Nolde records his esteem for Heinrich Sauermann, his employer, and seems quite happy during the almost four years he spent with him. He learned carving techniques used in contemporary furniture manufacture, and he helped restore antiques and other valuable objects including a large carved, wooden altar by the sixteenth-century German sculptor, Heinrich Brügemann. In addition, Nolde also learned drawing and design techniques by copying pieces of wooden ornament. When he was not working, he took instruction in painting and various other subjects.[17]

Nolde left Flensburg in the summer of 1888 and traveled to Munich to visit the annual arts and crafts exposition. He stayed several weeks, during which time he visited the museums and other sights. This stranger from the north with his strict Protestant background also experienced a Catholic mass for the first time in Munich and was deeply impressed by the ornament and ritual. At this point, Nolde traveled on to Karlsruhe where he found work as a carver in the Ziegler and Weber factory. He continued his artistic education by means of night courses at a school of industrial design.

It can only be a coincidence, but an interesting coincidence nonetheless, that Nolde's training up to this point conforms in certain important aspects to a program of educational reform put forth in 1893 by Professor Konrad Lange in a book inspired by Langbehn's *Rembrandt as Educator*. Lange called for a new emphasis on artistic education in the public schools and universities in Germany, not with the purpose of developing the individual student's aesthetic sensibilities, but to prepare him for an active role in society. "To these [new educational] ideals belongs the early education of our youth to industrious and productive creativity . . . to develop the physical and manual powers of the child and impart to him a sense of his own creative abilities and the drive toward activity and action."[18] Lange's language is more concrete than Langbehn's, but the concept

of art he discusses is Langbehn's—an art that renews the spirit and draws the creative forces of the individual to the surface for application in all other daily activities.

The foundation of Lange's program was instruction in drawing, especially the drawing of ornamental design derived from a study of natural forms indigenous to the native region of the student.[19] This would be followed by instruction in traditional crafts.

> As the boy becomes familiar with the use of tools and learns to work with the various materials on his own and to master the intricacies of the technique, he will gain an understanding of the artistic transformation of the material, of the influence of the material on the style of execution and of the essence of the artistic craft. And this will be of immeasurable importance for the development of our arts and crafts.[20]

This is how Lange interpreted Langbehn's vision of a new *"volkstümlichkeit"* art—as an art derived from the study of traditional crafts and the natural objects of the native landscape.

Nolde had, of course, completed his formal training before Lange's book was published, but his own later estimation of the importance of that training for his artistic development might be viewed as proof in part that the ideals stressed by Lange could be achieved through such a program of instruction. In 1906 Nolde wrote, "I want my work to grow from the material, just as in nature the soil from which it grows determines the character of the plant."[21]

In the fall of 1889, Nolde decided to take the plunge and move to Berlin, the capital of the Empire, in search of work. Like so many others, the young man from the provinces was drawn to the excitement and opportunity of the big city. Initially, his life was difficult there. He found no job at first, but by January he had secured a position as an ornamental designer in the furniture factory of J. C. Pfaff. Nolde worked at this position for almost a year, and he developed professionally and personally as he grew accustomed to Berlin and comfortable with his surroundings. Then in the winter of 1890–91, disaster struck. He became seriously ill. The diagnosis was tuberculosis. In his autobiography, Nolde narrates the sequence of events describing his reaction and his eventual cure:

> With a walking stick strapped across my back, my elbows aching, I wandered around in the forest surrounding Berlin, miserable, like a wounded animal, howling at the sky. The body of a strong man was pulled out of the Havel [a river north of Berlin]. *"Lebensmüde* (despondent)," they said, "suicide." I stood there with every thread of my being struggling for life, pleading. My body full of longing in a state of great desire, trying to suppress my heart which yearned so much for life, happiness, for glory. Oh, how my mind was full of pity! I was such a poor creature, doomed to death!—Such were my thoughts during these weeks. . . . I traveled home . . . ashamed because I was sick. People pointed at me. "They say he has tuberculosis," they said. "People in the big city become corrupt, or they die of tuberculosis."
> Some people advised me to go south, to the Harz mountains or to Davos. But my father said, "Stay home with us, my son, and get well here like your ancestors and all of us have always done."

> I roamed across the fields, along the banks of the small river. The wind blew fresh and bent the grass, the fields bloomed yellow with dandelions. And then came the meadows of May and in June the marvelous colors of the high grounds. I hadn't seen all this since my youth, since that time when one was an intimate part of it himself, and such things were understandably a delight.
>
> The sun shone so brightly and beautifully. On the incline of a canal, its ground warmed by the sun's rays, I lay down for many, many hours and days, seeking renewed strength, *nursing.*[22]

Berlin had won the first round; Nolde would not return there for ten years. But the two most important sources for his artistic life had been established by this experience. For thirty years after 1902, Nolde's art and life would move back and forth between these two poles: Berlin at one extreme with its excitement and potential for self-destruction and death, and, at the other extreme, his home-land with its healing, regenerating powers. The passage above sets up this opposition with almost classic Volkish imagery—Berlin, the unnatural city, is associated with winter, sickness and death; Schleswig-Holstein, the untainted countryside, is associated with spring, warmth, growth and health. One can almost feel the sun impart its healing power and the wind blow fresh, clean air into Nolde's lungs as he walks across the fields, and this is undoubtedly how he wishes us to understand the passage.

During that spring spent at home, Nolde received word that his application for a teaching position at the Museum of Industry and Crafts at St. Gall in Switzerland had been successful. He was overjoyed and went briefly to Berlin to gather his belongings and then returned home to prepare for the move. That summer, at age sixty-one, his father died. Nolde did not record his feelings concerning this event.

The teaching appointment in St. Gall began in January of 1892. In addition to his teaching duties which were varied but centered mainly around drawing and design instruction, Nolde was asked to create ornamental designs on a regular basis for city craftsmen to complete. It was during the five-year tenure in St. Gall that Nolde's artistic and intellectual development began to take a definite direction. In St. Gall Nolde formed two important friendships that provided him with considerable opportunity to discuss his ideas on art and reflect on the course he wished his own career to take.

One of the friends was Hans Fehr, and a student of Nolde's at the time, and the son of a local official. Fehr became one of Nolde's closest friends, helping him financially on occasions and writing a short monograph on Nolde after his death. Many of Nolde's letters which provide additional insight into the artist's mind at later periods in his life were written to Fehr, and reference will be made to them throughout the course of this study. Fehr also gave Nolde the only book he claimed to have read through completely in his entire life, *Ekkehard,* a popular novel by Viktor von Scheffel detailing the tribulations of

a monk from the monastery at St. Gall in the tenth century. The novel, first published in 1855, is a prime example of the middle-nineteenth-century German fascination with Germany's glorious past and of the attempt to evoke that past through inclusion of lengthy passages describing the landscape. This claim to have read only one book completely in his life is yet another aspect of the image Nolde attempts to present in his autobiography of an extremely individualistic personality whose artistic development was unimpaired by any external, literary influences. There is considerable evidence that Nolde's literary background was larger than a single volume, and that will be discussed in this study.

The second close friend during Nolde's time in St. Gall was Max Wittner, a young Jew who introduced the artist to the dramatic and poetic works of many contemporary literary figures including Knut Hamsun, Maxim Gorki and August Strindberg. Nolde had many "endlessly long, intimate conversations" with Wittner and the discussions between the two which he records reveal important factors in his own developing understanding of his art.

Nolde considered Wittner his intellectual superior and admitted that he gained much from these discussions. He enjoyed the confrontation with an individual whose background and experiences were the opposite of his own; Wittner was the son of a wealthy banker and had been raised in the big city. Above all, encounters with Wittner seem to have made Nolde aware of his own background and origins in a positive sense and helped him realize that this experience could serve as a source for artistic expression. He began to espouse the value of instinct in matters of art and life ("Instinct is ten times more [liberating] than knowledge"), which recalls the Volkish image of the peasant as a spontaneous, instinctual, almost Dionysiac creature. In a conversation about a man's place in the cosmos, Nolde calls forth very Volkish imagery.

> We spoke of the worlds around us and of the stars above us. "I believe in their effect on (us) men," I said, "and I believe in the moon and the sun and I sense their influence. And I believe in a glowing fire in the center of the earth and its connection to (us) men. It bubbles and boils down there with eruptions and quakes that seem to occur almost in sequence with revolutions and wars on the surface. And, if a wave of heat or a shot of cold hits us from below or above, then we little creatures will disappear like young shoots in a hard frost."[23]

Nolde relies here on a classic Volkish cosmography in which the sensitive individual acts as a spiritual conduit between the opposing, overwhelming forces of the cosmos and nature.[24] In this context, we might assume that in his conversations with Wittner, Nolde is not trying to be outrageous or incomprehensible, but rather that he is consciously drawing on his own peasant background and the established Volkish view of the peasant as a spiritual intermediary between the forces of nature and of the cosmos.

Nolde's art of the St. Gall period reveals a broad range of styles and subject matter which one might expect at this early stage of his career. He spent much of his time sketching and completing precise watercolor studies of local Swiss

architecture that recall in certain respects Dürer's watercolor studies of similar architecture in and around his home Nuremberg, which Nolde might have known. This precise, fairly scientific approach is also evident in the sketches and profile studies of the inhabitants of the many Swiss villages Nolde visited on hiking and mountain climbing excursions. It is when Nolde turns directly to nature itself and lets his imagination determine the actual vision he records that we can glimpse the force of his later art and the direction it will take.

A small watercolor entitled *Sunrise* from 1894 (fig. 4) is the major achievement of this early period in this vein. In it Nolde captures the sun as a glowing, bright red orb in the center of the composition, piercing a bank of heavy clouds above the tips of trees below. Nolde noted his fascination with this unusual creation:

> I had painted a modest, little watercolor of a heavy sun rising through the clouds. It stood on my desk for a long time, I must have looked at it a thousand times. It seemed definitive to me, because I was so enchanted by it. But I couldn't bring forth another picture of this type. . . .
>
> This dangerous path striving toward the heavens between the mists and the clouds with its dynamic forces at work would be traveled only by that artist on whom a true understanding of nature and the gift of productive fantasy have been bestowed. . . .[25]

Recent criticism has associated this painting with the tradition in northern Romantic painting of such depictions of the sun as disguised religious imagery. Although Nolde gives little indication of such intentions in his speculations on the painting, he was probably aware of this tradition and of the increasing prevalence of solar cultism among certain segments of the population in Germany around the turn of the twentieth century, as evidenced in a fanciful pen and wash drawing of a sun worshiper from 1901 (fig. 5).[26]

In fact, the phenomenon of sun worship was one of the more outré manifestations of Volkish thinking during this period, which sought the revival of this ancient Nordic religious practice. The common explanation for this ancient ritual among Volkish thinkers was the assumption of an innately Germanic longing for the sun caused by the dark, foggy Nordic climate which blocked the sun from view most of the time and allowed the Nordic peoples access to it only on rare occasions. This striving for the sun was symbolically associated with the desire for spiritual rebirth and enlightenment.[27] To Nolde also, this quality was one of the main characteristics of the Nordic spirit. In his autobiography he wrote,

> In the art of the nordic, germanic peoples one is moved by the spiritual warmth, the mysticism and fantastic qualities, by the restrained power and an often emotionally moving understatement.
>
> We nordic people understand the art of southern [i.e., mediterranean] peoples remarkably well and they almost never understand ours. It is as if this difference were a law of nature like the fact that the nordic people are always drawn south toward the sun.[28]

This transformation in the iconography of the rising sun during the course of the nineteenth century demonstrates a major difference between Germanic Romantic and Volkish ideas and images. To the German Romantic mind, the symbolism of a sunrise was often associated with Christian or vaguely classical pantheistic concepts to create new vehicles for religious expression, such as Caspar David Friedrich's *Tetschen Altarpiece* (1808) or Philipp Otto Runge's *Aurora* (1808–9). In contrast, the Volkish ideology saw in the rising sun a symbol of national or racial, rather than religious aspiration. Nolde for his part combined these tendencies in his paintings of sunrises. A more detailed discussion of the religious nature of sun imagery in Nolde's art and of the differences between Romantic and Volkish attitudes will follow in the final chapter.

Sunrise was Nolde's first attempt to deal with his understanding of the forces of nature in a direct, expressive manner, and he was not able to regain this vision for several years. For the most part during his residence in St. Gall, Nolde turned to more indirect means to express this fascination with nature's raw power. Though he gives us little information regarding his intentions in this work, his 1896 drawing entitled *Mask of Energy* (fig. 6) can possibly be interpreted as a personification of *natural* energy like the "glowing fire in the center of the earth" which Nolde described to his friend Wittner. There are certainly more references to natural energy (wind and fire) than mechanical energy in the drawing.[29]

In other works of this period, Nolde's intentions to depict the supernatural forces within nature in terms of personified beings are more obvious. In *Mountain Giants* (1895–96), which was his first oil painting, Nolde presents the fantastic spirits of the mountains as huge, robust peasant types seated around a table in a mountain cabin. He entered the work in the annual exhibition of 1895 in Munich, but it was rejected.

By this time, Nolde had decided to pursue a career as a fine (rather than commercial) artist and was feeling the need for more instruction, especially in oil painting techniques. On an application for a stipend to further his study, he wrote, "I believe I will be able to achieve the same in popular (*volkstümlicher*) art as Defregger."[30] This statement is significant because it reveals Nolde's belief that such "*volkstümlich*" art was a valid type of artistic expression and worthy of financial support. Franz von Defregger (1835–1921) was a Tyrolese painter of genre subjects and the favorite painter of Adolf Hitler. He painted in a style of academic realism that was found in most European academies of art in the second half of the nineteenth century. His works included many interiors and depictions of minor events in Central European history. Though Defregger's art was well known in Switzerland and Bavaria, his genre painting was still considered a lower form of expression by critics.[31] But with the advent of Langbehn's Rembrandt book and his advocacy of such "*volkstümlich*" art as the truest expression of the German spirit, this form of art gained new respectability in many circles and Nolde seems directly or indirectly to be aware of this.

During this period, Nolde also translated his fascination with the Alps and their mythic qualities into a series of personified faces—*Virgin, Monk, Eiger* (1894), *The Wild Parson* (1896), *The Sleeping Sisters* (1896), *The Ortler Dreams* (1895), *The Matterhorn Smiles* (1894, fig. 7), *The Myths* (1896) and others. Taking the popular names of the mountains as a point of inspiration, Nolde granted each mountain a facial expression meant to reveal its spirit or essential character. In doing this, Nolde was expressing a common perception of these natural phenomena as familiar but separate beings from another nonhuman realm who interact of their own accord with the human realm.[32]

That Nolde understood nature in this manner as an active force which continually observed and acted upon him is confirmed not only in his visions of the Alps, but also in his writings. Recalling an experience out on the marshes of his homeland in 1900, Nolde writes,

> And I admired the majestic heavens, spread out above me from here to there.
> Oh, the exchange of the spiritual with the simple-natural, how I enjoyed this.
> But often the whole of nature was staring at me, I felt, and sternly warning me![33]

He was equally convinced of the role played by this active nature in determining the character of the inhabitants "rooted" to their specific native soil. Describing his response to Ferdinand Hodler's *Night,* which he saw in the 1896 annual Munich exhibition, Nolde writes of his belief that the painting's "sinuous, pushing, wiry bodies are part of the character of the mountain folk, just as firs on the mountain slopes are gnarled and grown oddly."[34] Here he is referring to physical characteristics, but spiritual and artistic qualities could be determined by nature in a like fashion.

Nolde's Alpine series also proved to be the catalyst for his move into the field of fine arts. On an impulse after two of the depictions published in the journal *Die Jugend* were well received, he had the various mountain faces printed as postcards in 1897. They were an immediate commercial success. A printing of 100,000 cards sold out in ten days and earned Nolde 25,000 Swiss francs which he decided to use for the further art instruction he wished to receive.[35] Nolde realized that his masks and mountain faces were not serious artistic endeavors. Nonetheless, after the illustrations appeared in *Die Jugend,* the magazine's publisher, Dr. Hirth, was impressed with them and invited Nolde to visit him in Munich. Nolde described him as "a friend to all art and all genuine Germanism (*Deutschtum*)." The use of the phrase "genuine Germanism" would tend to identify Hirth with Volkish currents, especially the more racially oriented strain. A major expression of this strain was Friedrich Lange's *Reines Deutschtum. Grundzüge einer nationalen Weltanschauung* (1894). Hirth probably encouraged Nolde to pursue his goal of becoming an artist in the "*volkstümlich*"

vein. Nolde took the money and traveled briefly to Vienna to see the Dürer drawings in the Albertina and then decided to settle in Munich and enroll in one of the art academies there.

The year was 1899 and Nolde was approaching thirty-one years of age as he arrived in Munich. He tried at first to gain admittance to the studio of Franz von Stuck at the Munich Academy. He was unsuccessful and always regretted this lost opportunity which would have brought him into early contact with Kandinsky, Klee and others who were studying at the academy at the time. Nolde enrolled instead in the private academy of Friedrich Fehr in Oberpolling, outside of Munich, and the next year he went to Dachau to study with Adolf Hölzel, one of the founders of the New Dachau group of landscape painting.

At this time Hölzel was formulating his theories of an art based primarily on the harmonious relationship of rhythm, color and form within the composition. This "absolute art," as he called it, abstracted from nature and used natural objects only as integrated parts of the harmoniously structured whole. In his teaching, Hölzel required his students to analyze the works of master artists in terms of their formal qualities. Studies of this sort by Nolde survive, showing various masterworks reduced to broad, flat masses and light and dark areas. Hölzel was one of the first German artists to recognize the importance of the French Postimpressionists, and Nolde undoubtedly gained his first knowledge of them through his training with Hölzel.

Nolde stayed with Hölzel only a few months, feeling that this kind of art was not sufficient for his goals. He did gain a feeling for the expressive power of pure color which would reveal itself in his art in the next decade, and he formulated a concept of a vision of nature in art that was abstracted from the purely photographic qualities of its appearance. "The further one distances oneself from nature and yet remains natural, the greater the art," he wrote, which would seem to be his understanding of a similar statement by Hölzel that "the picture poses demands which cannot be satisfied from nature in the commonly accepted sense of the word."[36] This conception of artistic creation is at its core a Romantic one found in the theories of the German Romantic philosopher Friedrich Schelling and elsewhere.[37]

At the end of the summer, in a mood of general impatience and dissatisfaction, Nolde returned home to Schleswig-Holstein and the purity of the plains and the wide open spaces. "My ancestral home drew me to it and to my homeland: the ripe cornfields, the autumnal clouds, the broad plains (*Ebene*). The plains, where no lone trees destroyed the vision of infinity and where a post, standing in a simple plane, became a monument."[38] He spent the weeks at home thinking about all he had seen and experienced in the preceding months in Munich and contemplating the major figures of contemporary German art he had studied—Wilhelm Leibl ("at that time . . . , a fine, mysterious artistic phenomenon"), Adolph Menzel, Arnold Böcklin, Hans von Marées and others. In the end, he

concluded, none of this could be for him; he would have to find another way, his own way. "Whoever loses himself through influence, he was not born strong enough," he wrote.[39]

Still restless, Nolde traveled up into Denmark for a few weeks and then back to Munich for a brief period. Finally, in the late fall, he traveled to Paris and enrolled himself at the Académie Julian to study under Toni Robert-Flouri and Jules Lefevre. Hans Fehr was already in Paris as a diplomatic attaché with the Swiss embassy, so that Nolde had a contact and a good friend to show him around. He stayed in Paris for nine months visiting the galleries and museums, studying the course of French art in the preceding century (Eugène Delacroix, Honoré Daumier, Jean François Millet, Edouard Manet, Auguste Rodin and Edgar Degas all impressed him). In the Louvre, he copied Titian and enthusiastically admired works by Francisco José Goya and, perhaps most important to his later development, Rembrandt's "small and wonderful Emmaus picture." That spring at the International Exposition of 1900 Nolde saw Puvis de Chavannes' *Poor Fisherman* and later had a chance encounter with two German women, Clara Westoff, a sculptress who would later marry the poet Rilke, and Paula Modersohn-Becker, the major artist of the Worpswede school.

Yearning again for his homeland, Nolde left Paris in the summer of 1900 and traveled to Hamburg and then on to his home. In the fall, he journeyed once more into Denmark, settling for several months in Copenhagen. Nolde records that he felt almost as much an outsider here as he felt in Paris. His decision to find his own way, personally and artistically, was beginning to weigh on him. He was filled with doubt and undergoing much inner struggle.

> This winter of 1900–1901 in Copenhagen was a desperate time for me. I walked dejected along the canals. . . . I couldn't paint and couldn't paint and I was lonesome, shy and bitter and for months I spoke with no one. . . . Like a stranger I wandered about the city and often could hardly find my way. My life seemed lost to me. Often I saw myself as a victim of a too keenly felt desire and I pitied my own "selfhood" (*Ich*), the same "selfhood" that I even more frequently hated and I didn't want to be pitied. My thoughts moved continually within the darkest of dark regions. . . . I buried myself in brooding: "Is all of this happening through some will of nature and God, so that I might yet become an artist?" In my darkest moments this belief comforted me and allowed me to bear all this hardship.[40]

Out of desperation, he even placed an announcement in the newspaper— seeking company, but was not satisfied with any of the respondents. A young Danish artist invited him to his home out in the country, but the young man's aggressive religious views repelled Nolde. As spring came, Nolde's mind was still clouded and his mood was dark. Then he had an unexpected visitor. "The regional painter Momme Nissen came to visit me, that strange person who later buried himself in religious, catholic musings. We spoke with one another quietly and seriously. Then he went on."[41]

Since 1893, Nissen had been Julius Langbehn's chief and, in fact, only disciple—his "helpmate, secretary, servant and sworn friend"—until Langbehn's death in 1907. He was Langbehn's junior by nineteen years and three years younger than Nolde. Nissen was born and raised in Deezbüll in North Frisia, which made him a "Landsmann" of Nolde's. As Langbehn's follower, he was as satisfactory a disciple as anyone, especially someone of Langbehn's makeup, would desire. He was completely subservient, turning himself over to his master that he might be "re-educated" in the proper spirit. He supported himself and Langbehn as a portrait painter. After Langbehn's death, he edited and re-edited his master's writings and wrote a biography of him, *Der Rembrandtdeutsche Julius Langbehn* (1927).[42]

It is likely when Nissen called upon Nolde in Copenhagen, he came alone. Langbehn had recently taken up residence in Rotterdam and had converted to Catholicism there the previous year, and Nissen had to travel on occasion without his master to complete his portrait commissions.[43]

Nolde does not record what he and Nissen discussed, but there can be little doubt of the content of their discussions. In what manner Nolde received his guest's "good news" is less certain. Nolde was not by nature a follower, and he probably felt somewhat uncomfortable with the excitable, hero-worshiping personality of Nissen. It is possible that the visitor even tried unsuccessfully to "convert" Nolde to Langbehn's fold. That Nolde did, however, look on the writings and ideas of Langbehn positively as a source of inspiration is difficult to deny. The meeting with Nissen is important because it sets the last possible date for Nolde's acquaintance with the contents of the Rembrandt book and, as we shall see, it coincides with an important change in the course of Nolde's career. Nolde never admitted actually reading Langbehn and, in fact, he may not have—directly. If he had not read the Rembrandt book before the visit by Nissen, he may nonetheless have been familiar with its contents through contacts made in Berlin the year the book was first published or through later conversations, especially with Dr. Hirth or his own brother, Hans, whose interests and personality would have attracted him to Langbehn. The immense popularity and influence of the Rembrandt book in the decade of the 1890s is a focal point of this consideration.

Shortly after Nissen's visit, Nolde had another "chance encounter" that was of immense personal importance. While painting in the country outside Copenhagen at Hundested, he met a young Danish couple, Knud Rasmussen and Ada Vilstrup, a young actress whom he had encountered briefly upon his arrival in Copenhagen months earlier. Rasmussen was to become a famous polar explorer. Ada would become Nolde's wife.

By late spring of 1901, the cloud around Nolde had broken. The state of depression which had plagued him had dissolved and was replaced by an onslaught of activity and wild ideas. He continued to see Ada and their relationship grew intimate; he had found someone to share his life and his art. In July he traveled

briefly to Berlin to rent a studio. He was ready once again to confront the metropolis. He returned to Copenhagen to see Ada and then went to a small fishing village, Lildstrand, on the northwest coast of Denmark.

The summer at Lildstrand was a period of furious activity for Nolde.

> Evenings I sat in my small room scribbling away, sketching robbers and robbers' dens, beach runners, wild men, night-wanderers, sun worshipers and I don't know anymore what all these imagined drawings were.—What I wasn't able to capture sketching, disappeared as fast as it came into the far away eternal realms, where all flights of fantasy float continually.[44]

His letters from Lildstrand also reveal this agitation, but indicate that he believed his frenzy was taking a specific course, progressing toward his goal of realizing his artistic potential. On his birthday he wrote to Ada:

> I stood painting two small houses which lay peacefully behind the dunes in the evening shadows. It began to blow and the clouds became wild and dark, it began to storm and the grey sand swirled high up over the dunes and the little houses. A raging storm—then suddenly a powerful pencil drove its lead through the canvas—the painter caught himself, he looked around, it was still the same quiet, beautiful evening hour, only he himself had been overcome with this rage and had experienced the storm within. The image was gone. . . .[45]

Two weeks later in a calmer, more reflective mood, he wrote Ada again:

> Also I'm quite aware of the force of these internal and external battles and I don't underestimate them, but basically I find pleasure in them. I've always been a dare-devil and this quality still tingles today in my blood as much as ever. Earlier my development was somewhat one-sided, but now with maturity qualities reveal themselves and develop upward, outward and down inside me which most certainly will bring good results in my art.

He continues in the letter to describe the ideal state toward which he will strive: to be at once a natural man and an embodiment of culture, divine and animalistic, a child and a giant, naive and yet refined, full of spirit and full of insight, passionate and dispassionate—as complete in personality as the greatest artists were: Shakespeare, Rembrandt and Wagner.[46] This combination of oppositions within the personality of the great artist also conforms to Langbehn's image of Rembrandt.

At the same time Nolde wrote his friend Fehr, telling him of the elemental closeness to nature he now experienced:

> I lie constantly by the slope of this dune, listening to the rustling grass and the wind playing. The grass interweaves with my clothes and sand settles on me. In one pocket lives an old toad, and wild bees gather honey in my hat. Hands and fingers form roots deep down in the sand, the toes have already doubled in length and will soon grow into great trees, which will then flower in some strange color. When the sea breeze scatters the petals of the blossoms, strange fruit is formed, which everyone admires, but no one dares touch.[47]

Fehr had been aware of the crucial state his friend was passing through as he struggled to develop beyond the "Impressionist" stage in his art. When he received the letter, he felt Nolde had surely gone mad and he set off to find him.[48]

The sketches from Lildstrand, such as *Sun Worshiper* (fig. 5) reveal the agitation of Nolde's creative state at the time. Figures captured in a few brushstrokes loom before a landscape set in motion by unseen forces, not threatened, but rather a part of this nature. A more finished work, *Encounter* (fig. 8), conveys similar qualities. Two strange figures meet a third, larger figure on the beach before a dimly lit, stormy background. The meeting is not hostile or surprising, but congenial and civil. These creatures of imagination behave in their own twilight realm as their human counterparts do in their own daylight realm. In these works, Nolde seems to be calling forth images from the folk tales and spoken stories of his childhood; he seems to be giving expression to those experiences of his childhood unique to the child of Schleswig-Holstein, the traditional tales of his region which are told, retold, expanded upon and passed on from one generation to the next.

Nolde's finished landscapes of this period exhibit new qualities of strength and conviction as evidence that the artist was indeed beginning to find his idiom. *Home* (1901, fig. 9) is an excellent example in this respect. Nolde has been able to move away from the flat planes and abstractions which he had acquired from his study under Hölzel and yet retain a simplicity of presentation and an expression of the elemental qualities of the Schleswig-Holstein landscape that marked the best of Hölzel's works. The broad sky, the full, sweeping earth and the water which reflects the sky are joined and, one might almost say, given purpose by the great form of the Schleswig-Holstein farmhouse (probably Nolde's own family's), a form whose massive solidity is earthbound and monumental. Each realm of nature is represented in large, pregnant masses suggesting strength, growth, purpose and mutual interdependence. It is an essential image of the concept of "home," and the composition and the forms within will recur in Nolde's landscapes after World War I as the artist once again explores the feelings engendered by the idea of home.

Already at this early point in Nolde's artistic career it is possible that the art of Rembrandt was providing him with a model by which he might successfully approach his homeland and express his deeply felt emotional bond to it. An etching by Rembrandt from 1641 of a Dutch farmhouse and its surroundings (fig. 10) reveals many of the same elements in a composition similar to Nolde's painting and to the drawing upon which the painting is directly based (fig. 11). In all three works the heavy, massive form of a farmhouse or cottage looms above the horizon in the left half of the composition. Rembrandt emphasizes the rustic details of the thatched-roof cottage in his etching and thereby exploits the picturesque qualities of the scene. The natural surroundings are captured selectively with a sketchy line so that a sense of the total effect of nature is absent. This feeling for the totality of nature is much more evident in Nolde's oil painting

and in the study sketch. The overcast sky and the lush grassy areas are suggested in the same broad stroke of the brush or pen that eliminates detail and instead captures the sensation of interdependent realms of nature in large, simplified forms. Even more obvious borrowings from Rembrandt will turn up in later Schleswig-Holstein landscapes by Nolde.

In his Berlin studio, one of the first works Nolde completed was the second version of *Before Sunrise* (1901, fig. 12). Nolde had destroyed an earlier version of 1896 shortly before completing it.[49] This time he was much more pleased with the results and hoped that more works in this vein might follow.[50] The mountain setting of *Before Sunrise* recalls its original inspiration in the Alpine fantasies of Nolde's time in St. Gall. The two fantastic creatures in the painting seem to be distant relations of the figures in the Lildstrand sketches, but it is only on closer inspection that we realize how distant they really are. One of the imaginary beasts is perched upon a precipice in the upper left corner while a second, larger creature floats before a panorama of jagged, mist-covered rock formations which extend back into the pictorial space where they meet a heavy, swirling mass of clouds. The entire scene is charged with a dynamic rhythm that animates the natural elements and the flying creature itself, whose writhing form foreshadows the ecstatic dancers of later paintings by Nolde (fig. 1). The land-scape is not really Alpine, but pre-Alpine; the fantastic inhabitants are a vision of a prehistoric period, a primeval and mythic past before the enlightenment of the sun.

Toward the end of 1901 the changes in Nolde's inner life as an artist were complemented by two changes in his external life. He and Ada were married in Copenhagen and shortly thereafter he changed his name from Emil Hansen to Emil Nolde. He was to be a true son of the land.[51] In taking the name of Nolde, the artist was no longer identifying himself only with the narrow tradition of his own family which extended back for generations. He was identifying with the land itself, a limitless entity whose life spanned and circumscribed an infinity of human lives that had inhabited it.

If Nolde was already looking at the art of Rembrandt at this early point in his career as the painting *Home* may suggest, the influence of the Dutch artist was only one of many elements at work in Nolde's art at this period in his development. As the title of the second volume of his autobiography suggests, Nolde still had a long way to go to achieve some measure of artistic success and professional recognition. The first decade of the twentieth century was a period of continual financial hardship and personal and professional struggle for him. He did not turn to Rembrandt on every occasion, but rather at crucial times and in important works. Later in his career, as we shall see, Rembrandt's art would provide Nolde with models which would help him to formulate his visions of natural and religious phenomena.

3

A Rembrandt-German

Not only did the art of the Dutch master Rembrandt van Rijn offer Nolde a source of inspiration for his own art, but the figure of Rembrandt himself, especially the Rembrandt presented by Langbehn, had import upon Nolde's artistic development and upon his personality as well. As Fritz Stern has noted, Langbehn's image of Rembrandt the man was not entirely novel in the intellectual climate of Germany during the final decades of the nineteenth century. Several of Langbehn's patrons and allies, notably Wilhelm von Bode and Alfred Lichtwark, had lobbied in the years immediately preceding the appearance of *Rembrandt als Erzieher* for an increased appreciation and understanding of Rembrandt's art which "reached the highest intensity of life's truth" as a phenomenon which should be closer to the German's heart than the art of Raphael. Furthermore, the earlier criticisms of Eugene Fromentin, the leading French appreciator of Rembrandt, had firmly established a view of the Dutch artist as a "metaphysician" who "sees farther in the supernatural than anyone."[1]

Langbehn's contribution to the growing Rembrandt vogue was to weld these various themes together into a singular, if not entirely coherent, image of the artist and to place that image before the modern age as a vehicle for Langbehn's own ideas of national reform and personal, individual regeneration. Langbehn's figure of Rembrandt was meant to be seen less as a creature of flesh and blood than as the embodiment of a cultural ideal, "the highest form of life, art and individuality." The Rembrandt of Langbehn's book was a simple and modest man, yet primitive and passionate, who sought through his art a knowledge more profound than that gained through science. His religious expression was based on the immediacy of individual awe and faith, rather than dogma. He was willful and defiantly individualistic, but his most important quality was that of *Volkstümlichkeit*, which allowed him to transcend the various contradictions of his own soul. "By his *Volkstümlichkeit*, Rembrandt should inspire the Germans to return to the sources of their unity and individuality, to their oldest popular traditions. Only by being themselves, by belonging to their people and accepting their past, could present-day Germans become free individuals again."[2]

As outlined here, the correspondence between Nolde's character and Langbehn's image of Rembrandt should be somewhat evident. Like Rembrandt,

Nolde exhibited an extreme individuality, which, as we will discover shortly, often hampered his ability to interact productively with other artists and with dealers. Nolde recognized this "individuality" within himself, but on at least one occasion professed surprise at the severity of its appearance. In discussing his painting *Free Spirit* of 1906, which depicts the Free Spirit in the center of the composition surrounded by personifications of Praise on one side and Censure and Grumbling on the other side, all of which have no effect on the central figure, Nolde recognized in this a self-portrait, but says that he was ashamed that he had dared to perceive himself in this manner and turned the painting to the wall so that no one could see it. He continued:

> In later years I have often surprised myself with what I painted and occasionally, as with the Free Spirit, I created something beyond my immediate intentions, so that only later did I become conscious of the unintended elements. And often my powers of comprehension were taxed and could hardly wait until that which they could not understand, the highest artistic expression in the painting became evident during the course of my work.[3]

We can only surmise the truthfulness of Nolde's confession here, but the importance of such an admission lies more in continual emphasis on a spontaneity of expression which Nolde cultivated in much of his art, of which this passage is an example. Like Langbehn's Rembrandt, Nolde constantly praised the value of instinct and involuntary expression. "There is a lot I don't understand—but I don't need to understand it," he wrote elsewhere.[4] Also, as we have seen in his letters from Lildstrand in 1901, Nolde exhibited a volatile, primitive nature at times, especially during periods of heightened artistic activity, which corresponds to Langbehn's understanding of Rembrandt. Nolde's religious longings were also quite instinctual and antirational. "Knowledge and science are inadequate when it comes to the simplest questions about time and eternity, about God, about heaven and Satan. Faith alone has no limitations."[5] This statement by Nolde could almost have been written by Langbehn himself.

I do not mean to imply in this discussion that Nolde consciously emulated or imitated Rembrandt. Langbehn himself warned against such a misinterpretation of his book. These qualities were undoubtedly an integral part of Nolde's character, but his understanding of Rembrandt through Langbehn and his identification with the Dutch artist encouraged him to cultivate those aspects of his personality, rather than sublimate them, as a means toward developing his artistic vision. Nolde came closest to an actual emulation of Rembrandt in the years 1909 to 1912 when he completed his major religious paintings and in the period immediately following this when his drawing style took on a very Rembrandtesque quality.

The concept of *Volkstümlichkeit* was the quality that Nolde seemed most intent on cultivating in his own art during the first decade of the twentieth century. Oil paintings like *Milk Maids* (1903) and *Day of Harvest* (1904, fig. 13) reveal the first course the artist followed in this search for *Volkstümlichkeit*.

To express this quality of his *Volk* and their essential nature, in these works Nolde turns directly to the people who constitute this community, the peasants, capturing them as they go about their daily, traditional activities, in a vibrant, Impressionistic brushstroke which imparts a sense of energy and vitality to Nolde's interpretation of the peasant and his life. This view of the peasant and his labor recalls similar depictions by Millet, Van Gogh and Leibl, and Nolde at this point seems unable to proceed much beyond these fairly established traditions of nineteenth-century painting. The broadly executed brushwork suggests the late style of Leibl in the 1890s which Nolde knew from his time in Munich and also the stylistic experimentations of Georges Seurat in 1882 and 1883. It is uncertain whether Nolde saw any examples of Seurat's early work during his stay in Paris, but paintings by Paul Signac and other artists of the Neoimpressionist school were well known in Germany by 1900.

Nolde followed this avenue toward the expression of *Volkstümlichkeit* with some hesitation over the next few years, attempting as Rembrandt had done, to discover the qualities of *Volkstümlichkeit* in the common people of his homeland. In the summer of 1908, Nolde returned to this subject matter with renewed conviction. Two major works of that period, *Farmers in Viborg* and *Market People,* indicate how far Nolde had come in developing his expressive powers. The works also reveal a recognition by the artist of a fact to which he would only admit much later—he is no longer able to share fully in the lives of these people. These simple people may contain within their character the truest qualities of *Volkstümlichkeit,* but they keep this entirely to themselves. In both paintings a group of figures is gathered together in secretive conversation or some sort of nonverbal communication to which the artist and the viewer are not admitted. The vivid, intense colors of the faces of each figure suggest the equally vivid and intense nature of their communication with each other in spiritual terms; Nolde would return to this expressive format in the succeeding year as he began his first religious scenes of the life of Christ (fig. 14). But in these works Nolde gives us a sense of the closed, isolated community of a small, rural village and the feelings of agitation and suspicion such a community imparts to outsiders.

Nolde would later regret that his art was so little appreciated by his countrymen in Schleswig-Holstein. He already seems to realize here that they perceive him as an outsider.[6] His personality and his profession have divorced him from their community, and they can no longer accept him on their own terms. To another artist from a middle-class urban background who would always unconsciously retain a sense of separation from his subject when observing such activities, the deep-seated suspicious nature of these rural inhabitants might not be so obvious. But Nolde, by birthright, was once a member of this community, and the recognition of his present isolation is an integral part of these works. If he intended to give expression to his strongly felt sentiments of *Volkstümlichkeit,* he would have to find the means for that within himself and not within the outside community. From this point on, as we shall see, Nolde would realize

that the cohesion (*Bindung*) which he always sought to express in his art, the sensation of emotions and experiences shared with his *Volk* and native landscape, must take the form of intensely personal revelations. He would begin to see himself as a member of a community that existed on a deeper level, beneath the everyday interactions between individuals, and to perceive his art as representative expression of that spiritual communion. In the final volume of his autobiography Nolde wrote:

> The origins of my artistic expression lie deeply rooted in the soil of my own homeland. Even when my acquired knowledge and longing for further artistic development and new possibilities of representation reach into the most distant and primitive regions, whether it be in reality, whether it be imagination or dream—my homeland remains the original foundation (*Urboden*).[7]

The Impressionist style of Nolde's paintings in the early years of this decade, like *Day of Harvest* or *Spring Indoors* (fig. 15) also from 1904, perhaps also has some relation to Langbehn's writings. In a confusing passage in the Rembrandt book, Langbehn speculated on the visual qualities of his "art of the future," turning to the Impressionism of modern French artists as a model. He believed that style contained the greatest potential for adaptation to his concept of a new German art—"one might say that within this impressionism which is even now making inroads into Germany . . . is contained a very promising essence: the requirement for a healthy, clear, vital, modern German [school of] painting. When the momentary nature of impressionism is combined with the eternal qualities of the *Volk* . . . , the right kind of art will be created."[8] Rembrandt's art, according to Langbehn, exhibits this union of contrasting elements, and to a lesser extent so does the art of certain modern German painters like Leibl.[9] It is curious that Langbehn would momentarily abandon the nationalistic bias of *Rembrandt als Erzieher* and cultivate an admiration for a French, i.e., foreign style of painting. In all likelihood, it was the vitality of the brushstroke of a painter like Monet that attracted Langbehn's eye, and he could discover a similar power in the style of Rembrandt and other Germanic artists.

In Paris, Nolde himself was less than favorably disposed to the Impressionist painting he saw there, feeling that much of it was saccharine and devoid of any serious power of expression. According to his friend Fehr, much of the inner turmoil Nolde suffered during his stay in Denmark after leaving Paris was caused by the artist's desire to develop beyond the Impressionist tendencies in his own art and reach a new, more powerful style which could express his strongly felt longings. It is therefore curious that Nolde returned only a few years later to this Impressionist vein which he had earlier found so unsatisfactory. It seems likely that in this period when he was still searching and experimenting with his art, Nolde through renewed contact with Langbehn's writings was able to perceive new possibilities in this style that he had not realized before.

If the execution of paintings like *Day of Harvest* or *Spring Indoors* is related to the works of the French Impressionists, Nolde is certainly able at this point to add something of his own personality and personal vision to these works. The style is more energetic than many of the earlier paintings by the French artists, and the sense of vitality that the brushwork itself imparts to the paintings corresponds to the subject matter as Nolde conceives it. These paintings are a celebration of the joys of a simple life and the strength and reassurance of its eternal, cyclical nature as the seasonal references suggest. In these works, Nolde is also beginning to conceive of the relationship of human figures with natural phenomena, in this case vegetation, as an active, agitated state. The figures are surrounded and engulfed by the activity of nature and seem to exist in a state of dynamic harmony with it. The vision of man in nature which begins in these works will recur in many later paintings.

After their marriage, Emil and Ada moved to Berlin, where he had previously rented a studio. Early in 1902, Nolde submitted several paintings to the Berlin Secession for inclusion in the annual exhibition, but they were rejected by the selection committee. In the spring of that year, the couple traveled back to Schleswig-Holstein, and Nolde introduced his new wife to his family. Frau Hansen welcomed her new daughter-in-law warmly, but Nolde records that his eldest brother Hans at first refused to speak to Ada because she was a "foreigner." Only after she showed an interest in his knowledge of local history and customs (*Heimatkunde*) and his studies in that area did Hans come to accept her.[10]

During a brief visit to Ada's family in Viborg that summer, Ada became ill. This was the first of many illnesses that would beset Ada for the remainder of her life. Her frail health caused the couple to wander throughout the continent for the next several years as Ada traveled from sanitorium to sanitorium. Ada's condition would remain a source of constant concern and tribulation for both of them for many years. Their marriage would never produce any children.[11]

That summer the couple was struck another severe blow as Nolde's mother died. With her last breath she spoke the name of her beloved artist-son.[12]

By the fall, Ada had recovered sufficiently from her illness to allow the couple to move to Flensburg, where they rented a small second-floor apartment.[13] In the spring of 1903, the two moved again, this time to the large island of Alsen on the Baltic coast just east of Flensburg.

Nolde's artistic output during these months was understandably small and would remain so for a few years to come. As Nolde was unable to earn much of a living from his painting, he and Ada began to suffer financial hardships. In the fall they decided to move to the small village of Guderup on the southern coast of Alsen. There they were able to rent a small, ramshackle fisherman's hut. After visiting the couple and seeing the conditions under which they were living, Hans Fehr began sending them fifty marks a month to help them get by.[14]

The Noldes' financial condition was still tight, however, and Ada traveled alone to Berlin in the summer of 1904 in search of work in a theater or cabaret to increase their meager income. She found work, but in the fall her health again broke down. This time her condition was even more serious and, with additional financial help from Fehr and another friend, Nolde, at the advice of Ada's doctors, was able to take his wife to Taormina in Sicily for the winter.[15] Ada recovered there slowly throughout the spring of 1905, and the couple was then able to travel up to Naples. In the summer, they returned to Alsen where they bought the small fisherman's hut with the financial help of yet another friend. Still not fully recovered, Ada visited several rest homes in Germany during the summer and fall while Nolde traveled to Berlin in hopes of being able to take up his art again.[16]

In 1906, Nolde's financial and professional situation began to improve greatly. Carrying a letter of introduction from the poet Wilhelm Schäfer, whom he had met in Braubach while visiting Ada in a nearby sanitorium, Nolde traveled to Hagen and called on Karl Ernst Osthaus, a wealthy industrialist and art collector with "strong interests in educating the people" (*"starke, volkserzieherische Absichten"*) and a great interest in modern German art. Osthaus bought *Spring Indoors;* his collection would later form the nucleus of the Folkwang Museum in Essen. Nolde's description of Osthaus' *"starke, volkserzieherische Absichten"* does not associate him with the Volkish movement, but instead with an anti-elitist attitude toward art and artists which opposed the cliquish, aristocratic practices of art dealers and museum collectors still prevalent in Germany at the time. Osthaus became one of Nolde's earliest and strongest defenders and patrons. He invited Nolde and Ada to stay and work in this area for several weeks that spring and they moved to nearby Soest where Nolde busily sketched the cathedral and other examples of local architecture and completed a whole series of etched views of the town (Schiefler R46–47). While the Noldes were staying in Soest, the town's resident artist Christian Rohlfs called on them.[17]

That year Nolde also had his first painting accepted for exhibition by the Berlin Secession. Paul Cassirer, a prominent Berlin art dealer and a member of the Secession selection committee, decided to place *Day of Harvest* in the annual exhibition against the votes of others on the committee. Nolde was appreciative of Cassirer's action, but, by the artist's own account, Cassirer's support of him was short-lived. Four years later the art dealer would play a major role in the refusal of works by Nolde and other young artists to the Secession exhibition, and the ensuing scandal would result in Nolde's expulsion from the organization. For now though, things were looking up for Nolde. He was finally beginning to taste success after years of hardship and rejection. He and Ada traveled to Berlin for the opening banquet.[18]

Nolde met a second important patron of his art in the spring of 1906, Gustav Schiefler, a Hamburg collector who specialized in prints. Schiefler agreed to purchase an edition of the artist's etching series of 1904–5, *Phantasien* (Schiefler

R8–15), eight imaginative scenes and vignettes of fanciful creatures in the manner of the works Nolde created on Lildstrand in 1901. Schiefler visited the couple on Alsen during the summer of 1906 and soon became a close friend of the artist's. The next year he published the first scholarly article on Nolde's graphic art and later he edited the standard editions of Nolde's collected graphic works, which appeared in 1911 and 1927.[19] Late in 1906, Schiefler arranged a meeting in Hamburg between Nolde and Edvard Munch. The encounter was uneventful. Munch said little and Nolde even less. The Norwegian artist was drunk, Nolde reports; by this time he was in a permanent stupor from years of alcoholic abuse. They never met again.[20]

During this period Nolde's art was beginning to attract the attention of other collectors and patrons of modern art in Germany. His paintings were gradually exhibited in several European cities. Count Harry Kessler showed some of Nolde's works in Weimar and then sent them on to Brussels and the exhibition of the *Libre esthétique* group. In the summer of 1906, Nolde had his first one-man show at the Berlin gallery owned by Fritz Gurlitt, whose brothers, Ludwig and Cornelius, have been mentioned previously and whose entire family was instrumental in the development of the Volkish movement in the first decades of the twentieth century, having been personally acquainted with both Lagarde and Langbehn.

In Dresden an exhibition of several of Nolde's paintings was viewed with admiration by a group of young artists residing there who had organized themselves under the name *Die Brücke*. In February of 1906, Karl Schmidt-Rottluff wrote Nolde representing the *Brücke* artists and invited him to join their group. "You will know as little of the *Brücke* as we knew of you before your exhibition at Arnold," he wrote, and he continued in the letter to explain some of the intentions and goals of their group. "Now one of the aims of the *Brücke* is to attract all revolutionary and surging elements—that is what the name *Brücke* (bridge) signifies." On the practical side, the group also arranged several exhibitions of members' work annually and planned in the future to procure a permanent exhibition hall, the letter concluded.[21]

Nolde was elated by the letter. "I was not alone! There were other young painters, optimistic about the future, with aspirations like my own."[22]

Nolde gladly accepted the invitation to join the *Brücke,* but he and Ada did not immediately move to Dresden. At their invitation, Schmidt-Rottluff visited them in the summer of 1906 on Alsen. "He stayed with us for several weeks as our guest. It was very pleasant. We spoke together of art and other things, philosophizing as young painters are wont to do. I admired his acumen and knowledge and hardly knew what to say when he spoke of Nietzsche and Kant or other great figures of this kind. How would I know of such things[?]"[23] Schmidt-Rottluff's formal education was more extensive and complete than Nolde's. He had attended school in Chemnitz (now Karl-Marx-Stadt), near his home village of Rottluff,

and completed his education at the Technische Hochschule in Dresden. Nolde probably felt his education somewhat inadequate in this respect, but this passage is yet another attempt by Nolde to downgrade the extent of his own understanding of the history of German philosophical thought and present himself as an intuitive, highly individualistic personality. When he felt the urge to paint that summer, Schmidt-Rottluff would leave Nolde's small hut and wander off alone into the forest, often for days at a time. This brooding, solitary nature of the young artist, so similar to Nolde's own character, undoubtedly attracted the older artist to him. Of all the young *Brücke* painters, Schmidt-Rottluff was also closest to Nolde in his fascination with the expressive powers of colors and the inspirations which natural and religious phenomena exercised on his art.

Nolde participated in the first *Brücke* exhibition in the fall of 1906 and shortly thereafter he and Ada moved to Dresden. They had learned of a sanitorium there practicing a method developed in Sweden which might cure Ada's worsening condition. At night the young *Brücke* artists, Erich Heckel, Ernst Ludwig Kirchner and Max Pechstein, would visit them in their room and long evenings were spent in conversation and plans for their artistic future. All of these artists were much younger than Nolde. Kirchner was born in 1880, Pechstein in 1881, and Heckel and Schmidt-Rottluff in 1883 and 1884, respectively. Kirchner, Heckel, Schmidt-Rottluff and a fourth young artist, Fritz Bleyl, had all met in Dresden around 1905 and in that year had banded together to form the *Brücke*.

> These young men came together, not on pragmatic issues, but out of a great optimism, a positive and intuitive attitude toward art and life in general. The young artists were repelled by the lack of passion and commitment in the art with which they were surrounded.
>
> The Brücke rejected: the finished and correct formalism of the academies; the flat, linear, and abstract decoration of Jugendstil, which seemed like meaningless ornament to them; and the pleasing color sensations of impressionism. They looked at nature in an attempt to fix its most essential characteristics in terms of their own immediate reactions. They seemed to be searching for an intuitive expression, which they felt lay somewhere between imaginative and descriptive art.[24]

These motivations of the *Brücke* artists are so close to Nolde's own ideals at this time that one easily can imagine each party's excitement upon discovering the existence of the other party.

By the time Nolde reached Dresden, the four original members had been living and working for almost two years in a converted butcher shop in the working class quarter of Dresden which they used as their studio. There they painted together during the day, critiquing and criticizing each other's work. Often one member would translate a painting by another into a woodcut. When they were not painting, they studied and discussed old German prints, primitive art and the masterpieces of early modern art by Munch, Van Gogh and other artists. "In Dresden the anonymous guild workshop of the twentieth century, which Van Gogh had wished to establish in his own time in Arles, was a reality for a few years."[25]

Schmidt-Rottluff had mentioned his special admiration for Nolde's "tempests of color" in his invitation to the artist, but Kirchner seemed more taken by the imaginative qualities of Nolde's etchings. "His fantastic individuality gave a new trait to the *Brücke*. He enriched our exhibitions with his interesting etching technique and learned about woodcuts from us," Kirchner later wrote.[26] Nolde, for his part, was impressed most strongly by the youthful idealism of these younger artists. He does not record any special admiration for their art. After the initial excitement of discovering like-minded young painters, "optimistic about the future," Nolde was soon disappointed by what he found in the *Brücke* studio in Dresden. Although the spirit of communal artistic activity was beneficial to the younger painters, the older Nolde with his strongly individualistic nature could not work for long in this atmosphere. "I did not like the uniformity which was developing in the young artists, and which was often so similar in their works that one could only guess [their individual origin]."[27] He resigned from the *Brücke* in the summer of 1907.

As Nolde would later admit, this was only half the reason for his departure from the group.[28] He also realized during his time in Dresden that he was simply no longer able to deal with other people on a day-to-day basis and all the "unavoidable irritations" that this involved, even when the ideas and motivations of the others were so close to his own. The *Brücke* artists had invited Nolde to join them in order to draw one more "revolutionary and surging element" into their communal experiment. They admired his expertise in certain areas of art and his more developed style, but there is no evidence that they saw him as a leader or a teacher. Nor is there any indication that Nolde was seeking followers or students among them. What he needed from them was the emotional community. For much of his adult life, Nolde would suffer from this psychological dilemma of needing and wanting desperately to belong to some community, some unity, that was greater than he was alone and that extended beyond the boundaries of his own individuality. Yet at the same time he remained unable to overcome his own strongly individualistic nature enough to permit him to enter into such a community. It might be noted that both Lagarde and Langbehn exhibited similar traits in their personalities. They resolved this dilemma in their Volkish theories of human nature and creative activity and of the mutual interdependence of the individual and the *Volk*. It would be years before Nolde would resolve his own dilemma in his own way, but the eventual process of resolution would lead him to many of the same insights and beliefs posited by the earlier Volkish writers.

Despite the problems Nolde encountered while working closely with the young *Brücke* artists, the period of his membership in their organization also resulted in certain positive changes in his art. Immediately following his departure from the *Brücke*, Nolde entered into a phase of intense creative activity that would last for several years and produce many of his most important paintings and graphic works. Prior to 1907, Nolde's annual output had been somewhat

meager; he had never completed more than thirty oil paintings in a given year. In 1907, thirty-nine finished oils are documented; forty-eight oils are recorded in 1908, thirty-six in 1909, and eighty-four in 1910. And this level of production would remain high for several more years.[29] From the manner in which he describes the rapid flow of ideas and imagery at this time, this phase seems quite similar to the earlier period of increased artistic activity Nolde experienced on Lildstrand in 1901, although this later phase is much more extensive. It is interesting to note that both of these important phases of advancement were immediately preceded by some form of contact and communication with other artists. Although Nolde never records any details of these conversations with other artists, one must believe that something about them must have contributed to or even provided a catalyst for the increased and intense creativity that followed.

The fascination of the *Brücke* artists with Old German woodcut prints and with the carving and printing techniques of the process struck a sympathetic chord within Nolde and the various woodcuts he produced after leaving the group provided his art with a new range of expression. Nolde learned how to print his own blocks in the *Brücke* studio and the sight of the young artists at work rekindled the sense of enjoyment in carving and handling the material he had experienced during his apprenticeship in Flensburg. He gained a new feeling for the lively qualities of this natural material and the expressive possibilities of the grain and the irregular knots of the wood, when they were included in the carving process and allowed to participate in the final product. Nolde carried this new understanding and respect for the role the specific material could play in the creative process to other media at the time. His statement previously mentioned concerning his desire to let his "work grow from the material" as foliage grows from the soil, dates from this time.

In the winter following his resignation from the *Brücke,* when he was visiting Hans Fehr in Jena (where his friend was then teaching at the university) Nolde carried this interest a step further. He had finally returned to watercolors and was sketching the landscapes of the hills around Jena (fig. 16). Outside in the cold temperatures, he allowed the washes to freeze and sometimes used pieces of ice to apply them to the paper. "At times I also painted in the freezing evening hours and was glad to see the frozen colors turn into crystal stars and rays on the paper. I loved this collaboration with nature, yes, the whole natural alliance of painter, reality and picture."[30] In the small watercolor, *Cospeda, Trees in March,* painted in March of 1908, Nolde has succeeded in recovering his mastery of the medium which was first evident in the small watercolor of a sunrise painted fourteen years earlier. Here the artist has laid down washes of mustard, brown, green, orange, violet and light blue in diagonal bands from the lower left to the upper right corners. The washes blend into each other. The brush is strong and evident in certain areas and, in the left center and upper center of the composition, the patterns of ice crystals lend a unique visual texture to the work. All of this combines to create visually strong and emotionally

powerful abstract forms suggestive of the vital, dynamic qualities of pure, untainted nature.

The admiration of the *Brücke* artists, especially Schmidt-Rottluff, for Nolde's masterful use of color in his paintings must have given him a new confidence in this area. If his paintings preceding the *Brücke* period were "tempests of color," the works which followed it approached the intensity of a deluge. The first waves of this deluge were the flower garden scenes which first entered into Nolde's work at this time.

> It was mid-summer. The colors of the flowers attracted me irresistibly and suddenly I was painting. . . . The flourish of colors in the flowers and the purity of these colors—I loved them. I cherished the flowers in their fate: bursting forth, blooming, shining, glowing, expressing joy, [then] bending slightly, wilting, ending [this cycle] tossed in a ditch.
>
> Our fate as men is not always so consistent and beautiful, but it too always ends in the fire or in a grave.[31]

By this time Nolde had already formed an association in his mind between flower gardens and the memory of his mother, as mentioned previously, and it is evident in this passage that he also perceived the life cycle of flowers as potentially symbolic of human fate in an ideal sense, more pure and consequential than the individual life. This kind of symbolic vision has a long tradition in modern German painting, and the image of the flower was a favorite of early Romantic artists and theorists in Germany.[32]

Nolde's own similar vision of flowers serves to reaffirm the bonds between his art (and indeed much of the art of other Expressionist painters) and the earlier northern Romantic tradition.[33] Turning to a specific example of Nolde's flower paintings from this period, *Anna Wied's Garden* (1907, fig. 17), we can see that Nolde does not attempt here to emphasize the cyclical nature of the flowers; rather, he concentrates on a specific moment in their growth cycle when the flowers are at the peak of their development—"shining, glowing, expressing joy." With its "flourish of colors"—red, blue, turquoise, green, yellow, violet and magenta—and obvious fascination with the singular beauty and strongly emotional qualities of the scene, this work might be compared to a similar and roughly contemporary example from the late work of Claude Monet, *Water Lilies* (1904, Louvre). Paintings like *Anna Wied's Garden* and late garden and lily pond scenes of Monet as well as examples of flower painting by other early modern artists like Piet Mondrian and Paul Klee, though they might differ in the particulars of presentation, are all part of a new tradition and a new iconography of the flower in modern painting. All of these artists were attracted to the image of the flower, not only for its purely visual qualities, but out of feelings similar to those expressed by Nolde for the symbolic and expressive potential of the flower's life cycle and of the individual flower as a manifestation of the energy and purity of nature, bursting forth in full bloom, drawing into itself the hidden forces beneath the soil.[34] Klee's often quoted description of a pictorial

idea from his *Creative Credo* of 1918 calls forth much of the imagery: "An apple tree in bloom, its roots, its rising sap, its trunk, the cross section with the annual rings, the blossom, its structure, its sexual functions, the fruit, the core with the seeds. A complex of stages of growth." From the artist's abstraction of such a conceptual image "will finally be created a formal cosmos which so closely resembles the Creation that a mere breath suffices to bring to life the expression of religious feelings and religion itself."[35] If these qualities are only partially discernible in this earlier garden scene by Nolde, they will be fully realized in later works where the artist concentrates his vision on individual flowers in large, powerful images. These floral icons will be discussed in a later chapter and we will return at that time to a discussion of the points raised here.

In addition to the imagery of flowers and gardens, during the period of his membership in the *Brücke* and in the years just afterward other images suggestive of vitality, purity and innocence become prominent in Nolde's work. Foremost among these are works which deal with the image of the child. Nolde had painted children in a very sympathetic manner previous to this time. An oil painting of 1901 entitled *Children* presents two young girls peering out of the picture space, their eyes and faces rapt with expectation and innocent desire at what is before them.

In his first woodcut series completed during his *Brücke* membership, Nolde returned to the theme of the child and his fascination with the inner fantasy world of children. The *Big Bird* of 1906 (Schiefler H9, fig. 18), which Nolde translated into oils in 1912, shows a young girl standing before a large fluttering bird against a stark background of black and white bands. The juxtaposition of the lithe, innocent figure of the girl and the dark, struggling, demonic form of the bird seems to give expression to the magical, childlike state of mind, uninhibited by any logical or social conventions and initiates a flurry of associations, including sexual ones. Peter Selz points out the similarity between this composition and Munch's *Omega and the Bear,* a lithograph from the Omega series which he completed in 1909.[36] A second woodcut from 1906 by Nolde, *A Little Girl's Fantasy (Mädchenphantasie,* Schiefler H14), repeats this theme. A young girl holding a doll is shown in the left portion of the print; she looks out at us cautiously while elflike figures dance against the black background in the upper right corner of the composition.

The theme of the child and its innocent, imaginative, spontaneous state of existence finds its first important expression in German Romantic art and theory. Many Romantic writers turned to the image of the child to symbolize their ideas of free, imaginative creativity and a state of being which existed apart from the logical, stultifying world of the adult. "We must become as children again," wrote the Romantic painter, Philipp Otto Runge, "if we wish to reach perfection."[37] In his portrait of the Hülsenbeck children (1805–6, fig. 19), Runge shows us this world of the child and how separate it is from our own adult world. The three children peer out at us with some slight alarm at our presence. The

central child raises a whip, seemingly to ward off the intruder before him while the infant in the wagon instinctively grasps the stalk of a sunflower as if it were his possession, a part of his world. Only when our eye wanders into the background do we realize that this scene really is their world and not ours. The picket fence before which the children stand and everything in its path as it recedes into the distance is much too small to exist in the adult world. It is scaled to the world of the child.[38]

As the inheritors of certain aspects of German Romanticism, the Volkish writers also called forth the image of the child to make many of their points. Langbehn especially turned to the image of the child in his Rembrandt book. As we have seen, he intended his book and the future it heralded for "the uncorrupted, un-miseducated and uninhibited youth." As important to the regeneration of the German spirit as the cultivation of *Volkstümlichkeit* was the cultivation of a childlike nature (*"Kindlichkeit"*), which contained many of the same qualities as *Volkstümlichkeit*—simplicity, spontaneity and magical mysticism. "Simplicity is the panacea for the evils of the present," Langbehn wrote, and no German *Volk* had retained this sense of unspoiled *Kindlichkeit* more strongly than the inhabitants of *Niederdeutschland*.[39]

Nolde, as a subscriber to both German Romantic and Volkish beliefs, brought forth this image of the child in his art. To him, children and their world were closely linked to the secret life of nature and the fantastic, spiritual world of the *Volk*. In what must be seen as his masterpiece in dealing with the theme of the child, *Wildly Dancing Children* of 1909 (fig. 20), he brings together all of these aspects. In the middle of a flower garden in full bloom several children holding hands dance in a circle. The figures jump and dance with total abandon, their faces radiant with glee. Like the movement presented in *Candle Dancers* (fig. 1), this is not a celebration of harmony, but a frenzied surrender of individuality. The children's activity seems less a game than a ritual of energy and Dionysiac innocence. Painted in a brushstroke whose wildness matches the subject, the figures of the dancing children seem almost to dissolve into the vibrant, shimmering background of the flower garden. Rilke had written of a nature which "celebrates its own festivities," unaware and unperturbed by its human observers. Here, Nolde suggests that children in their most primitive state are allowed to participate in these festivities of nature to which we are not privy. It is as if the artist has caught Runge's Hülsenbeck children unaware as they practice their secret ritual in their secret world of nature.

This association of the child with natural forms is not uncommon in artistic expression in Germany around this time. Paul Klee, Ernst Ludwig Kirchner, Paula Modersohn-Becker and others all painted works which present children united with natural or primitive objects in an attempt to create a symbolic statement of the fresh, innocent world of the child. *Wildly Dancing Children* is unique among these depictions by German artists in the emphasis Nolde places on the activity of children as a manifestation of their separation from the world of

everyday reality. In this painting Nolde's conception of a ritual dance approaches what William Butler Yeats would later describe in the final stanza of *Among School Children:*

> Labor is blossoming or dancing where
> The body is not bruised to pleasure soul,
> Nor beauty born out of its own despair,
> Nor blear-eyed wisdom out of midnight oil.
> O chestnut-tree, great-rooted blossomer,
> Are you the leaf, the blossom or the bole?
> O body swayed to music, O brightening glance,
> How can we know the dancer from the dance?[40]

That image is presented in contrast to Yeats' vision in the first stanza of children in a parochial school where they learn to "be neat in everything/In the best modern way" (lines 5–6). Yeats' dance does not seem to have the frenzied, uncontrolled qualities of Nolde's dance, but like Nolde the poet presents this ritual of innocence and abandonment of self, this melding of dancer, dance and natural form, as a more natural state of the child, opposed to the cold, rational environment of the adult-controlled classroom.

Nolde related the details of the germination of his painting in his autobiography: "Painting outside, I had unfortunately wiped off the colors [from my brushes] in the grass frequently. The children did not notice this. They rolled and jumped around and afterwards were all painted and brightly colored like little Bacchantes."[41]

The idea of the dance was also viewed at this time and earlier as a manifestation of certain ancient and traditional qualities of the *Volk,* specifically of the ancient Germanic tribes. Karl Müllenhoff wrote in the introduction to his collection of folk songs and fairy tales of the nature of the dance in ancient times and its relation to still extant children's dances (eleven of which are contained in his collection). One passage curiously foreshadows Nietzsche's theories of pagan dance rituals, put forth almost thirty years later.

> The further we go back in time, the more we must assume the closest connection between the song and the dance itself. Just how such a dance was created, can be learned from children's dances. . . .
> However, the closer dance and word and manner are interconnected, and all of them exist in the closest relationship to pagan cult ritual, . . . the more this entire art had to be destroyed through the infiltration of Christianity.[42]

In this context, *Wildly Dancing Children* can be seen as not just a game played by modern children, but something that exists on the threshold of timeless ritual and contains within it the potential to open the door to the distant past and collective subconscious of the *Volk.* Whether Nolde actually intended this painting to endender such distant associations cannot be said, but he was strongly aware

of and sensitive to the idea of dance as an irrational, heathen ritual. In the year following the completion of *Wildly Dancing Children,* he gave a very specific expression to his belief in dance as the core of pagan ritual in *The Dance around the Golden Calf.*

In depicting this scene from Exodus, Nolde refines the ecstatic Impressionist brushstroke of *Wildly Dancing Children* within more strongly defined forms painted in intense glowing hues of yellow, red, orange, magenta and blue, by which means he is able to communicate more forcefully the pleasure-pain experience of the dancers as they are racked into unnatural, twisted configurations by their intoxicated frenzy. The limbs and heads and great shocks of hair of the four female dancers, two seminude and two completely nude, flail about wildly as they stomp and rant before the golden idol. This theme of intoxicated dance would be more compactly presented in the later *Candle Dancers,* but already in this composition the Dionysiac qualities of the dance as Nietzsche conceived it are beginning to take form. The figures are defined entirely in the hot, vibrant colors which seem to emanate from them as manifestations of their heightened emotional state. The colors and the movement of the figures set the surrounding space in motion. These figures would become for Nolde almost an archetypal image of pagan ritual and primitive passion; he would repeat them in countless works, including a color lithograph (Sch. L56) and designs on ceramic plates.[43]

Nolde expressed on more than one occasion a recognition of his strong attraction to contrasting elements and opposing states in his art. It should not be surprising, therefore, to find that he was fascinated by those aspects of existence which seemed opposed to the vitality, innocence and purity of the world of nature or the child, namely the dark, intoxicating, confusion of urban life. As early as 1905, Nolde developed a routine which would continue for many years of spending part of the year in Berlin and part in Schleswig-Holstein. He was keenly aware of the extreme contrasts of these two locations and admitted that he seemed to find some sort of inspiration and exhilaration from a regular alternation between them. In 1910, he began to record his observations of what he saw as the essential qualities of this "reverse side of life" so different from the simple, traditional world of the North Schleswig peasant.

For several weeks in that year, Nolde lived in "a small, dark hotel" near the harbor in Hamburg where he observed the life of the sailors and their prostitutes and the flurry of activity around the port. All this he translated into a series of ink drawings, woodcuts and etchings of the Hamburg harbor (Sch. R136–47, H35–37). Nolde records a fascination with the inhabitants of this district, this dark side of humanity, in his autobiography, but also sympathy for their lot, recognizing that most of them were born into this kind of life and were never able to escape it. For this reason, Nolde approached his subject at this time, the harbor environment itself, as if he were engaged in a battle of wills: "Will this conquer me or I it?"[44] This was yet another period of intense activity for the artist, a time of total immersion in his art to the exclusion of any outside stimuli.

He records with some amazement how he was able to awaken in the middle of the night at the exact moment necessary to retrieve his etched plates from the acid bath.[45] "The resulting etchings had noise and uproar, frenzy and smoke and life, but only a trace of sunlight."[46]

Indeed, these etchings exhibit a freer and finer line and a darker, more varied texture than any of Nolde's graphic works of the previous five years. As Peter Selz has noted, the harbor etchings are not as freely imaginative as other earlier or later etchings by Nolde. Rather the artist's vision seems entranced by "the visual stimulus of the industrial landscape, the port with its barges, tenders, tugs and docks, and its waves and smoke" (fig. 21).[47]

To these scenes of the Hamburg harbor must be included an etched series of steamers and tugboats laboring through rough waters (Sch. R129–35, fig. 22) and a related oil painting, *Tugboat on the Elbe*, all of 1910. In the etched depiction of a steamer on the Elbe River, the dark tonalities and the sketchy, active line and the heaving masses of Nolde's graphic style work together to create a vision of a manmade object struggling against the elemental forces of nature and achieving through this struggle a kind of union with these forces. This merging of human technology with elemental nature is more strongly suggested in Nolde's oil painting of the same subject. The forceful brushwork and thick impasto bring out the fluid atmospheric qualities of the scene, dissolving detail in favor of a dramatic vision of the power of nature. As one might expect, for an inhabitant of a region whose daily life was so closely tied to the sea geographically, economically and culturally, the sea and its seemingly unlimited force were an important influence upon Nolde in forming a pious, awestruck attitude toward nature and natural phenomena. The exact nature of Nolde's understanding of the sea in symbolic, transcendent terms will be discussed in more detail in Chapter 5.

It is in the sketches of Berlin night life begun by Nolde in the winter of 1910 and the finished paintings of the subjects completed the following year that a vision of life in the metropolis as a contrast to and even opponent of the purity and energy of the life allied with nature is expressed in a most unequivocal fashion. Nolde recorded the circumstances of his sketches of the patrons in the Berlin cabarets and dance halls in his autobiography. Every night around 11:00 P.M., he and Ada would go out to costume balls or cabarets and then later to taverns and night cafes, "where pale, powdered and smelling like corpses, impotent asphalt lions and lascivious ladies of the *demimonde* sat in their elegantly audacious robes, worn as if they were queens." Nolde would carry a sketching pad.

I sketched and sketched, the lighting in the rooms, the tinsel facade, the people, all of them, good or bad, the occasional inhabitants of this *demimonde* or the completely decadent; I sketched this dark side of life with its make-up, with its slimy dirt and its corruption. Everywhere there was visual stimulus. These people weren't important to me; they came and danced, sat

there and went on and I captured on my paper only what seemed essential to me. It was often oppressive in these depths among all the light-headed happy and miserable people. I sketched and sketched.[48]

This sense of visual stimulus and artifice is evident in finished oil paintings like *Gentleman and Lady* of 1911. The bright, garish colors lack the emotional power of Nolde's color combinations found in paintings of other subjects, and the paint itself is much thinner than Nolde's characteristic impasto, denying the scenes any sense of activity or vitality. The figures are static and unanimated with crudely drawn, masklike faces. These qualities are also found in *A Glass of Wine* (1911), which focuses on a female figure in a large hat painted in jagged, angular lines which recall similar scenes of Berliners painted by Kirchner around this time. In the painting entitled *Slovenes* (fig. 23), we are confronted by two ghastly creatures, a dark-skinned, heavy-featured man and his companion, a female, whose gaunt, skull-like face reveals a great walleye. These two are seated before a still life of two glasses and a wine bottle and we are tempted to read a causal connection between the figures and the still life, as if their gross facial distortions were in fact the product of the life they lead and their inner corruption was no longer disguisable through makeup. This disturbing vision seems almost to be a vicious reworking of Edgar Degas' *Absinthe Drinker*.

The reference to Degas in this context of depictions of the urban life and its inhabitants should serve to remind the reader that such scenes of the evils of modern life in the city are not solely the domain of Nolde and other German Expressionist painters. Images of the desperation and isolation of life in the metropolis recur as a common and pervasive theme in European art and literature in the latter half of the nineteenth century. Nonetheless, in the case of Nolde and many artists of the Expressionist generation in Germany who were influenced in part by the Volkish criticism of urban life, this view of the city and its inhabitants involves specific assumptions not held to such a degree in other European countries at this time. The Volkish view of the city held that it was "almost characterless" because it existed "outside of every relationship to the landscape."[49] In defining this quality of city life, the Volkish writer Otto Gmelin stated, "the essence of the metropolis is all pervading sameness; it is to that degree something which has no soul, because the soul is individual. The theater, the cabaret, popular hit songs, fashions, modern dances—all that is international, [it] is not individual and not Volk-oriented, it does not derive from any specific landscape. . . ."[50] This is the basis of Volkish condemnation of city life, that it had lost all ties with local history and tradition and no longer had a creative spiritual relationship with nature, and Nolde subscribes to a large degree to this aspect of Volkish thought in his depictions of Berlin night life. The very title of the painting *Slovenes* tells us that we are looking at two individuals who are not native to Berlin. They are members of the Slavic community in Slovenia (in northwest Yugoslavia) who have been uprooted and drawn to the big city; through

that process they have lost all contact with their native land, the source of their true being. *Slovenes* deals with a double tragedy in this respect. The degradation and distortion we seem to witness in this painting are not just a product of the life it portrays. They stem also from the uprooted nature of these individuals whose strong racial character seems almost to be dissolving before our eyes.

As we have seen, the first decade of the twentieth century was a period of tremendous growth and development for Nolde. His contact with the artistic community in Germany was firmly established during this period. By 1910, he had developed his art to the point where he was able to convey his own ideas and intentions in a highly forceful, expressive manner, and his style would change little from this point on. The culmination of this personal and artistic development is to be found in the religious scenes Nolde painted from the years 1909 through 1912. These paintings are the masterworks of this stage of Nolde's art, if not of his entire career.

The circumstances under which the first paintings were created in 1909 conform to the course of events already encountered during earlier periods of intense creative activity in Nolde's life. There was a stage of critical self-examination, self-doubt and dissatisfaction followed by an agitated, almost trancelike state during which the paintings were completed. Nolde recounted the events in the following passage from his autobiography.

> I was no longer satisfied with the way I drew and painted during the last few years, imitating nature and creating form all done preferably with the first stroke, the first brushful of paint. I rubbed and scratched the paper until I tore holes in it, trying to reach something else, something more profound, to grasp the very essence of things. The techniques of Impressionism suggested to me only a means, but no satisfactory end.
>
> Conscientious and exact imitation of nature does not create a work of art. A wax figure confoundingly life-like causes nothing but disgust. A work becomes a work of art when one re-evaluates the values of nature and adds one's own spirituality. I tried to pursue notions such as these, and often I stood contemplating the landscape, so grey, so simple, yet so splendidly rich with the animation of the sun and wind and clouds.
>
> I was happy when I could make something concentrated and simple out of all this complexity . . . I began to feel a need for greater cohesion (*Bindung*).

In the midst of this inner struggle, Nolde became deathly ill with a case of food poisoning. Ada returned from a visit to England to nurse him back to health. After a period of recuperation, Nolde again felt the urge to paint and pursue new directions in his art. Sensing this, Ada again left and, still in a fever, Nolde began to paint.

> I drew thirteen people on a canvas, with a hard pencil and a sharp point. The Saviour and his twelve apostles, sitting around a table in the balmy spring night, the night before Christ's great passion. These were the hours when Christ revealed to his beloved disciples His grand thought of redemption. From the innermost depth He spoke the words preserved for us in His sacraments. John leaned his head on the shoulder of his divine friend. ———

Without much intention, knowledge, or thought I had followed an irresistible urge to represent profound spirituality, religion, and fervor (*Innigkeit*). A few of the heads of apostles and a head of Christ I had sketched before. Near shock I stood before the drawing. No image of nature was near me, and now I was to paint the most mysterious, the profoundest, most inward event of all Christian religion! Christ, his face transfigured, sanctified and withdrawn, encircled by His disciples who are profoundly moved.

I painted and painted, hardly knowing whether it was night or day, whether I was a human being or only a painter.

I saw the painting when I went to bed, it confronted me during the night, it faced me when I woke up.

I painted happily. The painting was finished. *The Last Supper.*[51]

This passage provides us an interesting insight into the workings of the artist's mind. Nowhere else in Nolde's autobiography is the close connection between the artist's desire to capture the essential qualities of the landscape experience, to express his own deeply felt subjective bond with nature, and his intensely strong religious and spiritual longings so clearly and openly realized. As Nolde describes these events, the landscape experience led him almost directly to the vision of spiritual redemption. Like Runge who perceived in the landscape "the purest thing there is in the world, in which we can recognize God or his image," Nolde seems in this passage to be describing a relationship between the individual and the landscape that is essentially romantic in tenor and whose mystical, pantheistic quality was adapted by many early Volkish writers as a central tenet of the Volkish view of nature, that is, that the native landscape of the individual contained within it certain transcendent forces which could interact with the soul of the individual to lead him to a vision of spiritual harmony and regeneration.[52]

As the artist's extremely personal vision, *The Last Supper* (fig. 14) breaks with the traditional iconography of the scene. Nolde foregoes a depiction of the dramatic moment of Leonardo's fresco where Christ announces His forthcoming betrayal in favor of an earlier stage of the gathering, showing Christ offering the wine to His disciples with the words: "Drink ye all of it; For this is my blood of the new testament, which is shed for many for the remission of sins." The choice of this moment is significant for its emphasis on the spiritual community of Christ and His disciples and the Eucharistic ritual it symbolizes, rather than the human imperfection of the betrayal. Nolde's evocative use of colors to convey a strong, emotional state reaches a new level in this work, as the rough-hewn, masklike faces of the disciples seem to glow from an inner light that reaches its greatest intensity in the face and robe of Christ. The bright, nonnaturalistic colors of the faces and the crowded space in which they are placed recalls the compositions Nolde chose for his paintings of North German farmers done the previous year and the suggestion of spiritual community already evident to some degree in these earlier works. The quiet, pious intensity of *The Last Supper* may also be inspired in part by Nolde's memory of Rembrandt's small *Supper at Emmaus,*

which exhibits a similar sense of religious aura throughout the entire space of the canvas.[53]

After completing *The Last Supper,* Nolde painted *The Derision of Christ* which "saved me from drowning in religion and compassion."[54] This was followed by yet another religious painting, *Pentecost* (fig. 24).

> Then again I went down to the mystical depth of human divine existence. The painting of the Pentecost was sketched out. Five of the fishermen apostles were painted in an ecstatic supersensory reception of the Holy Ghost. My Ada arrived that evening. I was distracted. She saw it, and the very next morning she departed for somewhere on her own initiative. The painting could have remained a fragment—but now I kept on painting happily—red-lilac flames above the heads of the disciples, in the holy hour pregnant with joy when they became blessed apostles called upon to bear witness to divine revelation.
>
> "Go you therefore, and teach all nations, baptizing them in the name of the Father, and the Son, and of the Holy Ghost." This is what their divine friend called to them, and how beautiful is all they report Christ is saying to them. How infinitely beautiful it must have been to be present when He said these words.
>
> The apostles went forth into the world. The message of redemption kindled magnificent fires. "Believe and you will be saved!" Altars, crowns, and empires tottered and tumbled.—
>
> Engrossed with feelings such as these I painted my religious pictures. Light and dark and the cold and warm of hues occupied the painter. So did the representation of people moved by the spirit of religion, and also deep groping religious thoughts so despairing that they almost drove him insane. The Bible contains contradictions and various scientific mistakes. To remain uncritical demands the very best of intentions and an almost superhuman respect.[55]

Both in terms of composition and subject matter, Nolde's *Pentecost* exists as a pendant to *The Last Supper.* As in the earlier painting, here a group of figures set around a table in a confined pictorial space. The figures are painted in bright and intense colors and the faces of Peter and the apostles flanking him, with their strong, transfixed features, stare out at the viewer as flames dance upon their heads. Like *The Last Supper,* Nolde's initial conception of the *Pentecost* was based to a large degree upon the biblical account of the event, but the final statement of the painting was highly personal and expressive in its interpretation of the miracle, as Nolde explained in his discussion of these paintings.

> I doubt that I could have painted with so much power the Last Supper and the Pentecost, both so deeply fraught with feeling, had I been bound by a rigid dogma and the letter of the Bible. I had to be artistically free, not confronted by a God hard as steel like an Assyrian king, but with God inside of me, glowing and holy like the love of Christ. *The Last Supper* and *The Pentecost* marked the change from optical, external stimuli to values of inner conviction. They became milestones—in all likelihood not only for my own work.[56]

The ideas of spiritual redemption and mission with which these paintings are concerned occupied much of Nolde's creative activity and intellectual speculation in the years immediately preceding and following the paintings' inception. These ideas extend beyond the narrow boundaries of the specific religious events into a realm of more general concern with the role of spiritual redemption and

mission in early twentieth-century European culture. In relying not only on "the God within himself," but on his vision of the apostles with the strong, expressive features of North German peasants, Nolde suggests a broader context of spiritual regeneration whereby these peasants are understood to be the receptacles of an intense spirituality untainted and unaffected by the increasing complexities of modern life. This attitude is strongly Volkish in its origin, further reinforcing Nolde's connection to this ideology.

Three years after these paintings were completed, a public controversy would arise surrounding Nolde's religious paintings of 1912 and his claim to have painted the disciples of Christ as "strong, Jewish types" in these works. At that time he would be critical of the traditional practice in Western art of depicting Christ and his followers as Mediterranean or Aryan types. However, in these first religious paintings of 1909, this anachronism does not seem to be a concern. In these early works, Nolde intentionally uses Aryan models for the disciples, but he does so less out of a desire to conform to tradition than to set up an explicit association between the peasants of his homeland and the followers of Christ.

Like Gauguin in Pont-Aven twenty years earlier, Nolde seems here to conceive of the mysterious, superstitious nature of the peasant as the closest modern equivalent to the pious, irrational mentality of the first Christians. However, unlike the peasants as Gauguin envisioned them in his *Vision after the Sermon* (1888), for example, Nolde's peasants are not just witnesses to a miracle of Christian tradition, but actual participants in these miracles, modern-day protagonists in the central rituals of evangelical Christianity.

At one point in his discussion of these paintings and their inception, Nolde asks, "Why did the message of redemption have to settle out in cold dogma and vain form, only rarely kindling a small flame which quickly dies? . . . Why did happiness and enthusiasm end so soon?"[57] But these questions are in part rhetorical and Nolde provides the answers to them later in the same passage. "Faith is easy for the simple-minded. His convictions are built on a rock unshaken by doubt. In the absence of knowledge, dedicated piety has all the room."[58] This is the religious orientation of the peasants in Nolde's native Schleswig-Holstein, a mystical faith which is easily rekindled into manifestations of religious fervor comparable to the state of faith in the early Christian church.[59] It was to this kind of mentality that Nolde attempted to direct his religious paintings, and he was pleased when these "unsophisticated people" grasped the "sacredness" of these works. "Even the most intricate and profound works became meaningful to them in a short while."[60]

In his religious paintings and in his discussion of the motivation underlying them, Nolde's emphasis on the primacy of mystical faith and on the central symbolic importance of the Eucharistic ritual as a focus for this faith has some relation, albeit indirectly, to the theological speculations of Paul de Lagarde some thirty years earlier and to the Volkish critic's attempts to define a new

faith, a "Germanic Christianity." Lagarde was obsessed with the decline of faith in the modern world; in seeking the root cause of the present-day dilemma of Christian theology and practice, he grappled with the same questions asked by Nolde, why did the mystery of early Christian faith and the true teachings of Christ become so encased in unfeeling dogma? Lagarde traced the origin of this transformation to the earliest interpretations of the Gospel by Paul and his followers. Paul, the Jew, "the utterly unauthorized . . . who even after his conversion remained a Pharisee from head to toe," was guilty of corrupting the Gospel by infusing it with Jewish elements.[61] In his essay, "The Religion of the Future," Lagarde called for a fusion of the original doctrines of the Gospel (where the Eucharist would hold a special position) with the "national characteristics of the Germans," that is, the old virtues of the Germanic tribes. Lagarde was unclear on just how this new faith was to be created or from where these old Germanic qualities should be revived. If these qualities still existed among any segment of modern German society, it was probably among the peasant classes where they would be found. As for the genesis of the new faith, Lagarde referred repeatedly to a spiritual rebirth on a national scale in contexts that suggest a cultural and nationalistic meaning beyond a strictly religious interpretation of the idea.[62]

In all probability, Nolde was not familiar with the writings of Lagarde on a firsthand basis even though certain aspects of his orientation toward religious experience recall Lagarde's solutions to the crises of modern Christianity. Lagarde cannot really be regarded as a direct formative influence on Nolde's religious attitudes. However, as already noted, in his criticisms of modern culture Lagarde expressed the sentiments of a sizeable portion of the German population during his lifetime. Moreover, his attacks upon the current demoralized state of Western theology as he saw it and his call for the return to a simple, mystical faith as an essential component in the regeneration of German spiritual life continued to find acceptance among an ever increasing number and range of individuals after his death.[63] From Nolde's own statements we can conclude that the artist would have been in agreement with many of Lagarde's ideas, and in that context these ideas deserve to be mentioned in this discussion of Nolde's religious paintings.

It is unlikely that Nolde had any direct contact with the ideas of Lagarde beyond the artist's own participation in an intellectual climate where these ideas prevailed. Still, through his familiarity with Langbehn's *Rembrandt als Erzieher*, Nolde would have encountered Lagarde's ideas in a slightly altered state. In the earlier discussion of Langbehn, it was stated that the ideas concerning the current decline of German culture and the longing for a rebirth of the German spirit which Langbehn adapted from Lagarde and other sources were molded into a "cultural ideal," the figure of Rembrandt. It is in Langbehn's interpretation of Rembrandt's deeply religious nature that the ideas of Lagarde (and Langbehn) are most directly applicable to the present discussion. Rembrandt's deep religiosity and "inwardness," his power of mythical imagination which gave his religious

paintings the freshness and innocence of childhood memories, and his strongly felt bond with his own *Volk* and his native homeland, all these qualities unite within the artist to enable him to express "the objective spirit of original Christianity *(Urchristentum)*." "One could almost believe," Langbehn wrote, "that something of that melancholy kindness, of that subdued character, that inward orientation which is so inherent in certain inhabitants of the North German lowlands of Holland . . . might also be found in the personality of the loving author of the Christian doctrine. As the countryside is, so are its people . . . Christianity originated between heather and sea just as the disposition of the *Niederdeutschen* did."[64]

At one point in his autobiography, Nolde discusses certain inspirations of his own religious painting. The emphasis he places there on the original memories of his childhood imagination seem to recall Langbehn's emphasis on this quality in his description of Rembrandt. "The images of the boy of long ago, as I sat during the long winter evenings deeply moved reading in the Bible, became vivid again. They were pictures that I read of the richest oriental fantasy. They danced before me continually in my imagination, until much, much later when the now-grown man and artist painted them in dream-like inspiration."[65]

The freshness, immediacy and undeniable validity of the child's religious experience which Nolde describes here and which Langbehn associates with the truest expression of the *Volk* and "the objective spirit of original Christianity" should not be underestimated as a strong and conscious motivation in Nolde's approach to religious subjects in his art. In a third masterpiece of his early religious paintings, *Christ among the Children* of 1910 (fig. 25), Nolde captures the essence of this experience in a work which combines the theme of the child as it appeared in his earlier paintings with the drive to express the intense spiritual union of Christ and his followers that was so central to *The Last Supper* and the *Pentecost*. This is a scene rarely depicted in earlier Western art, but there is at least one important earlier representation of the scene—Rembrandt's famous "Hundred Guilder print," the etching of 1648–50 entitled *Christ Healing the Sick*—which might have inspired Nolde to paint the scene.

While Rembrandt chose in his etching to emphasize Christ's humility and humanity as the savior and healer of the sick, the poor and small children, Nolde reinterprets the scene in very different terms. The large form of Nolde's Christ divides the canvas in half as He turns His large, blue back on His disciples to the left and embraces the seething mass of small children on the right. The children are painted in bright, warm colors that enhance the movement and exuberance which emanate from that half of the canvas. The static, solid figures of the disciples on the left are painted in cool blues and greens. Nolde conceives this event as a confrontation of opposite worlds—the cold, static, rational, questioning world of the adult disciples versus the warm, ecstatic, energetic realm of total un-self-conscious joy and acceptance in which the children reside. Christ occupies the space between these two worlds and characteristically turns

his back on the adult world. "Suffer the little children to come unto me, and forbid them not: for such is the kingdom of God. Verily I say unto you, Whoever shall not receive the kingdom of God as a little child, he shall not enter therein." (Mark 10:14–15, Luke 18:16–17)

In his own estimation, Nolde's religious paintings of the years 1909 to 1912 were the climax of his career up to that point. These works were also the first paintings by Nolde to receive widespread critical acclaim and condemnation from the German art world and to secure Nolde's position as a major figure in a new generation of young German Expressionist artists.

When the young director of the Halle Museum, Max Sauerlandt, decided to purchase *The Last Supper* after it was exhibited there with several other paintings by Nolde, he had to fight the museum's trustees in this matter to the point of threatening his resignation to secure the acquisition. After the painting was purchased, Sauerlandt's decision came under further heated criticism by Wilhelm von Bode, the reigning head of the German art establishment.[66] Sauerlandt remained a steadfast supporter of Nolde's art, however, and published the first major monograph on the artist in 1921.

Karl Ernst Osthaus exhibited another of Nolde's religious works, the monumental *Life of Christ* (1912) with its large central Crucifixion and four smaller scenes on each wing, at his Folkwang Museum and then took the "altarpiece" to the Brussels World's Fair of 1912 where he intended to show it in the religious pavilion he had been asked to organize. When officials of the Catholic Church saw the large paintings, they protested vehemently at the depictions of Christ and his followers as "strong Jewish types" and the work was removed from the exposition. According to Nolde, in a counterprotest, Osthaus closed the pavilion and left Brussels. Nolde related his reaction to the incident in his autobiography.

> At the time I didn't know that Protestants as well as Catholics did not like and did not want my pictures. They had kept silent. Naturally I had not asked them how religious pictures should look. I created them instinctively, painting the figures as Jewish types, Christ and the apostles too, Jews as they really were, the apostles as simple Jewish peasants and fishermen.
> I painted them as powerful Jewish types, since the weaklings were certainly not the ones who followed the revolutionary teachings of Christ. . . .
> The fact that during the Renaissance the apostles and Christ were represented as Aryans, as Italian or German scholars, must have convinced the Church that this practice should continue forever, that this artistic deception—to be quite frank—justified further deception.[67]

It was not until after the First World War that Nolde's religious works found more positive appreciation among German art critics. In 1919, Carl Georg Heise published a study of Nolde's religious paintings in which he described the artist's motivations and inspirations in the earliest works.

> He [Nolde] does not open the Bible in order to represent the traditional events, he creates out of the imaginary world of his childhood. In this way his work departs radically from historical painting and strives to be nothing less than a vessel of the divine, as an intimate, exquisite embellishment of the deepest primitive emotions of mankind, experienced on a new

and personal level in a powerful spiritual upheaval, but translated into the archetypical through the unusual formal powers of the artist. One thinks of Nietzsche, for whom at the time of his *Zarathustra* the language of Luther's Bible became such an inspiration.[68]

Heise was one of the first German critics to recognize the validity of Nolde's religious paintings as expressions of a personal, ecstatic spiritual longing and as an attempt by the artist to reach a level of primitive, archetypal emotion by translating this spiritual longing into strong, monumental forms.

None of Nolde's religious paintings was ever a commissioned work, nor was he or any other Expressionist painter commissioned to complete any large-scale public monument, a fact that Nolde bitterly acknowledged.[69] Although no church or temple ever agreed to exhibit one of these paintings permanently, several of Nolde's religious works including the large altarpiece and the *Mary of Egypt* triptych (1912) were exhibited in the medieval church of St. Catherine of Lübeck in the winter of 1921–22. A reviewer of this exhibition noted how powerfully these paintings worked in this kind of surrounding where the diffused light of the church muted the intense colors of the various paintings to a full, but vibrant glow.[70] Sauerlandt also recognized the appropriateness of Nolde's paintings, especially their colors, to an expansive church setting. "It is this [use of color] which gives Nolde's biblical paintings the unmistakable character which removes them far from all religious art of the nineteenth century and permits them to appear related not in form but in emotion to the utmost depth which the early Middle Ages have created in stained glass and to the art of the seventeenth century."[71]

Nolde was not the only modern painter of religious subjects to suffer from a lack of support and understanding on the part of established religions. As Peter Selz points out, "with rare exceptions, . . . religious authorities in our time have tended to prefer sweet, or at least 'non-controversial,' devotional images to powerful and authentic statements about life and its ultimate values, and this was doubtless why no use was found for Nolde's myth-making representation of violence and tragedy."[72]

Nonetheless, Nolde's religious paintings continued to attract the attention and imagination of a small group of friends and admirers in the years immediately following World War I. At least one of that group, G. F. Hartlaub, perceived the close bond between certain aspects of Nolde's religious expression and the spiritual qualities of *Niederdeutschland*. In assessing Nolde's religious art, Hartlaub found the indelible stamp of the North German spirit.

In this North German, whose adventurer/seafarer nature runs continually "between the coasts," from the North Sea, to which he . . . is rooted with all threads [of his being], to the South Seas [Nolde's journey to New Guinea] . . . a particular attraction to biblical and legendary tales must exist, which he captures out of the spirit of a primitive, barbaric Orient and which he knows how to grasp with the most refined religious sentiments in a human and superhuman sense that perhaps only a European can feel. His pentecostal disciples of Christ appear at first

glance to be painted as if they were wild, babbling freaks in a state of terrible possession until one suddenly recognizes in them the familiar features of North German sailors and at the same time a wealth of subtle spiritual qualities.[73]

According to Hartlaub, only one other European artist, Rembrandt, has so successfully combined the spirit of the *Volk* with an expression of primitive exoticism in his art. "In the same way Rembrandt, *Niederdeutscher* and son of a seafaring people like Nolde, had transposed the Old and New Testament back into the twilight of a Jewish Orient, in order to make it 'distanced' and again mysterious."[74]

Although Hartlaub does not specifically mention Lagarde or Langbehn in his discussion of Nolde, his debt to them should be noted in the emphasis he places on geographical origin as a determining factor in the individual's creative expression and in the choice of Rembrandt as an ideal to which he compares contemporary artists. Hartlaub also recognized the underlying motivation and intention in Nolde's art, to approximate through pure emotional power delving into his own innermost depths the mystical vision of "primitive man—biologically a dumb animal, but yet (to the perceptive) so close to paradise, at which we adults smile and are simultaneously astounded."[75]

By far the most serious and important critical reaction to Nolde's religious paintings occurred very early during the period of 1909–12. The circumstances surrounding this criticism would have a decisive effect on the course of Nolde's career and the development of his art from that point on. In 1910, Nolde sent several of his recent paintings including his *Pentecost* to the jury of the Berlin Secession for the annual exhibition. He had been a member of the Secession since his first painting had been exhibited by the organization in 1906, but since 1908 his submissions to the annual exhibition had been steadily refused.

The jury for the 1910 Secession exhibition was especially intolerant of the entries submitted by other young German artists as well as Nolde, but Nolde seemed particularly incensed by a comment from Max Liebermann, the president of the Secession, concerning the *Pentecost:* "If that picture is exhibited, I'll resign."[76] In response to this reported statement which Nolde saw as an attack directed at the very essence of his art and in an angry reaction against the growing conservative tendencies of the Secession group, Nolde sent a letter to Liebermann critical of the older artist ("From a worldly point of view, it may have been the greatest blunder of my life; from an artistic point of view, bold, a proud act.")[77] He also sent a copy of this letter to the editor of *Kunst und Künstler,* the semiofficial organ of the Secession, and circulated copies among the organization's members and to the daily press. Karl Scheffler, the editor of the journal, published the letter along with a scathing attack on Nolde and a notice of the artist's expulsion from the Secession for publicly insulting its president. The "Nolde conflict" had begun.

Nolde's bitter complaint against Liebermann and the Secession hierarchy was an expression of his own frustration (and, if we believe Nolde, the frustration of the younger generation of German artists) over the calcified state of the arts in Berlin. To Nolde, Liebermann represented the older, conservative generation of German artists who controlled the exhibition policies and avenues of public acceptance in the Berlin art world. As Nolde saw it, these older artists consciously opposed the younger artists by refusing to allow the practitioners of newer, more radical styles access to major exhibitions and publicity in art journals. Nolde's letter was a statement of open warfare; unfortunately, his attack on Liebermann was of the most personal kind. Part of the letter reads as follows:

> It is the case with the clever, old Liebermann as it has been with many a clever man before him: he doesn't know his limits. His most important life's work: his agitating efforts for the Secession and the artistic point of view for which it strove, scribbled and quarreled; he now seeks to rescue it and becomes nervous and rambling in the process. He tries to achieve the same thing in his art. He sees to it that as much as possible is written and published about himself, he acts, paints and exhibits as much as he can. The result of this is that the youngest generation [of artists], sick and tired of this, can and will no longer bear to look at his works, that they recognize how calculated all this is, how weak and *kitschig* is not only his recent work, but much of his earlier work. The critics will soon come to the same conclusion, then public opinion will follow and so the art house of Liebermann, founded on such insufficient quality, will disappear.[78]

Nolde relates much of the verbal exchange between the two sides in this public controversy in which he had placed himself. From the statements he reprints in his autobiography it appears he had at least some support from other young artists, but, when the matter was brought to a vote before the Secession members, the actions of the young Secession artists did not follow their words. The lack of active support and the misunderstanding of his actions by the young artists Nolde felt he represented was a painful experience for him, he writes. Equally distressing to him were the accusations of anti-Semitism leveled against him—charges that he strongly denied, even in 1934 when *Jahre der Kämpfe* was first published.[79]

Despite Nolde's protest, the charge of anti-Semitism received widespread acceptance at the time, costing him the friendship of Max Wittner and the support of certain young Jewish artists, and this point is still emphasized in more recent criticism of Nolde. Peter Selz has written of Nolde, "his autobiography and letters are filled with the narrow-minded anti-Semitism, nationalism and racism prevalent among the isolated German peasantry and later exploited so successfully by the Nazis."[80] This in itself may be a slight oversimplification, but the fact remains that Nolde himself was later attracted to the National Socialist rhetoric which spoke of a grand, mystical vision of national and spiritual regeneration and he even joined the North Schleswig branch of the Nazi Party.[81]

The reconciliation of Nolde's art and the powerful, exhilarating, life-enhancing qualities of his best paintings with the artist's later support of certain aspects of Nazi ideology and policy is a problem that confronts every student of the

artist. Indeed, there may be no satisfactory reconciliation possible for the sensible and thoughtful individual. We have already encountered Nolde's attraction to opposing qualities and contrasting states of the human condition even within himself. The seemingly irreconcilable differences between the spiritual ideals Nolde sought to express in his art and the terrible realities of the Nazi experiment he initially supported may indicate the greatest contradiction within the personality of the artist.

The point of intellectual contact between Nolde and the National Socialists can be found within the confines of Volkish thought from which the underlying beliefs of both Nolde and the Nazis developed. Therein lies the tremendous cultural-historical importance of this ideology which could inspire the highest and the lowest of human aspirations. Nolde recognized the common origin in Volkish thought of his views and those espoused by the Nazis, but his fervent belief in the ideals of national and spiritual regeneration which he drew from Langbehn and other sources blinded him to the horrible transmutation of those ideals by the practitioners of National Socialism. Like so many others of his generation who were also inspired by the ideas of the Volkish writers and later tacitly or openly supported the Nazi cause, Nolde confused intellectual ideals and political realities. Surveying the state of the world in 1941, the German social psychologist Otto Rank recognized this tendency as a constant in human behavior when he wrote of the nature of social evil, "All our human problems, with their intolerable sufferings, arise from man's ceaseless attempts to make this material world into a man-made reality . . . aiming to achieve on earth a 'perfection' which is only to be found in the beyond . . . thereby hopelessly confusing the values of both spheres."[82] Perhaps more than any other modern system of ideas that engendered both further ideological developments and practical applications, Volkish thought exhibits this tragic desire to reconstruct the real world according to ideals which properly belong only in the mind.

A particular kind of racial thought played an important role in Volkish thinking from its earliest phase of development. As increasing credence was given in the writings of Volkish theorists to the importance of the regional landscape in contributing to and even molding the character of its inhabitants, these determinants within the landscape and the entire process by which a regional character was formed came to be perceived as absolute, indelible principles. In the latter half of the nineteenth century many of these writers began to discuss the concept of race not only in genetic, but in geographic terms.[83]

Every regional landscape, it was assumed, affected its inhabitants over a period of time so that the natives of a specific region developed a unique bond with their natural surroundings, a bond peculiar to them and foreign to the inhabitants of another landscape.[84] Strict adherence to this belief would result in limiting the concept of a distinct race into much smaller units than the several races accepted by scientific standards, but it also created the concept of a race as a much closer community which shared not only inherited biological factors, but a common bond with external, natural surroundings, that is, a *Volk*.

At this stage in the development of Volkish thought, theories about the nature of race, though somewhat irrational and mystical in their inception, were relatively harmless and not infused with assumptions of racial inequality and superiority which characterized later racist thought. Each race was assumed to have its own native landscape. In the last two decades of the nineteenth century, however, anti-Semitism began to enter strongly into the racial thought of Volkish writers. Jews were viewed as the sole exception to the rule; they were a distinct race without a native landscape, a homeless, wandering people without roots in a given region. As the Volkish view of the landscape became increasingly rural and romantic in its orientation and the peasant became a Volkish ideal, opposed to the unnatural development of large urban centers and their "uprooted" inhabit- ants, the Jew was identified as an agent of the forces of modernity and urbanization which threatened the bastions of Volkish strength and unity.[85] According to these writers, the Jew, lacking a spiritual bond to the land and its history that the native German had, became the prime enemy in the eyes of many Volkish writers and had to be contained and controlled, if the Volkish battle against modernity was to be won.[86]

If a distinction can be drawn between racial thought, which perceives each individual above all else as a member of a given race, and racism, which expounds the superiority of one race over another and antagonism between races, then it is appropriate to associate Nolde's attitudes regarding race with the former cat- egory which corresponds to the earlier phase of Volkish speculation about racial character. Nolde was undeniably a strong believer in the inviolability of race, but he saw each race as equal and indispensable to the continuation and growth of world culture. "Seen in a broad context," he wrote, "no race may be worse or better than another—before God they are all the same—but they are different, very different, in their stage of development, in their life, in customs, stature, smell and color, and it is certainly not the purpose of nature that they should mix with one another (i.e., interbreed)."[87]

From another perspective, however, in statements like this, Nolde's attitudes toward race seem most suspect. The wording of the above passage is uncomfort- ably close to Adolf Hitler's discussions of the necessities of racial purity in *Mein Kampf:* "Any crossing of two beings not at exactly the same level produces a medium between the level of the two parents. . . . Such mating is contrary to the will of Nature for a higher breeding of all life."[88] Hitler continues beyond Nolde, however, to explain the eventual results of racial intermixing: "Blood mixture and the resultant drop in the racial level is the sole cause of the dying out of old cultures; for men do not perish as a result of lost wars, but by the loss of that force of resistance which is contained only in pure blood."[89] The common source for these attitudes is the Volkish concept of nature as an active, determining force with a "will" of its own that controls and regulates the course of human destiny.

Such a belief on Nolde's part did not, however, preclude contact between various races and peoples. In fact, as we shall see in the next chapter, Nolde gained much insight from his contact with races and peoples very different from his own. He felt an especially strong emotional bond with Asian peasants and South Sea natives he encountered during his 1913–14 journey to New Guinea, believing as he did that these individuals had the same close affinity to their native landscape that he had to his own. He met them as a member of one *Volk* meeting members of another *Volk*. The important consideration here was to retain the essential nature of one's native *Volk* while respecting the nature of the foreign *Volk*.[90]

The great tragedy of the Jewish people, as Nolde saw it, was that they had been forced into a situation where they could no longer retain their identity as a *Volk* and had to adapt themselves to the life and customs of a foreign *Volk*.

> Through their unfortunate settlement in the domain of the Aryan people and their strong participation in their [the Aryans'] native affairs and culture a situation has arisen which is intolerable for both sides.
>
> This is not their fault, with their "state" within so many other states. The Roman decree which led to their final displacement should be rescinded.
>
> Their reunification and the foundation of a Jewish state in a healthy, fertile part of the world might be the greatest, most humanely conciliatory act of the peoples [of the world] and the future.[91]

Nolde may have seen his conflict with Liebermann as a struggle between a German and a Jew who was meddling in affairs of German culture and whose very nature did not allow him to appreciate the essentially Germanic-Christian quality of Nolde's art. His public statements, however, take a slightly different direction. His quarrel with Liebermann centered mainly around what he saw as the latter's attempts to force the style of French Impressionism on young German artists, a style that was not suitable to the German nature.[92]

The most important consequence of the clash with Liebermann and the Berlin art establishment for Nolde was a clarification in his own mind of the purposes of his art. Faced now with a real adversary, an embodiment of all the forces Nolde imagined had opposed the development and successful reception of his art during the previous decade, he finally began to conceive of his art as the expression of a new revolutionary attitude. "I wanted the recognition of the opposing artistic attitude," he wrote, "the division of foreign and German, of what was past and what was to be. I was anxious for the most distinct separation possible. I hoped with my criticism to break the power of Liebermann or at least to weaken it. My action was to be the prelude for our young, German-inspired generation—preparing the way. It was the first decisive step toward a new spiritual order."[93]

As this passage suggests, Nolde began around this time to understand the purpose of his art in terms of a mission: the creation of a new kind of art that would glorify a new spiritual attitude in Germany. It was during this period that

Nolde would come to see his paintings as a manifestation of a "new German art." The nature and demands of this mission would isolate Nolde from many of his fellow artists and from a public that did not understand the intentions of his art, but that isolation was only physical, for Nolde felt himself to be part of a larger spiritual community in his endeavors. In a lengthy passage in his autobiography, he describes his state of mind at this time and his visions of the future.

> Living apart and shy, in ascetic self-denial, brooding and alone—this was my lot. I believe in some respects my comrades experienced the same thing. Our road was a struggle, a struggle for the regional (*das Heimische*), for that which is still slumbering within us, to be awakened by us and newly perceived, a struggle against everything foreign, against the corroded and against all insipid *kitsch*—a proud struggle.
>
> I saw us young artists . . . as though driven by fate set down in a heavy, pregnant atmosphere that one finds before every earth-shattering event. Philosophers and poets created their greatest works; *prophetically* they foretold of war and of new beings in solemn words. We painters, standing on the hot ground in a state of excitement, painted what we saw with young eyes. . . .
>
> We young artists instinctively wanted to give back to German art the Germanic character which it had lost 250 years ago, but in a newly-born form and in full color. I served this cause, barely aware of what I was doing, as if out of an innate sense of duty. And I passionately love the old, pure German art for its austere, stubborn, spiritually perfect beauty, for its phantasy which is so deeply rooted in nature and in the ineffable. A truly inward, heartfelt art once existed and still exists in Germanic areas, in Germany; and practically all non-Germans with their love for sweet, round forms stand speechless and uncomprehending before it.
>
> My joy and my love were reserved for medieval sculpture, Dürer's linear fantasy, the passion and grandeur of Grünewald, the childlike beauty of Cranach, Hans Holbein's great technical ability, Rembrandt's divine humanity, and the work of many more artists, all of them shining like stars in the German heavens.
>
> Oh Germany, in passion and in travail! Germany, a dreamland in poetry, in music, in color. And your youth, they are your best and most beautiful hope for the future.
> It was the time around 1912.[94]

In its ecstatic militant tone and its highly visionary quality, which calls forth an image of the future created from an ideal memory of the German past, Nolde's passage is strongly reminiscent of the style, imagery and emphasis of Langbehn that we find for instance in the following pronouncements from *Rembrandt als Erzieher:*

> The prophet had always been related to the artist; the one perceives, the other creates a total vision from the individual components of an organic mass.
>
> As in the days of the old Germanic league, today in the realm of German art a young, developing superpower stands opposed to an old, declining superpower. Growing stronger, the North demands its right. . . . The *Niederdeutschen* have now taken possession of the inheritance of Arminius.
>
> Goethe, Rembrandt, Luther—this culture . . . is the true salvation of the Germans.
>
> A figure like Rembrandt, at least for Germany, can create a bridge between the fragmented man of today and the total man of the future.
>
> The new spiritual life of the Germans . . . is a matter for the German youth, especially the uncorrupted, un-miseducated, uninhibited German youth.[95]

Furthermore, we could encounter statements of similar tone and emphasis in the writings of Nietzsche, Wagner and other late nineteenth-century figures who sought a reform of German culture based on the ideals of a past age. In this respect, Nolde's attitudes and his intensity of expression reflect and continue the strident militarism which pervades so much of the cultural criticism in Germany during this crucial period of its history.

If there is a work by Nolde of this period which corresponds in its emotion and subject matter to the above passage from his autobiography, it is his *Prophet,* a woodcut of 1912 (Sch. H110, fig. 26). The face, intentionally crude and strong in its depiction, recalls the heavy, deeply carved style of the medieval statues Nolde studied during his apprentice years and admired so much for their intense, expressive power, a quality which is captured in this work. The gaunt cheeks, sunken eyes and tortured facial expression of the prophet suggest the lonely, groping "ascetic self-denial" which Nolde identified as his own state of mind at this time. The *Prophet* woodcut complements the passage from Nolde's autobiography in its emotional expression, but it reveals a greater sense of questioning and uncertainty than we find in Nolde's description. In the woodcut we experience the act of prophecy but are denied a glimpse of the prophetic vision. *Prophet* is perhaps a more honest appraisal of the artist's situation around 1912, for when Nolde discusses this period in his autobiography he is looking back at it from a time over twenty years later, reflecting on the intervening years and the course his art has taken. In 1912 Nolde's vision of the future, at least as expressed in his works dating from this period, was not fully realized. The highly evocative, mystical landscapes which are to be understood as the strongest expression of this vision were not yet a part of Nolde's art.

Nolde was sustained in his battle with the Berlin art establishment and his solitary quest for the creation of a new German art form through the strong emotional bond with his native landscape which he continued to experience and with the great Northern artists of the past whose art, as Nolde saw it, was similarly rooted in the landscape experience. He recorded in his autobiography numerous instances during these years when he retreated to the landscape and a Romantic-Volkish vision of nature to recuperate from emotional exhaustion and worldly conflict and to regenerate his spirit, as he had done many times before. After the weeks of intense mental and physical exertion during which he completed his first religious paintings in 1909, Nolde withdrew to the countryside.

I gazed along the paths and sketched the milk maids with their buckets full, the fence gates, the clouds, the sun and the water in which everything was reflected.

When the sea was calm on mild days, it was incredibly beautiful. But also when the heavy storm clouds appeared. On the flat plains they are the terror of weak spirits and to the strong every time they are an experience in the drama and power of nature.[96]

After an incident at the inaugural dinner for the *Sonderbund* exhibition in Cologne in 1912 when, after daring to criticize Cézanne, Nolde was again ostracized by the art dealers at his table, he fled the room and instinctively sought the landscape.

> I sensed the evening and the lyricism of the landscape, the landscape full of experiences and history. And soon I was again free of prejudice before the works of art in the exhibition, before Van Gogh and Gauguin, Munch and Cézanne, examining, weighing as I did with our fresh, young generation of artists. I walked and walked. My thoughts glided across to the greatest works of past ages—where I always preferred to be—to Grünewald and Rembrandt, the most powerful painters, ending finally with Rembrandt in a chiaroscuro (*Helldunkel*) of joyous ecstasy, with him in whose life a turning point came where people left the great artist alone and isolated as he created his most magnificent pictures, radiant in their glory for eternity.
>
> Since that time it has always been the case that the painters with much intelligence and little artistic talent became the "officials," the rulers and governors. The works of the really great artists first became a part of the consciousness of the *Volk* only after they had died and the silent artists like Runge and Friedrich were quickly forgotten, only to be later revived.[97]

Nolde's description of the landscape experience here as a response not only to the objects within nature, but to the history and lives that the landscape contains as a repository of the past is a classical conception of the Volkish view of the landscape. His extremely personal identification with Rembrandt at this point in his life is evident. Nolde was hoping during this period for a similar turning point where he too would be left alone to create his greatest works.[98] His identification with the Dutch artist was so strong at this time that he traveled to Holland in January of 1911 in the midst of his conflict with Liebermann to experience firsthand the art of Rembrandt and the land which inspired it.

> We journeyed to Holland. I waved to the canals with their gliding boats as they wandered through the flat, green countryside; on either side the marshes with the brightly colored animal life, a land like my own land. I waved in greeting to the mills and they waved back with their sails.
>
> We came to Amsterdam, the city with the canals, where the tiny brick buildings were reflected, oblique and delightful as they leaned against each other. It was Rembrandt that we sought. . . .[99]

Nolde had traveled a great distance in the previous decade in terms of his art; the destination was now in sight and the focus of all the years of struggle was becoming clear to him. After a brief interlude, he would resume his approach toward the spirit of Rembrandt and begin to translate the experiences of *Niederdeutschland* as he describes them in his autobiography into actual paintings.

4

The Experience of the Primitive

The journey to New Guinea of 1913–14 which Nolde, as a member of an official German expedition, undertook along with Ada was more than an interlude for the artist. Although the art of various non-European and primitive cultures which Nolde saw and collected during his travels had little if any formal effect on his art, the experience of these strange and exotic peoples, their primitive mentality and customs, and the landscapes that were such an essential formative factor in these cultures served to reinforce the primitive, intuitive drives the artist felt within himself and the expression of these qualities in his art.

Like so many European artists of his generation, Nolde was strongly attracted to the art of primitive cultures even before his firsthand contact with these cultures. In the years immediately following his expulsion from the Berlin Secession, he frequently visited the ethnological museums in Berlin and Hamburg, sketching objects from the collections. Part of Nolde's interest in the examples of primitive art stemmed from a Romantic fascination with the artistic expression of what he perceived as a purer, more primal state of human existence that was fast disappearing in the face of encroaching European civilization. He was also attracted to the artifacts for their crude, but energetic quality, and in 1912 he began to write an appreciation of primitive art, *Artistic Expression of Primitive Peoples* (*Kunstäusserungen der Naturvölker*) which was never completed beyond the introductory remarks. In the surviving manuscript, Nolde criticizes the art of classical Greece and the Renaissance as no longer valid for his generation.

The ideals of our predecessors are no longer ours. Why is it that we artists love to see the unsophisticated artifacts of the primitives?

It is a sign of our times that every piece of pottery or dress or jewelry, every tool for living has to start with a blueprint. — Primitive people begin making things with their fingers, with material in their hands. Their work expresses the pleasure of making. What we enjoy, probably, is the intense and often grotesque expression of energy, of life. These sentences reach into the present, and perhaps even beyond it.

The fundamental sense of identity, the plastic—colorful—ornamental pleasure shown by "primitives" for their weapons and their objects of sacred or daily uses are surely often more beautiful than the saccharinely tasteful decorations on the objects displayed in the showcases of our salons and in the museums of arts and crafts. There is enough art around that is over-bred, pale and decadent. This may be why young artists have taken their cues from the aborigines.[1]

Significantly, among these "aborigines" Nolde included the medieval German artisans and "the simple, monumental sculptures in the cathedrals of Naumburg, Magdeburg, or Bamberg" which they created.[2]

Nolde was drawn to "the fundamental sense of identity" and the intense, energetic expression in these objects of primitive origin that seemed to him to develop almost from the material of the object itself and the "inner necessity" of the individual who created it, because Nolde himself had sought to cultivate these same qualities in his own art almost from the beginning of his career and his apprenticeship as a wood carver. He felt a profound identification with and inspiration from the artistic expression of any primitive culture, believing that they all exhibited these qualities to some degree.

> Exotic arts—just like the earliest primitive European folk art, masks and ornaments—all of it seemed very close to me. It is marvelous that folk art appears so early in the history of every race, long before many other things—sophistication, vulgar taste, and cheap elegance.
>
> And the primeval power of all primitive people is germinal, is capable of future evolution. Only insipid decadence is perishable.
>
> Everything which is primeval and elemental captures my imagination, the vast raging ocean is still in its elemental state, the wind and the sun, yes the starry sky are more or less what they were 50,000 years ago.[3]

This passage gives us a great deal of insight into the artist's mind and the nature of the affinity Nolde felt for primitive and folk art. The association he makes here between certain qualities inherent in these primitive objects and a primal, elemental state of nature suggests that he perceived these objects as yet another avenue to approach a more general, all-encompassing view of the world— a primitive, mystical vision of natural forces at work within the landscape and within the individual psyche. Between 1912 and 1914, Nolde would pursue this vision by means of an appreciation of primitive art and through the experience of primitive cultures outside Europe. After 1914 he would take a more direct and for him more valid approach, turning to his own native landscape in an attempt to experience it in a primal, elemental state and to give expression to the magical forces which emanated from this region, just as the primitive South Sea islander perceived and reacted to his own landscape.

For the time being, however, Nolde continued to admire the art of all primitive peoples. Because he believed that this art could have a beneficial and inspirational effect not only on himself, but on an entire generation of German (and European) artists, he actively supported efforts to acquire primitive art objects for German art museums before these artifacts and the cultures which created them disappeared entirely from the face of the earth. He wrote letters from New Guinea to museum officials in Germany urging them to increase their acquisitions of primitive art before it was too late.[4]

A similar motivation led Nolde to regret the disappearance of much folk art native to Schleswig-Holstein and to praise the few individuals with insight

and patriotism who collected these artifacts. The culprit in the demise of European folk art was the same as that causing the disappearance of non-European primitive art—industrialization and its corollary, imperialism.[5] In this context Nolde perceived an interesting relationship between the decline in interest and appreciation for the skilled, hand-crafted qualities of folk artifacts and the appearance of a rapidly accelerating decline in the "vital energies" (*Lebensenergien*) of a given family in modern Europe, as though the two phenomena were linked to each other in some causal manner.[6] This is a widely held Volkish attitude—as contact with traditional values is severed, the entire *Volk* and the family units within the *Volk* gradually lose the collective spiritual energy that was contained and circumscribed by these values. From a slightly different, but related focus, this is also the theme of Thomas Mann's *Buddenbrooks* (1901).

With such interests already established as an important inspiration to his own art, Nolde was elated at the opportunity to participate as a pictorial reporter in an expedition to German New Guinea sponsored by the German Colonial Ministry. The major purpose of the "medical-demographic German–New Guinea expedition," as it was officially known, was to study and diagnose the health conditions in the German colonies in that part of the world. In addition to Nolde and Ada, the other members of the party were two physicians and a trained nurse.

The group departed Berlin on October 2, 1913, traveling across Russia and Siberia by rail to Manchuria. From there, the party journeyed down into Korea and sailed across to Japan where they spent three weeks. Sailing back across the China Sea to the Asian continent, the party visited several cities in China before departing Hong Kong for Manila, the Palau Islands, finally arriving at their destination, New Guinea and New Ireland (the former German colonies, Kaiser-Wilhelm-Land and Neu-Mecklenburg).[7]

Nolde began sketching the inhabitants of the countryside through which the group traveled from the time they entered Russia. In the rail stations at Siberia, he studied the Russian peasants as they huddled together in the cold winter air awaiting local trains. Nolde sent these sketches of the first part of his journey back to Germany and upon his return he worked these studies into finished oil paintings. As one might expect, Nolde felt an empathy with these people and their bitter struggle with the rugged environment which they met with characteristic peasant stoicism. Like his native Schleswig, the expansive Siberian plains were to Nolde virgin land (*Urboden*), untainted by modernization and industrialization, in appearance and climate still much the same as they had been for centuries. The lives of the peasants of this region were still closely linked to this vast, barren *Urboden*.[8]

One of these paintings of Russian peasants, *Shivering Russians* (1914), depicts two huddled figures wrapped in heavy garments and straining against the wind. Only their large heads are uncovered, and their heavy features are set in a painful grimace. With the exception of his religious paintings, this expression of suffering is rare in Nolde's art, as is the compassion evident on the part of

the artist for these two creatures. Another of these paintings, *Three Russians* (1915, fig. 27), is a study of the Russian peasant character. The heavily painted features of the faces which stare boldly out at the viewer suggest that Nolde is also attempting to convey the physiognomy of a specific racial or regional type. The strength of character, however, predominates as the major quality of the figures portrayed. The heavy, dark-skinned, square faces of the two men are images of brute strength and conviction molded by generations of struggle against a hostile environment. In contrast to the men is the face of the woman on the right whose bony, emaciated features and eyes which do not meet ours convey a sense of silent resignation. If we compare this portrait of Russian peasants with a similar depiction of European peasants by Nolde (fig. 13), the directness with which these figures confront us is striking. It would appear for whatever reason that Nolde felt able to meet these members of a *Volk* completely separate in customs and history from his own *Volk* on a more candid basis without experiencing the suspicion and secrecy which surround the Danish peasants. There is no indication that Nolde is observing these peasants with any feeling of superiority. If anything, the dignity he imparts to the individuals betrays a sense of admiration for their strong, untainted character.

Nolde's watercolor sketches of the natives of New Guinea are equally impressive. Most of the figure studies are sensitive sketches of individual heads. The area of New Guinea and the smaller islands to the east of it where Nolde completed these sketches includes at least two major geographical races, Micronesian and Melanesian, among its native populations, and the distinguishing characteristics of a specific race are often evident in Nolde's watercolor sketches. There is little indication that Nolde intended these sketches to be solely studies of the distinctive facial features of a given race or that he was even aware of the variety of geographical races within the New Guinea *Volk*. The major purpose of these sketches for Nolde seems to have been to record the appearance of the specific individual he was sketching as a proud member of a vanishing race. In fact, Nolde was overjoyed when the portraitlike nature of these sketches was finally appreciated. Several years after returning to Europe, the Colonial Ministry decided to purchase fifty of these sketches and the former governor of New Guinea, now back in Germany, was on hand to assist in the selection. Nolde had met him in New Guinea and believed at the time that the governor had little interest in what the artist was doing. It was with some amazement that Nolde watched the former governor react to the studies as he leafed through them, "Yes, I know that man." "This one lives on that island."[9]

As with the sketches of Russian peasants, several of the New Guinea studies were the basis for finished oil paintings. One such painting, *New Guinea Savages* (1915), repeats the composition of *Three Russians*. Three dark heads dominate the canvas, peering out at us with wild, excited eyes. The whiteness of the natives' eyes and teeth is enhanced by the dark brown of their skin and the dark blue background against which they are placed. Nolde described his first en-

counter with the inhabitants of the smaller islands occurring as a group of enslaved cannibals were brought aboard his ship. "When one of them looked at me out of the corner of his eye, it was eerie; and when they stared directly at me, it was as wild and hostile as the stare of a black panther or leopard."[10] The wild, primitive quality of this initial experience is still evident in the oil painting completed in Germany. Unlike the related painting of Russian peasants, the heads of the natives in this work seem to sway slightly to one side or the other, bristling with energy and moving in accordance to some unperceived rhythm.

Another of the New Guinea oil paintings, *New Guinea Family* (1915) depicts three natives, a man, a woman and an infant, seated before a traditional hut. The male figure with a huge, fierce, masklike head moves his arms wildly in a gesture that may be interpreted as protective. Nolde captures in this work the social unit common to every *Volk*—the family—in its most basic, primitive state.

While in New Guinea, Nolde also sketched scenes of the landscape in colored chalks. Many of these sketches adhere quite closely to the actual scenery of the islands, but some are quite imaginative and expressive in their transformation of native vegetation into lush, primeval gardens. In one of these sketches, for example, Nolde depicts a group of huge, yellow single-leafed plant forms bursting from the soil in the lower left and a bush with gigantic, magenta blossoms on the right before a brightly colored, stormy sky. The sketch captures the supernatural quality of a primeval landscape with its *Urpflanzen* animated by unseen forces of nature.

In *Tropical Sunrise* (1914, fig. 28), a finished oil painting related to the South Sea sketches, the sun, a glowing, red orb, rises through almost palpable clouds above the seething ocean. Painted in large areas of pure white, green and red, the heavy, pulsating forms of the clouds and waves translate into an expression of primal forces set in motion by the huge, central sun. In subject matter this painting continues the theme of a rising sun which runs through Nolde's work from his earliest paintings (fig. 4) to his late watercolors (fig. 50). If we compare *Tropical Sunrise* with the small watercolor *Sunrise* from 1894 or with other early landscapes by Nolde (fig. 9), we perceive a greater sense of turbulent movement in the painting of 1914 conveyed through the irregular massing of the color areas and the juxtaposition of complementary colors of intense reds and greens. The symmetry of the earlier sunrise composition is abandoned here in favor of a more intuitive ordering of the elements to capture the chaos of a primitive, untamed landscape. By the time of the 1914 painting, Nolde exhibits the ability to express his tremendous empathy with nature and its elemental forces in terms of powerful, energetic abstractions of colors and forms. Recalling Nolde's admitted fascination for elemental, chaotic scenes, the viewer can almost believe he is experiencing a vision of the first days of creation.

The months in New Guinea and the entire journey for that matter were a remarkable experience for Nolde and remained one of his fondest memories throughout his life. Even in New Guinea, however, the artist was aware that the

Urnatur, the primitive state of existence, which he perceived was already an illusion, or soon to be one. Nolde believed the colonization of these areas and the encroachment of Western civilization were fast destroying the original, untainted nature of the landscape and its native inhabitants. Throughout the third volume of his autobiography, Nolde is critical of the methods and effects of European colonization.[11] In a March 1914 letter to Hans Fehr, Nolde wrote:

> With touching devotion, with the best intentions and awareness and with modest success at first, the pious white man seeks by missionary means to weaken and finally to bury the pagan customs, the integrity and the will of these primitive people. He works with the energy of a mild fanatic until one innocent victim after another docilely submits to him. . . .
>
> The undermining and zealous cultural annihilation of weaker peoples is painful to experience first-hand. . . .
>
> We live in an age where whole wilderness regions and primitive peoples are being ruined; everything is being discovered and europeanized. Not even one small piece of primitive wilderness with its native inhabitants will remain for future generations. In twenty years everything will be lost. . . .
>
> These primitive people *within* their natural surroundings, are one with it and a part of the great unity of being. At times I have the feeling that they are the only real humans, that we are some sort of overeducated mannequins, artificial and filled with dark longings.
>
> I paint and sketch and seek to capture some sense of this primitive state of being.[12]

Nolde viewed the demise of this primitive culture with more than just nostalgic regret. The indignation one senses in this letter did not arise only out of a liberal, humanitarian revulsion to one race destroying another. With the final destruction of these primitive cultures, Nolde believed, an aspect of human nature would disappear that was of vital importance not only to the members of this primitive culture, but to all of mankind.

Nolde explains this in a passage recounting the departure by ship for the return trip to Europe. On board were several European plantation owners who had lived in the Orient for many years and who told many tales of their encounters with wild animals and other gruesome occurrences. "We heard these stories as if they were calls from the primitive wilderness," Nolde wrote, "and measured against this, how boring was the life in our own well-kept, proper homes, ordered down to the smallest detail—Is this the reason why revolutions and wars must continually arise, uprooting and destroying? Then how horrible it will be when all the wilderness areas have been cleared away and whole continents and races must battle and murder each other—just so something is happening."[13]

Nolde captures in this passage a clear expression of the pre-1914 mentality of so many Europeans, languishing in their own affluence and political stability and desperately longing for something, anything to break the mood of boredom. But the necessity of wilderness to the entire human race which Nolde emphasizes here is a belief whose roots extend back beyond the immediate pre-War years. In fact, this idea was one of the major points espoused by Riehl in his *Land und Leute* (1853), which influenced so many later Volkish writers. Most of the first

chapter of Riehl's book dealt with what he felt to be the immense importance of maintaining large areas of forest as wilderness regions within Germany to function as a source of renewal and revival of vital social forces. Without wilderness accessible to large populations, society would soon crumble as its strength gave in.[14]

Riehl is somewhat unclear about why this contact with the wilderness is necessary for mankind, but Nolde is more conscious of its effect on him and his generation. His awareness of an intuitive, spontaneous, precognitive state within his own psyche led him to recognize this primitive mentality as an essential component of human nature and caused him to view the primitive wilderness and primitive cultures as necessary external manifestations of this inner drive, as the stimuli to bring this aspect of the psyche to full expression. Nolde wrote that as a man and an artist he felt the need to experience the entire range of human existence from the primitive state of the island native, to the simple, earth-bound ways of the peasant, to the busy, hurried, all-consuming life of the city dweller and finally to the end of the cycle in decadence and destruction. "Working in and among this tumult [of experience], I felt at times as though I was spiritually engulfed in it, but always able to stand apart from it. With the South Sea journey, I believed that I had successfully experienced the first, primal state."[15]

Nolde's recognition of a spiritual bond to this primal state was as necessary to his artistic existence as the close union he felt with his homeland. When the roots to this inner state were broken, the spiritual life of the individual would wither just as it would if the roots to his native region were severed. Peter Selz has noted, "He [Nolde] hoped . . . that by absorbing some of the culture of the islanders, he would be able to approach the mystic sources of art and recapture what Jung would call a 'racial memory.'"[16] In fact, C. G. Jung would write in his introduction to *Symbols of Transformation*, first published in 1912, in curiously Volkish terms, "the man who thinks he can live without myth, or outside it, is the exception. He is like one uprooted, having no true link either with the past, or with the ancestral life which continues within him, or yet with contemporary . . . human society. . . . The psyche is not of today, its ancestry goes back millions of years. Individual consciousness is only the flower and the fruit of a season, sprung from the perennial rhyzome beneath the earth. . . ."[17] Jung's emphasis in this passage on the psychological necessity of myth actually restates Nietzsche's premises of his *Birth of Tragedy*, but the imagery of vegetal growth and the description of a collective psyche as a "perennial rhyzome" recall the Volkish conception of individual and racial character. This is not meant to suggest that Jung had any direct connection with the Volkish movement; nonetheless Jung's phrasing illustrates how much Volkish imagery had permeated the vocabulary of even the most advanced German intellects of the period by 1912.

This myth-making capacity and the ability to integrate it into the psyche of the individual as a vital part of his daily life are what fascinated Nolde about

the primitive cultures he encountered during his journey and what he himself sought to cultivate in his own personality and art through a mystical experience of his homeland and all the mythical elements it contained. Concluding his narration of the South Sea journey, he wrote, "In all countries and all levels of cultural development, religions and ages, men seek, groping, the supernatural-divine, the highest exalted above all else."[18]

Nolde and Ada departed Pinang (Malaysia) by ship for the return trip to Germany in June of 1914. Docking at Aden after crossing the Indian Ocean, they first heard news of the assassination of Archduke Ferdinand. Sailing up the Red Sea, the news that war had been declared reached them as the ship neared Suez. After crossing the Mediterranean, the ship traveled to Marseilles where Emil and Ada were disembarked. They sailed back to Genoa and then traveled by rail through Switzerland to Germany. The couple spent a few days in Munich with friends and in Halle with the Fehrs. By late summer, they were back on Alsen.

5

A Prophet in His Own Land

Nolde and his wife had left Germany for New Guinea in the wake of the personal and professional conflicts that had engaged the artist for several years. They returned the following year to a Germany at war with most of Western Europe, embroiled in a national conflict which overshadowed Nolde's own situation during those years. Looking back at the causes of the war, Nolde recognized that the rapid industrial development in Germany during the preceding fifty years had led to a preoccupation with material concerns, a major factor in leading his country into war. "These need not be the goals of today," he later wrote.[1] Despite his suspicion of the motives of Germany's statesmen in engaging the country in war, Nolde remained anxious about the eventual defeat of Germany, fearing that this outcome would destroy what little of Germany's great cultural and spiritual heritage had survived the decades of rampant materialism.

The artist himself was too old for military service, but many of his younger friends and artists were killed in battle—August Macke, Franz Marc ("We were shattered, for we loved him in his animals. His place remained empty.") and many others.[2]

Nolde and Ada lived in the small fisherman's hut on Alsen until 1916 when they moved across the province to the small village of Utenwarf near the artist's birthplace. Although they would continue to spend the winters in Berlin for another twenty-five years, for the remainder of the artist's life his time in Schleswig-Holstein would be spent in and around this region in the northeast corner of the province. The majority of his oil paintings and watercolors of this last period of his life would be painted in this setting.[3]

After his expulsion from the Berlin Secession, Nolde retired almost completely from public life, no longer choosing to participate in the activities of the Berlin art world. In his autobiography he records the approaches of several writers and art critics in the years 1912–13 and later, and his rejection of their requests to write articles about his art or reproduce his paintings in their journals.[4] What Nolde felt he required during these years were the solitude and isolation of his studio in Schleswig-Holstein, undisturbed by the outside world, to be alone with himself and his art, to create the "great, solemn subjects" that he

sensed were immanent.[5] He reserved his art and his presence for only a few close friends and admirers. The mission of his art—in which he still believed fervently—would be a lonely one. His prophecy would be a solitary vision, meant for his close circle of friends and for the future generations to which it was directed.

The years following his return from New Guinea were an extremely productive period for Nolde. He did much sketching and studying of the animal and plant life and the clouds and other natural phenomena around Utenwarf. He had rediscovered his fascination with the watercolor technique during the New Guinea journey, and once back in Schleswig-Holstein he continued working in this medium. Nolde painted subjects other than landscapes or landscape-related scenes in the period from 1915 through the 1930s, but the majority of his paintings during these years dealt very closely with the landscape of North Schleswig. This chapter will concentrate almost entirely on those works. It was in these evocative landscapes in oil or watercolor that the many tendencies and ideas that surfaced periodically in Nolde's earlier paintings—the striving for a new form of expression and a "strong, German art" of the future, the inspiration of Rembrandt, and finally the artist's intensely felt mystical bond with his native landscape—would reach fruition. In this respect, these landscapes are the climax of Nolde's artistic development.

Inspired in part by the South Sea experiences and the bond he perceived between the natives and their landscape, Nolde sought to renew contact with his own homeland during the war years, to re-experience and strengthen the bond between his inner being and the soil which nurtured it. "When elemental closeness in romantic, fantastic, free creativity seemed to shrink from my grasp, I stood again before nature searching, sinking roots into the earth, humble, absorbed in seeing, gathering in with my eyes and then returning [it] with my eyes. . . ."[6]

This process of "sinking roots into the earth" gave Nolde the inspiration for the major landscapes he painted during the war years. The first of these important landscapes, *Marsh Landscape: Evening* (fig. 3), an oil painting of 1916, is a remarkable example of evocative color and vision. In this painting there is a strong sense of fluidity and movement, even rhythm, in the meandering line of the stream in the center and the more agitated areas of clouds above and water below linked by the stream. This is a new, expressive conception of an active, turbulent nature that is not found to any great extent in Nolde's early landscapes. The broad plains of lush green marsh and the sulphur-yellow sky have relatively undefined edges, and the grey areas above and below are equally rough in execution. For all its specificity of location, that is, the marshland around Utenwarf, the summary lack of detail in *Marsh Landscape* or of any human form to provide the viewer with secure references to the world of everyday experience and visual reality has the effect of evoking a scene from another time and place, perhaps another world. In fact, the great flowing, seething masses

and intense, unnatural colors suggest a scene of primal genesis before any inter-
ference by the hand of man. This painting captures the experience of natural
forces at work in all regions of the landscape as effectively as the earlier tropical
landscapes painted by Nolde (fig. 28). In its emotional effect it gives full expres-
sion to the notion of a primitive, emotional bond between man and nature.

These qualities become all the more evident if we compare *Marsh Landscape*
with a painting by Caspar David Friedrich from around 1832. *Large Enclosure
near Dresden* (fig. 29), a painting Nolde may have known from his brief stay
in Dresden, is almost identical in composition. Using virtually the same elements
of marshy area, water and sky, Friedrich's scene makes a totally different emo-
tional statement. The precision of the representation and details of trees, and the
small boat provide the viewer with a ready set of references for placing this
scene within the real world, even if those references are then turned back on
him as the perspective is distorted to produce a great swelling curvature of the
earth. The effect of this curvature and the sweeping curves of the water and
clouds is to place our point of view several feet off the ground and create a sense
of exhilaration as we are pulled into the picture space and back to the horizon.
We are presented with the real and familiar world and then immediately over-
whelmed by it.[7]

Nolde's world overwhelms in a different manner. The viewer is not drawn
into the space, but confronted by it. The color areas create no sense of comforting
three-dimensional space, but burst out from the canvas with force. Nature in
this painting lacks the seductive transcendence of Friedrich's presentation of
Romantic nature. It seems almost actively to seek out the viewer and force itself
and its "rhythms" on him.

The title the artist gave to this painting is *Abendstimmung (Evening Mood)*.
Nolde uses the term *"Stimmung"* often in his autobiography when discussing his
relationship with his native landscape and its effect on him. From the context
of these descriptive passages it is evident that Nolde intends the term to connote
more than the Romantic concept of "mood" within the landscape, emotional
response evoked within the observer by a particular visual quality of nature.
Rather Nolde uses the term to suggest this more active side of nature that we
encounter in *Marsh Landscape. Stimmung* in the landscape seems to be a man-
ifestation of something within nature, an emanation from beneath it.[8]

The concept of a "Postromantic" landscape that actively exerted its forces
upon its inhabitants was an important development in later Volkish views of the
landscape. In an article entitled, "Landscape and Soul," the Volkish writer Otto
Gmelin described the process by which these natural forces were transferred into
the soul of the inhabitant as a "mutual continual give and take" in which the
soul imprints the landscape with a sense of unity, but at the same time receives
from the landscape an impression of its own "natural rhythm." These rhythms
are active, "aspiring" forces, according to Gmelin.[9] Although Nolde never uses
the term rhythm in discussing his landscape, the active, rhythmic quality of his

later landscapes would suggest that he understood these natural forces of the landscape in a manner similar to Gmelin.

Gmelin was not the only Volkish writer to use the term rhythm in discussing this mythical exchange between the landscape and its inhabitants. Langbehn also refers to a certain "inner rhythm" that enters into this process, although he associates this quality with the human element in the exchange rather than the natural element which he characterizes as exhibiting an "inner symmetry." He associates the quality of symmetry with the realm of mysticism. Langbehn's thought pattern in this section is very difficult to follow (as it is in many sections of the Rembrandt book), but he seems to be implying in this passage that nature per se is a cold and objective concept and becomes complete or fulfilled only when merged with the human element (i.e., an observer) and its mystical longings. The idea of a synthesis of opposite tendencies is central to Langbehn's thinking here, as it is elsewhere, but in this case Langbehn sees the synthesis progressing toward a specific goal: "All life however moves steadily in a direction away from symmetry and toward the rhythmical."[10]

Arcane as these observations by Langbehn are, they may provide insight into a new perceptual development among certain Germans of Langbehn's generation and the succeeding generation. It pertained to a movement away from a mysticism that was basically symmetrical and precise in its expression (certain paintings by Friedrich and Runge, for example) toward a mysticism that was more formless, chaotic and "rhythmic" in its expression (the landscapes of Nolde, as well as certain paintings by Marc and Kandinsky) and much less "precise" in its message than earlier examples. Langbehn's association of the properties of logic and rationality with the concept of symmetry does not, however, work satisfactorily when analyzing paintings by Friedrich. The calculated symmetry in these paintings has an effect on the viewer which proceeds far beyond the boundaries of logical perception.

Marsh Landscape establishes many of the visual qualities and the mystical, rhythmic emphasis that Nolde would adapt in later landscapes. Another major landscape of the war years, *Landscape with Young Horses* (fig. 30), also of 1916, introduces further elements of the expressive vocabulary that Nolde would continue to employ. This painting, which may have been completed before *Marsh Landscape,* was one of the last works finished by Nolde on Alsen before the move to Utenwarf. The landscape depicted is one of the lush green meadows of the large island. In the lower left corner, two horses stand in the meadow as the only evidence of animal life in the vast panorama, but they are not necessarily the only animate objects in the landscape. Above them, in the sky which takes up two-thirds of the canvas, looms a huge cloud formation "like great, dark fingers reaching across the heavens, throwing their shadows into the distance."[11] Although the colors in the *Landscape with Young Horses* are more naturalistic than the colors of *Marsh Landscape,* the intense greens of the meadow and the contrast of dark grey and an almost incandescent white in the clouds enhance

still further this sense of a manifest supernatural energy. The horses perk up their ears, as if in reaction to this phenomenon. They represent a state of being which has an even closer affinity to nature and its forces than the human inhabitants of the landscape.

The dynamic conception of the landscape which is such an important quality in these two 1916 Nolde paintings corresponds to the treatment of landscape imagery in the poems of two early Expressionist poets, Georg Heym and Georg Trakl. In fact, Karl Ludwig Schneider has theorized that this "dynamization of the landscape image" in the works of Heym and Trakl was a major factor in the development of the new Expressionist style which broke so effectively with the lyrical styles of nineteenth-century German poetry.[12] Especially in the poetry of Heym from the years 1909 through 1911, this "dynamization" is achieved through the use of clouds, notably the movement of clouds, as a central motif. In these poems, the emphasis on the unusual lighting effects caused by the clouds and on the remarkable, strange transformations of the cloud forms themselves serves to transport the emotional quality of the work beyond the natural empathy of Romantic lyric poetry into a new realm of expressive style. In poems like "Den Wolken I" ("Clouds I") and "Den Wolken II" ("Clouds II") of 1909, the cloud forms become animate objects in their own right as personifications of apocalyptic riders and warriors.[13]

This close connection between Nolde's interpretation of natural elements within his landscapes and Heym's similar use of these elements as metaphors in his poems should indicate in one respect how strongly the artist participated in the artistic climate of the Expressionist generation. Despite his solitary nature, Nolde did have a certain affinity with many of the young artists and writers of his day in his aspirations and in his vision of a new art form. To that degree he was justified in seeing himself and his art as a part, however isolated, of a greater community of artists who were seeking to break with the past and create a new art for the future.

There is one other literary precedent for the symbolic use of cloud forms we encounter in Nolde's *Landscape with Young Horses* that is chronologically more distant from Nolde's painting than Heym's poetry but worth mentioning in this context. In his poem, "The Golden Horns" (1802), the Danish Romantic poet Adam Oehlenschläger conjures up a vision of dynamic nature complete with rolling clouds that is analogous in its emotional tenor and natural imagery to Nolde's landscape. The third stanza of the poem reads:

> Night hurries
> In cloudy flurries;
> Tumuli waken,
> The rose is shaken,
> A voice through the skies
> Profoundly sighs.
> Over the storms
> The gods arise,
> War-crimsoned forms,
> Star-flashing eyes.[14]

The gods referred to in this stanza are the ancient Norse gods who arise in the modern era in the course of the poem to grant mankind a second vision of the heroic splendor of the ancient days and thus turn the tide of the present age away from a narrow secularism and toward the mythical imagination of the Nordic spirit. Nolde himself was not disinclined to such an orientation; on more than one occasion he mentions specifically the inspiration of Nordic mythology in his art.[15] It is uncertain whether Nolde knew of Oehlenschläger or of this poem in particular, but the poem is in itself an interesting vision of a landscape energized by natural and supernatural forces in a manner similar to Nolde's landscape. As an important contribution to the Danish cultural heritage that had some impact on the regional culture of Schleswig-Holstein, the poem is at least an interesting coincidence. We will return later in this chapter to an examination of cloud motifs in Nolde's landscape in a somewhat broader context and some of the points made here will be amplified at that time.

In many of Nolde's landscapes painted in the 1920s and 1930s, we encounter evidence of a renewed inspiration of the figure of Rembrandt and the spirit of his art. As is so often the case with Nolde, this inspiration of Rembrandt seems to be influenced by Langbehn's conception of the Dutch artist and by other ideas found in *Rembrandt als Erzieher*. Specifically, certain landscapes by Nolde of this period seem related to Langbehn's interpretation of the Schleswig-Holstein landscape as an embodiment of Rembrandtesque qualities. As we have seen, Langbehn's special understanding of Schleswig-Holstein played a central role in his vision of a revitalization of the German artist. Because of its geographical connection to Holland as part of the greater *Niederdeutschland* which included both regions, because of its unique contribution to German history and because of its intimate connection to Rembrandt and his students, Langbehn believed Schleswig-Holstein would have a special destiny in Germany's cultural future. It would be a "New Holland" that would nurture the spiritual rebirth of the German *Volk* and bring forth a new "Rembrandt" to give full expression to the life of the new age.[16]

This image of Schleswig-Holstein had a profound impact on the many young Germans who read and discussed the Rembrandt book, especially on Nolde who saw himself a native son of this region. If he felt a certain pride and attachment to his native land before his acquaintance with Langbehn's book, these feelings would have been greatly strengthened by his contact with Langbehn's ideas and given an entirely new focus and direction as Nolde began to see his homeland as the prophesied birthplace of a new German art.

In this context it is not unwarranted to interpret certain of Nolde's landscapes like *Landscape, Hallig Hooge* (fig. 31), one of several watercolor sketches of the small islands near the coast of North Schleswig completed by the artist in 1919, or the related watercolor, *Windmills* (fig. 32), as images of a "new Holland." The associations with Holland in these watercolors are, on one level,

metaphorical, that is, the sketches establish elements of the landscape that are common to both regions—the broad plains, the canals and seashore, the boats, bridges and windmills—but these two works also suggest a reference to the seventeenth-century Dutch landscape tradition as embodied in the art of Rembrandt. If we compare these watercolors with a sepia sketch by Rembrandt from 1654–55 of a canal and towpath (fig. 33), we find many of the same visual qualities in all three works—a quick, heavy line which captures the objects depicted in a very abbreviated form, a fluidity of line and a strongly horizontal format. The deep blues and greens of Nolde's watercolors, lighted by touches of white or gold, add a sense of emotional intensity to these sketches that is lacking in the monochromatic Rembrandt sketch. In this manner, Nolde is able to enhance the visionary qualities inherent in Rembrandt's style.

An even more striking example of the direct influence of the art of Rembrandt on Nolde's paintings can be found in an oil painting of 1924, entitled *Windmill* (fig. 34). The composition of this painting suggests a 1641 etching by Rembrandt, *The Windmill* (fig. 35), as its source. Nolde seems to have been familiar with this particular Rembrandt etching for many years, because two of his lithographs of 1907, *Windmill* (Sch. L22) and *Great Windmill* (Sch. L23), appear to be almost free copies of the etching. In the oil painting of 1924, Nolde has taken the main elements of Rembrandt's etching, the large looming windmill and the cottage beside it, and rearranged them slightly in reversing the composition.[17] The horizon line is higher in Nolde's painting, and the canal which is barely evident in the lower right corner of Rembrandt's depiction is now very prominent. The large blank area of sky in Rembrandt's work is filled with looming cloud forms in the oil painting. Nolde's use of color, however, is the major innovation. He abandons the minute detail of Rembrandt's etching in favor of large flat areas of color applied in thin washes that allow the weave of the heavy sailcloth to show through and enhance the roughness of execution. Dark areas of muted green, blue and lavender are set off by the intense white of the mill and the glowing orange areas in the cloud and the cloud's reflection and in the cottage and path. The swelling curves of the canal and the cloud above it oppose the massive black form of the upper section of the windmill and its vanes. These elements combine to create a monumental, timeless expression of mystery and dark force.

Still, from the evidence in this oil painting and the two watercolors, it would seem that Nolde was at least thinking of Holland on occasions when he looked at his native Schleswig-Holstein, if he was not observing it almost directly through the eyes of Rembrandt. In these paintings Nolde is giving expression to the experience of his journey through Holland in 1911 and his recognition of that countryside with its canals, windmills and broad plains as "a land like my land."

At this point in the discussion of Nolde's landscapes as attempts to capture the mysterious essence of his native region and to interpret this landscape as a

"new Holland" and the new spiritual center of *Niederdeutschland,* another factor must be mentioned and considered. After the defeat of Germany in World War I, Denmark renewed its claim to the region of North Schleswig at the Versailles conference, insisting that Germany be forced to carry out the agreements of the Prague Peace accord of 1866 stipulating that a referendum be held to determine the political allegiance of North Schleswig. The Allies agreed to Denmark's demand, and provisions for a referendum were written into the peace treaty.

The referendum took place in two zones in February and March of 1920. The residents of the first zone, which encompassed the northwest sector of North Schleswig and Nolde's birthplace, voted for incorporation into the Danish state. The second zone, the southeast sector of the region around Flensburg, voted to remain within the German state. A new border was created in July 1920, and North Schleswig was a divided land for the first time in its history.[18] Nolde was one of 30,000 residents of German descent and allegiance in the area now under Danish rule. He and Ada decided to remain at Utenwarf and Nolde took the Danish citizenship he kept until his death.[19]

In doing so, the artist chose allegiance to his homeland over allegiance to the German political state, but he was by no means at ease with this decision or with the political division of his homeland. In 1921, he completed an oil painting in which Adam and Eve are shown crouching on either side of the Tree of Knowledge. They stare out at the viewer with faces full of pain and despair. Nolde titled the work *Paradise Lost.* If the personal meaning of this painting is not obvious in the work itself, a passage in Nolde's autobiography describing the many hours he spent at Utenwarf during the war years observing the natural beauties of that region provides additional insight. "These were quiet magical hours, youthful and carefree, at peace with one's own self, at peace with the world and peace on earth—O, God, if it had only been so," he wrote. At the end of the long descriptive passage, Nolde wrote, "If you ever paint Paradise, remember these hours here, which you experienced so pleasantly."[20] After 1920, that paradise was no longer intact for Nolde. The magical hours were, at least in one respect, a memory.

Nolde's own emotional ties to his homeland were founded not only on his experience of the landscape as he saw it before him, but also on his realization of the timeless nature of what he perceived and an appreciation of the generations of family history contained within this landscape. In this respect, he took a special interest in the manmade elements of the region, the farmhouses and windmills built in a manner long established by tradition, standing as they had for centuries, for so long that they had become an integral part of the landscape and its character.[21] What he perceived and experienced as he wandered through his native region had been perceived and experienced in much the same way by his father and by many before him.

After 1920 all this began to change and rather rapidly. In the years immediately following the annexation of much of North Schleswig, the Danish

government began to develop the land in this region. To increase the amount of arable land in this area, Danish authorities embarked on large-scale projects to drain the low-lying marshlands. Many of the old mills and farmhouses were torn down in this process and replaced by more modern structures. The plant and animal life of the marshlands were also altered irrevocably by the drainage projects. Nolde, as one might expect, was greatly disturbed by these changes and the methods by which the results were achieved. "And where are the mills, the bridges, the sluices, the canals, the boats?" he wrote later. "Replaced by toll houses, pumping stations and obstructing dikes. Coming generations will soon know nothing of the lost beauty. The most unusual, perhaps the most beautiful region in the sacred German empire has been divided, torn up and lost—the work of engineers and men foreign to the country and of the injustice of a border."[22] He even conceived and planned a drainage project on his own which he felt would better retain more of the original character and natural beauty of the marshlands, but it was not accepted by the local authorities.[23] What upset him even more, however, was the complacency with which the marsh inhabitants and farmers accepted these changes. As he complained in a letter to Hans Fehr of September 10, 1925. "Probably the residents and the farmers are hardly aware of the ideal values and the beauty of their native landscape and that is not to be expected, but that he so completely misunderstands his economic position in this case and collaborates, undermining his existence and that of his children, that is very regrettable."[24]

Shortly after this letter was written, Ada and Emil began to look for another place of residence on the German side of the border. They found a location still within sight of Utenwarf in an area that was as yet unaffected by the drainage projects. They named the site Seebüll and had a house built there to Nolde's design. In the spring of 1927, the structure was complete and the couple moved from Utenwarf.[25]

The transformation of his homeland undoubtedly had a profound and painful effect on Nolde, but in his statements and indeed in his paintings he remained undaunted in his vision and took comfort in the larger considerations of his art. "Seen in a larger context," he wrote, "these disagreements [i.e., the changes in the landscape] are perhaps only unfortunate errors in [the perception of] beauty and much more important than seeking opposition is the discovery and cultivation of communal element: the common bond between peoples. . . . In regard to my art it has been said that it should play a mediating role in Northern Europe."[26] Still, the changes in his homeland in the 1920s provided Nolde an additional motivation to give expression to the spiritual essence and natural beauty of his native landscape. As he continued to search for means to formulate his vision of North Schleswig as a repository of German spirituality and a vital force within the greater *Niederdeutschland,* he had to be aware that the landscape which nurtured this spirituality and linked this region with Rembrandt's Holland was being swiftly transformed. His new art would be even more important for the future generations who would not know the source of his vision as he had known it.

As has been noted in the course of this examination, a central tenet of the Volkish understanding of the regional landscape and of the bond between that landscape and its inhabitants was the assumption that some beneficial exchange of properties, a sort of symbiosis, took place between nature and the individual. Nolde, for his part, subscribed to this belief and described the process as "the exchange of the spiritual with the simple-natural."[27] Implicit in this assumption is the view of nature as a living entity emanating "life forces" from one sphere of nature to another and to the individuals who inhabited the landscape. The quality of dynamism which we have already encountered in Nolde's landscapes was anticipated in this Volkish view of the landscape as a cosmic arena, receiving "life forces" from the heavens, storing them beneath the soil and then transferring them to the elements, including man, that were rooted to it. Within this scheme, the role of the peasant as most complete embodiment of the *Volk,* inexorably linked to the soil, was seen as that of a spiritual intermediary, participating in the dynamic exchange by drawing "life forces" from one realm and transmitting them to the other realm through his aspirations.[28] Some Volkish writers did admit that the peasant was probably not conscious of this function, but Langbehn for one saw "the genuine artist" as just such a "conduit" of natural forces. Nolde's own description of the stars, the moon, "a glowing fire in the center of the earth" and their effect on him is a modified expression of this spiritual interaction.[29]

What is important in the present discussion is this image of an element within the landscape providing a link between the forces of the earth and the heavens. In several of Nolde's landscapes that image furnished the artist with a formula to express the spiritual qualities of his native landscape. In two of these landscapes, *Sultry Evening* (1930, fig. 36) and *Northern Windmill* (1932, fig. 37), Nolde presents a landscape with a storm sky in which the areas of sky and earth are visually linked by strongly ascending forms in the right half of the canvas—flowers in *Sultry Evening* and the windmill in the other painting, which is a refined variation of the 1924 *Windmill.* The intense reds, oranges and yellows and the strong contrasts of the active clouds are repeated or reflected in the earthly realm below—in the Frisian farmhouse in *Sultry Evening* and in the body of water in *Northern Windmill,* which seems to smolder within the flamelike reflection. In *Sultry Evening,* the outline of the farmhouse recurs in the cloud bank above it as if conforming its shape to the elements of the realm below in accordance with some unseen law of nature. All of this suggests the exchange of certain qualities, that is, spiritual forces, between the two zones of heaven and earth. Like the peasant in the Volkish view of nature, the flowers and the windmill seem to facilitate this exchange and participate in it as integral parts of the scheme.

Moreover, these objects, the windmill and the flowers, exhibit a close and literal bond to the soil, a bond acting on the native peasant in a more figurative sense. The concept of "rootedness" is strongly and convincingly depicted in these forms. The flowers, of course, are direct products of the soil; their beauty,

color and freshness, indeed their entire being, can be seen as manifestations of a vital force coursing beneath the earth's surface. The windmill, though manmade, is equally "rooted" to the soil from Nolde's point of view. There is in *Northern Windmill*, in fact, the suggestion through the partial reflection in the water of the mill that its "roots" are present far beneath the surface. Like the ideal peasant or Langbehn's "true artist," the tall blossoming stalks and the windmill with its vanes outstretched like arms "aspire" toward the heavens. The human metaphor of the flowers and the windmill must not be overlooked in these paintings. Nolde's understanding of flowers as symbolic of the human life cycle has already been noted, and he perceived a human equivalency in windmills as well.[30]

As in the earlier *Windmill*, Nolde makes maximum use of strong color contrasts in these oil paintings; the areas of bright oranges, lavender and white stand out against the dark greens and blacks that dominate the landscape. The sense of natural drama expressed in these paintings through this use of color is something to which Nolde was continually attracted. "In the city one is concerned very little with the phenomena of nature," Nolde wrote, "one hardly notices the roll of thunder or lightning. The drama is not experienced. On the plains it is different. The individual farms and villages tower above the horizon and during nights of heavy storms, the fire of one area [almost seems to] shake hands with another fiery area."[31]

The *Sultry Evening* title that Nolde gave the 1930 oil painting would seem at first to contradict much of the above discussion on spiritual qualities within this landscape. The German word *"schwül"* (sultry) is, however, another term like *"Stimmung"* that seems to have had a special, unconventional meaning for Nolde. One of a series of aphorisms that Nolde wrote down explains his understanding of the term: "Mysticism in science is deplorable; mysticism in art is sultry. A sultry atmosphere is fertile, it fosters weeds and marvelous beauty, both. The stronger element wins."[32] The sultriness of the evening in the painting indicates a moment pregnant with natural drama and mystical potential.

Nolde achieved the most impressive results with this formula of a natural element dominating the landscape and linking the sky and earth in *Sultry Evening* and *Northern Windmill*, but he repeated it in variation in many other landscape paintings. In a later landscape, *Flowers and Clouds* of 1938, the central elements of the composition recur, and the drama of color is even stronger in this painting than in the earlier works. We view a world of intense orange, yellow, red and blue that seems to consist only of clouds and flowers, symbolic manifestations of the natural forces in their respective realms of heaven and earth. In a 1916–17 sketch in colored chalks, *West Schleswig Landscape* (fig. 38), we can easily recognize the familiar elements of flowers (a row of gigantic, brightly colored tulips) and a cloudy sky in a composition that establishes the basic formal interactions of the later oil paintings.

Standing before the broad plains of his homeland, "where no lone trees destroyed the vision of infinity and where a post, standing in a simple plane,

became a monument," Nolde could always experience a feeling of transcendence.[33] The geographic characteristics that linked his native landscape with the rest of *Niederdeutschland* seemed to have a special significance for the artist and for other Germans of his generation. In the essay *Worpswede* written in 1902, Rilke put forth the image of the *Ebene*, the broad plains of Northern Germany, as a symbol to embody the aspirations of a new age. He wrote that it is interesting to note how each generation focuses on a different aspect of nature to express its own ideals. His own generation was no longer attracted to the mountains and castles of his father's generation,

> . . . for we live under the sign of the plains and the sky. These are two words, but they actually encompass a single experience: the plains (*die Ebene*). The plains are an emotion from which we grow. We understand them and they have an exemplary quality to us; there everything is meaningful: the great circle of the horizon and the tiny things that stand simple and important before the sky. And the heavens themselves, whose changing patterns of light and dark are narrated to us by each of the thousand leaves of a bush with different words. . . .[34]

Many of Nolde's landscapes celebrate the vast panorama of his homeland and his emotional experience of this *Ebene* with an intensity that recalls Rilke's praise of the plains. It is as though the artist, too, saw in this phenomenon a personal symbol for his own longings and an image of a new age of spirituality. In an oil painting of 1935, *Frisian Farm on a Canal* (fig. 39), Nolde places a simple farmhouse and a glowing yellow haystack against a huge sky of brilliant, rich blue. Two small clouds at the top of the canvas relieve the intensity of the sky. The only other elements within the landscape are a canal and a simple bridge which crosses it. The painting captures the strangely compelling nature of a region that consists of only two elements, sky and earth, in their most basic state. The deep blue of the sky, which is not a solid hue but varies subtly throughout the upper three-fourths of the canvas, creates a mood of solemn piety that pervades the entire painting.

Often in his watercolors, such as *Marsh Landscape* (fig. 40), Nolde dealt with the plains as the sole subject of a landscape. Here the marshland takes up the major portion of the composition. The sky is only seen in the upper fourth of the sketch, but its sulphur-yellow color is reflected in the ponds of the marshland below. Between the ponds run paths painted in dark brown and blue leading to the pasture land near the horizon and in the foreground. A few houses are suggested on the horizon with touches of red. Nolde's fluid technique of applying the washes on wet paper allows the color areas to bleed into one another, melding together all the elements of the landscape. As in the previous oil painting, this watercolor suggests the monumental simplicity of the marshy lowlands as well as a magical, glowing quality through the bright, unnatural yellow areas.

The image of *Ebene* recurs with increasing frequency in the late poems of Georg Heym, but Heym's use of the plains as an expression of an inner state and a subjective reaction to the world is quite different from Nolde's use of the

motif. In several poems from 1910 and 1911, the plains become "principally a metaphor for the emptiness of the world and for the metaphysical insecurity of man."[35] The limitless horizon and the vast, empty spaces of the plains only serve to intensify the isolation and desperation the poet feels. Unlike Nolde, Heym is unable to find anything within the landscape to which he feels a spiritual or emotional bond. The infinity of the plains only reinforces the poet's sense of his own significance and frailty.[36] This feeling of existing in a cold, dark world that provides neither comfort nor shelter to the individuals was common to many young Germans of the Expressionist generation, and it is one factor which separated Nolde from them. His adherence to certain tenets of Volkish thinking gave him an understanding of the mystical powers of the landscape and an image of himself as an integral part of a great cosmic scheme. Because of the emotional bond he felt with the landscape around him, he was always able to transcend his personal situation, no matter how tragic and isolated it might seem, to participate in the secret life of nature. Believing in an inner correspondence between his own spirit and the "moods" (*Stimmungen*) of nature as revealed in the austere, monumental forms of the landscape and the dramatic interactions of the earth and the sky, Nolde could discover what he interpreted as elemental truths about the cyclical nature of life and the diversity of creation. Furthermore, he could identify his own subjective reaction to the natural landscape with the collective spirit of the many generations of North Germans who had populated his native region for centuries, creating in the process a special bond between themselves, the *Volk*, and the native landscape. In this respect, Nolde had at all times an "objective correlative" for his own emotions that Heym and other young Germans lacked. The contemplation of the infinity and simplicity of the plains, which so terrified Heym, became for Nolde a process of spiritual renewal and self-discovery.

The kind of transcendent experience one encounters in the landscapes of Nolde and the endeavor to record within the continual transformations of the landscape the evidence of mysterious forces at work behind the processes of nature is not unique to the art of Nolde. This creative activity has an almost unbroken tradition in European art and literature that begins just before the turn of the nineteenth century. Borrowing from Thomas Carlyle, M. H. Abrams has termed this proclivity, exhibited by many modern artists and poets, "Natural Supernaturalism"— "the general tendency . . . , in diverse degrees and ways, to naturalize the supernatural and to humanize the divine."[37] The cultivation of this "natural supernaturalism" is one of the hallmarks of Romantic literature, especially in England and Germany, as Abrams has demonstrated. In the visual arts also, this tendency takes hold in the Romantic era and continues to find adherents up through Nolde's generation of artists and beyond it.[38] Robert Rosenblum has noted that the "search for divinity outside the trappings of the Church lies at the core of many a Romantic artist's dilemma: how to express experiences of the spiritual, of the

transcendental, without having recourse to such traditional themes as the Adoration, the Crucifixion, the Resurrection, the Ascension, whose vitality, in the Age of Enlightenment, was constantly being sapped."[39] A key to understanding the landscapes of Nolde on one level is the recognition within his art of the heritage of German Romanticism, of which he himself was at least vaguely aware. Beyond Grünewald and Rembrandt, the two artists with whom he felt the greatest affinity were Friedrich and Runge.

Few of the artists of the last century, or of this century for that matter, who sought to uncover the divine in nature were able to find the natural equivalent of the Crucifixion or the Adoration, although Friedrich certainly came quite close to achieving this in some of his paintings. The religious longings of most of these artists were not restricted to the narrow confines of traditional Christianity. The spiritual, transcendental qualities of their work are expressed most often in what M. H. Abrams calls "natural polarities"—the extremes of natural phenomena (e.g., the concepts of the sublime and the beautiful in the Romantic era) that could encompass the entire range of man's religious experience.[40] Many of Nolde's landscapes concern themselves likewise with natural polarities. The celebration of the vast plains of the artist's homeland in these paintings often consists largely of the simple, stark opposition of two basic elements of nature, land and sky. Nolde's fascination with contrasting or opposing states in a variety of contexts within his art has already been noted. This tendency continues in his landscapes and is an expression on one level of the artist's deep concern for the basic dualities of human existence—good and evil, life and death, male and female—dualities which are also at the core of much Romantic art.[41] Abrams reveals that beneath the Romantic fascination with opposing states "lay centuries of speculation about the natural world—speculation whose concerns were not aesthetic but theological and moral. . . ."[42] At the root of this speculation, according to Abrams, is the recurrent question of accepting the world as the creation of a benevolent God, when so much of it seems wild, terrifying and bent on man's destruction.

As a development out of Romanticism, Volkish ideology in its earliest stages carried on this concern with the dichotomies of human existence and attempted to resolve them by combining them within a single concept. Langbehn's image of Rembrandt is primarily a union of opposites: "The nature of this genuine lower German (*niederdeutschen*) master, consisting of light and dark, reason and mysticism, makes him especially well suited to exercise a decisive influence in the transfer of German culture from the realm of the clear-transparent-critical science into the realm of the obscure-reflecting-creative art."[43] Like earlier Romantic theorists and writers, Langbehn's concerns in the Rembrandt book were basically theological and moral, rather than aesthetic; his intentions in calling for a New Age of Art were essentially religious. It is no accident that the major formative influence on his thinking was Lagarde, a theologian, and that Langbehn himself spent the last years of his life dealing directly with religious questions.

Through his familiarity with Volkish thought and attitudes, Nolde received an impetus toward this kind of antithetical vision, especially in regard to his understanding and interpretation of the landscape experience. The Volkish writers adopted a view of nature as an affirmation of divine presence which was postulated by the German Romantics. They also subscribed to the German Romantics' fascination with natural polarities. To this conception of nature, these writers added their own peculiar interpretation of the interactions between these natural polarities. The Volkish landscape was more dynamic than the Romantic landscape, but it was also more accessible to the individual, who maintained a specific place and purpose within the scheme of nature.

Volkish thought replaced the Romantic image of "the individual . . . pitted against, or confronted by the overwhelming, incomprehensible immensity of the universe"[44] with the concept of an individual who gained strength through his membership in a greater spiritual and cultural community, the *Volk,* and whose religious longings and interaction with the landscape were shared by the other members of the community. As a social unit, the *Volk,* whose communal bonds and relationship with the native landscape were rooted in centuries of local custom and belief, took the place of the sentient Romantic individual in Volkish writings. The Volkish critics and writers expanded the religious, mystical longings of the individual member of the *Volk* as they were manifested in the landscape experience even further beyond the boundaries of established religious dogma. By including certain pre-Christian traditions and beliefs within their understanding of the spiritual life of the *Volk,* these writers tapped the remnants of pagan myth and, perhaps without being aware of it, a pre-Jungian concept of the racial subconscious.[45] The interest of certain participants of the Volkish movement in regional folklore, much of which retained pagan, pantheistic notions from ancient Germanic sources, or in ancient rituals such as sun worship brought these writers very close to a full-scale revival of the mythic consciousness in modern times.[46] Only the intellectual restrictions of national and racial considerations prevented the complete realization of this revival within the Volkish movement.

Common to both the Romantic and the Volkish interpretations of the landscape experience is an implicit reliance on the mystical experience of the individual before nature, the ability of the individual to receive a transcendent revelation within the natural setting. Nolde was privy to such sensations of transcendence, often to an ecstatic degree. He wrote to his wife of such an experience when she was away on a visit: "Last evening heavy dark clouds rolled above the horizon. I was sitting on an overturned basket hunting ducks. All at once I could feel no ground beneath my feet, I was one with the universe, until, suddenly aroused, I again perceived reality."[47]

In many of Nolde's watercolor sketches of the North Schleswig landscape there is a sense of this kind of ecstatic reaction to natural phenomena. In the watercolor *Evening Landscape, North Frisia* (fig. 41), for example, two large orange and brown clouds float slightly above the horizon and a plowed field

whose furrows stand out from the deep purple earth in the same unnatural orange of the clouds. The intense, bright orange of the huge clouds pulls the viewer's eye toward them and at the same time causes the cloud forms to push forward before the darkened area below. Using the furrows as natural orthogonals, we also sense that the spatial recession is too rapid for the perspective of a figure standing on the ground. In fact, the small watercolor can be seen as a visual expression of the kind of experience Nolde described in his letter. The juxtaposition of areas of intense orange and deep blue and the soft, atmospheric quality of all the elements within the composition signal a departure from the world of visual reality. In the watercolor we enter a more subjective, mystical realm where the natural polarities of the clouds and the plowed earth are reconciled within the spiritual experience of the observer. The bright orange cloud masses continue to expand before our eye and we feel ourselves drawn uncontrollably to this area of the work, as though in the presence of some compelling emanation of divine power.

Within many, if not all, of his landscapes Nolde continued to express the intense religious longings he had sought to express in the great religious paintings of 1909–12. By sublimating his religious drives and transforming them into evocative, mystical visions of the landscape, the artist revived many ancient symbolic motifs from his own ancestral legends and also from the repository of mythic concepts common to many other ancient cultures.

Massive, rolling clouds are a recurrent motif in Nolde's landscapes. As they drift majestically across the vast plains of the region, these fantastic cloud formations are in fact the most impressive natural phenomenon of the North Schleswig landscape. When they occur in a painted landscape by Nolde, it is possible to interpret these clouds as symbols of divinity or divine power. Nolde recognized the anthropomorphic form he had given to the handlike cloud formation in *Landscape with Young Horses* (fig. 30) and, although he does not specifically call it the hand of God, the supernatural association is difficult to avoid. As we have seen, cloud formations could also be a catalyst for a mystical experience in Nolde's fantastic world. Finally, as the stanza from Oehlenschläger's poem demonstrated, a nineteenth-century tradition prevalent in Northern European regions associated clouds with diety. Nolde need not have known of Oehlenschläger to make that association, however, for the association of forms in the sky with divine forces is probably the oldest of man's religious tendencies. As the ethnologist and historian of religions Mircea Eliade has noted,

> What is quite beyond doubt is that there is an almost universal belief in a celestial divine being, who created the universe and guarantees the fecundity of the earth (by pouring rain down upon it). These beings are endowed with infinite foreknowledge and wisdom; moral laws and often tribal ritual as well were established by them during a brief visit to the earth; they watch to see that their laws are obeyed, and lightning strikes all who infringe them.[48]

In recognizing the symbolic imagery of clouds, Nolde identified his own experience of the landscape with a tradition that spanned the entire history of mankind from prehistory to the present age. The awe with which the artist seemed to react to these powerful forms demonstrates his affinity with the primitive mentality that he admired.

A small watercolor, *Marsh Landscape, Gotteskoog* (fig. 42), reveals the strength of the artist's association of cloud forms and divinity. In the watercolor we recognize the familiar flat expanses of the region that spread out before us in an unbroken plane to the horizon, above which impossibly large, thick, fingerlike clouds move across the sky from right to left. Nolde employs a different technique in this painting. After completing the sketch with watercolors, he outlines the forms of the landscape in pen-and-ink, further enhancing the heavy solidity of the cloud forms. The colors also emphasize the central role of the clouds and their dominance over the landscape. The only area of bright color, an intense yellow, is contained within the outline of the clouds. These huge formations tower above the dark plains and the tiny farmhouses on the horizon, as images of incredible supernatural force dwarfing the handiwork of man. The very name of this region, *Gotteskoog,* suggests a close bond with divine power. The *koog* is an area of land which has been reclaimed from the sea and maintained with dikes. This particular *koog* is literally "God's land." Nolde described this region with its natural and supernatural beauty in his autobiography as if it were a scene of divine revelation: "floating over the smooth, vast water the spirit of God, surrounded by the splendour of heaven, reflecting the drifting clouds and all the birds, thousands of migrating ducks soaring up into the sky, blotting out the sun. . . . The sea breathed in great breaths, shallow and deeply." With a note of bitterness, he adds a reference to the drainage projects in the region. "For the future will remain just a few small, dark waterholes, like God's tears, shed for a land of primordial beauty transformed into the everyday."[49]

In *Red and Violet Clouds* (fig. 43), another watercolor that deals almost exclusively with clouds, the incredible range and delicacy of color Nolde is able to achieve give a sense of immanence and transcendence which the artist associated with clouds. The technique used here, washes applied to damp paper so that the pigments bleed into each other, is yet another example of Nolde's experimentations with watercolor. In this particular work the washes were probably applied initially without any definite natural form the artist wished to represent. The cloud forms suggested themselves only after the washes had been applied. Then in the lower section of the paper, Nolde outlined the form of a farmhouse overlooking the sea to complete the vision. The tremendous feeling of pure energy emanating from the clouds emphasizes the specific religious symbolism traditionally attributed to clouds as the active, creative aspect of the divinity. And through the technique which he employs here, a free association that approaches pure boundless creativity, Nolde merges his own activity with that which he symbolically represents.

Nolde brings his strong attraction to cloud forms and their transcendent power close to home, literally, in the watercolor *Seebüll with Cloudy Skies* (fig. 44). Painted sometime after the completion of his new home at Seebüll, the watercolor is more carefully composed and finished than the previous two. As in most of the other watercolors which deal with clouds, the sky encompasses almost all of the composition. The darkened form of the unusual six-sided house stands on an area of high ground in the lower area of the paper. Above it looms a huge cloud mass in brown with pure yellow highlights. This yellow continues down into the area of sky below the cloud to surround the house with an intense warm glow. The strong contrasts within the cloud mass give it a sense of tremendous power, and its presence dominates the scene as though it were some sort of supernatural messenger announcing its profound revelation to the artist below.

If clouds represented the spiritual forces of the heavens in the Volkish cosmology which Nolde adopted in his landscapes, then flowers embodied the forces beneath the earth, the other pole of the exchange process occurring within the landscape. Nolde's strong attraction to flowers for both aesthetic and symbolic qualities has already been mentioned. In the 1920s and 1930s, the artist returned to the motif of the flower, refining his vision in both oil paintings and watercolors, often focusing on individual plants by removing them from a natural surrounding and placing them against a blank background so that they became in some instances almost floral icons.

The Romantic and Volkish traditions of regarding flowers and other forms of vegetation as manifestations of a vital force coursing beneath the soil are strongly rooted in very ancient beliefs (which even survived in local rituals in rural regions of Europe into the nineteenth century). These objects were perceived as symbols of fertility and regeneration and therefore of a divinely sanctioned continuation of life. According to Eliade,

What is important in all these customs is this notion of the constant flowing of life between the plant level—as a source of never-failing life—and the human; men are all simply projections of the energy of the same vegetal womb, they are ephemeral forms constantly produced by the overabundance of plants. Man is an ephemeral appearance of a new plant modality.[50]

Blossoming flowers and fruits in this context represent the flowering of divine potential and creativity.

In his watercolor of *Ripe Hawthorns* (fig. 45), Nolde captures this sense of bursting energy, the climax of a life cycle. Although Nolde recognized the cyclical nature of the flowers' life, he almost always painted them at this stage of full bloom and ripeness. The lush red berries are interspersed with bright yellow, purple and green leaves. The color areas remain relatively pure and intense through Nolde's delicate technique in this painting which allows few colors to bleed into one another. One might almost describe the composition of this watercolor as "burgeoning"—the darker forms and pigments are relegated

to the upper and lower edges of the paper and in the center the small round berries and leaves are arranged in a pattern of explosive red and yellow that recalls the interaction of colors in the right half of *Christ among the Children* (fig. 25). The entire watercolor becomes an image of joy and celebration of life.

Red Poppies (fig. 46), one of many watercolors by Nolde depicting this flower, demonstrates how effectively the artist could suggest the form and achieve a highly emotional expression. These small rapid sketches used a limited number of colors laid on the paper in delicate flat areas. The incandescent red of the blossoms has an almost intoxicating effect on the viewer, and the individual petals of the flowers seem to flow and bristle in response to the "life force" within them. We can see only the blossoms and a section of stem. The flower's connection to the soil is implied only through the intense color and movement of the blossoms, which further enhance the magical quality of the image. Traditionally in Western art, as J. E. Cirlot has noted, the poppy appears in allegorical representations as a symbol of fecundity because of its prodigious number of seeds.[51] It cannot be determined that Nolde was aware of this iconographical tradition, but he does seem to recognize and emphasize in the flower the open, receptive forms of the blossoms and their intense red coloring which may also have suggested a symbolic association with earlier artists.

Nolde's admiration for Van Gogh as well as his natural attraction to sunflowers led him to use these flowers as the central motif of many of his paintings.[52] *Ripe Sunflowers,* an oil painting of 1932, depicts two huge blossoms set against a dark stormy sky. The mood of this flower painting is much less exuberant than in those discussed above. The dark tonalities of the sky create a somber atmosphere, as the heavy flowers begin to sag under their own weight and the natural forces within the plants begin to ebb. The cyclical nature of the entire life process is not ignored by the artist, however, and the full, womblike form of the blossoms filled with seeds is emphasized, suggesting the continuation of the cycle.

The close association Nolde perceived between flora and divine powers is clearly revealed in another, later oil painting, *The Great Gardener* (1940). In this work of great tenderness and childlike naivete, a kindly, bearded old man, the image of the German *lieber Gott,* here in the role of a divine gardener, lovingly tends to His creations. The fantastic brightly colored plant forms respond to His affection and presence as they rise up before Him.

The entire process of creation, in a biological as well as a divine sense, is a recurrent theme in Nolde's landscapes. Many of the landscapes that do not deal specifically with flowers nonetheless employ motifs that in their archetypal form symbolize the union of elements within the creative process. The image of the windmill, for instance, which occurs in these landscapes with such frequency that it takes on the nature of a personal symbol for the artist, can be identified on one level as an aspect of the procreative act, an instrument of the wind which C. G. Jung has identified as the archaic symbol for the fertilizing agent.[53] In *Northern Windmill* (fig. 37), this interpretation is further supported

by the form of the windmill which, when associated with the round, womblike body of water beside it, becomes one half of a symbolic union of male and female elements. Mircea Eliade has written of this kind of archaic, symbolic conception,

> Water nourishes life, rain fertilizes as does the *semen virile*. In the erotic symbolism of the creation, the sky embraces and fertilizes the earth with rain. The same symbolism is found universally. Germany is full of *Kinderbrunnen, Kinderteichen, Bubenquellen* (children's fountains, children's ponds, little boys' springs). . . . But, underlying these beliefs, and indeed all myths about human descent from the earth, vegetation, and stones, we find the same fundamental idea: Life, that is, *reality,* is somewhere concentrated in one cosmic substance from which all living forms proceed, either by direct descent or by symbolic participation.[54]

According to this ethnological orientation, the earth itself is understood as a receptacle of the fertilizing agent. In a landscape like *Evening Landscape, North Frisia* (fig. 41), where Nolde depicts the earth in plowed furrows, he revives an even more specific image. In juxtaposing the clouds and the furrowed land in such a monumental conception, the artist realizes on a symbolic level the "cosmic hierogamy of Sky and Earth," the mythical primal act of creation.[55]

In this work and in so many of Nolde's other nature landscapes where he seems to be consciously or unconsciously employing ancient, mythic conceptions of nature and expressing a primitive, mystical, awe-struck attitude at the core of the landscape experience, we find the artist moving out of the narrow confines of Volkish ideas and imagery into a realm of more universal, symbolic orientation toward the mysteries of human existence. There can be little doubt that Nolde was strongly influenced by certain Volkish concepts and attitudes in formulating a specific artistic relationship with his natural surroundings. He cultivated a mystical, empathetic bond with his native landscape that Volkish thought sought to reinstate in the German mind. When discussing the nature of his landscape experience in his public statements and in his autobiography, Nolde continued to describe this experience within the national or regional limitations Volkish thought placed on the relationship of the individual to his native landscape. Still, Volkish ideas remained a point of departure for Nolde. Once he had absorbed these ideas, when he approached the landscape and began to interpret it, he was able to give expression to the sort of all-encompassing mythic attitude that was never quite accessible to the adherents of a strictly Volkish approach.

Nolde's seascapes form a separate, but very significant category within his landscapes. In his native North Schleswig, the sea with its tremendous presence is as much a part of the landscape as the vast marshlands and the magnificent cloud formations. The various seascapes Nolde painted reveal a continual fascination with this vast elemental force. The artist's first pure seascapes date from the years just before the journey to New Guinea. In 1911 he completed a series of autumnal seas which depict massive cloud formations hanging above a sometimes turbulent sea. *The Sea III* (fig. 47), an oil painting finished two years

later, developed out of these first seascapes, but deals much more directly with the sea itself and its limitless force. Four-fifths of the canvas is taken up by the sea and its powerful waves. A strip of greenish sky with tinges of yellow is visible at the top of the canvas. There is no evidence whatsoever of land within the painting. The viewer is drawn right into the water itself and placed in the midst of the heaving waves and whitecaps of the bottle-green ocean.

In this painting Nolde conveys the experience of the individual pitted against a force whose sheer immensity threatens to dwarf man's sense of self-importance. The experience was a personal one for the artist. In his autobiography he related the events which occurred during a stormy boat trip across the Kattegat a few years before this painting was completed.

> A little fishing trawler took us across to Anholt, a tiny, unimportant island in the middle of the Kattegat. . . . On the return trip the water was violent; our ship was so small. My Ada stood on deck, seasick and tightly grasping the mast. . . . I stood beside her, desperately clinging to the stair railing, watching in amazement, rising and sinking with the ship and the waves.
>
> This day has remained so fixed in my memory that for years afterwards all my paintings of the sea consisted of wildly heaving green waves and only a little fringe of yellow sky on the upper fringe.
>
> If a wave had swept me overboard and I had had to struggle for my life among the elements—would I then have been able to paint the sea even more powerfully?[56]

In this early seascape of 1913, the force of the ocean is partially diminished by the decorative qualities of two whitecaps to the right and left in the center of the canvas that repeat the same gentle curving form. In his later seascapes like *Sea E,* one of a series of seascapes painted in 1930 during several weeks spent on the resort island of Sylt off the coast of North Schleswig, Nolde overcame this decorative impulse; the elemental force of the water and waves is now expressed with less reserve.[57] Here a massive wave in the lower half of the canvas breaks upon a turbulent sea. The sky above the waters seems to swell with equal intensity as great yellow and turquoise bands sweep through the dark blue sky in the upper right corner.

This sense of the ocean as boundless energy and all-encompassing mass is masterfully conveyed in a small watercolor, *High Seas* (fig. 48), which may also date from the period of Sylt. An almost abstract pattern is created from the irregular color areas of turquoise and dark blue that form the waves. The broken, agitated lines between the colors crackle like electric charges, suggesting the tremendous force beneath the surface of the water. The sky above the waters is equally forceful and captured in intense colors of deep purple, rust and yellow-green.

Nolde recognized how strongly the presence of the sea and the constant battle the inhabitants of the coastal areas and lowlands fought with it had determined the character of the North Schleswig native including the artist himself.[58] The threat of flooding was an ever-present reminder of the great untamed force

lying in wait beyond the dikes. If this existence lived out on the brink of destruction molded the stalwart constitution of the region's native inhabitants, it also created a situation that, in its essence, removed the individual from the comforts and conflicts of modernity, placing him instead in direct contact with an almost supernatural force whose unfathomable actions could grant favor or ruin.

Nolde captured this transcendent quality of the ocean's power in a small watercolor entitled *Flood* (fig. 49). The glowing, translucent colors and the gradual but inevitable flow of the lavender wash as it slowly engulfs the golden sky and the tiny red farmhouses create a vision that is almost biblical in its associations of divine providence and regeneration of the landscape.[59] Nolde achieves this quality through the soft, evocative colors and a process of flooding the pigments onto the paper that seems to recreate the action depicted. Following a traditional symbolic interpretation, the great lavender funnel on the right that descends through the sky to the earth below can be understood to carry within it the promise of transformation, rather than destruction.[60]

The mythological symbolism of water and the ocean did not escape Nolde, and it must have provided him with further evidence of the very special nature of a homeland so closely allied with the sea. As we can interpret it from his various seascapes, the constant presence of this elemental force, which Nolde experienced throughout his entire life, resulted in an understanding of the sea in keeping with the most recurrent mythological conceptions of bodies of water as the beginning and end of all life. Mircea Eliade has written of this primitive symbolic vision of water,

> In whatever religious framework it appears, the function of water is shown to be the same; it disintegrates, abolishes form, washes away sins—at once purifying and giving new life. Its work is to precede creation and take it again to itself; it can never get beyond its own mode of existence—can never express itself *in forms*. Water can never pass beyond the condition of the potential, of seeds and hidden powers. Everything that has form is manifested above the waters, is separate from them. On the other hand, as soon as it has separated itself from water, every "form" loses its potentiality, falls under the law of time and of life; it is limited, enters history, shares in the universal law of changes, decays, and would cease to be itself altogether if it were not regenerated by being periodically immersed in the waters again. . . .[61]

In this respect, the sea as a natural symbol of divine forces is a different kind of religious manifestation than other natural elements that appear in Nolde's landscapes. The sense of pure, formless potential inherent in the sea transcends the cyclical quality of the rest of nature, yet the essence of its immense force is comprehensible only in combination with this natural cycle and the "forms" of nature which germinate from this source. The visual immersion one experiences in so many of Nolde's seascapes can be seen in this context as a recognition of the process of regeneration which is the total symbolic content of water. In certain seascapes, like the watercolor *Sea with Red Sun* (fig. 50), this concept

is given more concrete expression through the inclusion of a "form" in the process of regeneration. Here the sun, a bright red orb, burns through the clouds above a turbulent sea, a variation on the theme and composition of Nolde's earlier sunrises in the Alps (fig. 4) and in the tropics (fig. 28). The placement of the sun on the central vertical axis of the composition emphasizes the mythical rising and setting course of the sun which will bring it into contact with the water. There is in the touch of orange in the water directly beneath the sun the sense of the recent departure of the sun from the water which still glows from its heat. In symbolic terms, the image of the sun can be seen to represent the primordial force, the first creative ordering of matter, rising above the chaos of the formless waters from which it has emerged to give form and light to the regions above the waters.[62] As is so often the case, in certain autobiographical statements Nolde seems to define his attraction to the sun in terms of an innate quality of his Germanic character that manifests itself in a worship of the sun and its life-enhancing powers—an understanding probably drawn from Volkish sources.[63] However, from the visual evidence of Nolde's painted sunrises and from his comments on the small watercolor *Sunrise* of 1894, it is clear that he also subscribed to an interpretation of the sun which moved beyond the limits of Volkish thought and approached the symbolic appearance of the sun in paintings of other Northern European artists like Van Gogh or Munch. The concept of the sun common to all three painters can also be located within the speculations of late nineteenth-century thinkers as well, such as Nietzsche's ideas of an *Urlicht* (primordial light), and it involves considerations that are more religious than nationalistic or racial.[64]

Throughout his long life and career, with its struggles and hardships and conflicts, Nolde professed a single purpose in his art—to give expression to what his friend and admirer Max Sauerlandt called "the mysterious life of his homeland, so closely merged with nature itself."[65] Like Rembrandt with whom he so often identified, Nolde sought to delve into the innermost depths of his own being as it experienced the secret, dark forms and moods of his native landscape, to reach thereby an emotional and spiritual state common to all the inhabitants of the region and to translate this experience onto canvas. The key to this process was the cultivation of a new way of seeing, "as if one had been reborn."[66] His art, Nolde hoped, would facilitate this process. "There are many individuals within the *Volk* with an unclouded eye," Nolde wrote elsewhere. "They greatly desire direction, they have a moving wish for [spiritual] elevation and a great beauty. And art should not be lowered; the people want to be raised to its level. Elevated, as it occurs within all religions."[67] This was the ideal of Nolde's art, but it was an ideal which was only partially realized during the artist's lifetime, for the individuals that he wanted to be moved and inspired by his art remained untouched. At one point he confided to Hans Fehr, "I wish so much that the people of my homeland would take part in my art, but they do not. . . ."[68] In this

respect, Nolde was indeed a prophet in his own land, misunderstood or ignored by the people he strongly desired to reach. As he did so often, the artist found solace in these moments of frustration and unrealized dreams in the example of Rembrandt. To a friend he wrote, "Perhaps a coming age will regard the isolated, solitary stance of artists as the best and most exceptional qualities of this epoch. . . . That Rembrandt in his late years was denied the recognition of his age is certainly a source of great joy to us today."[69]

If we can interpret the landscape paintings of Nolde as his prophetic vision for the future generations, then we must recognize how strongly this experience is rooted in the past. Like the solutions arrived at by Lagarde and Langbehn, Nolde's vision was both forward-looking and backward-looking, an attempt to encompass and revitalize an entire span of cultural and historical experience of a people and transform it into images of inspiration and insight for the coming age. As we have seen, Nolde's landscapes reach back into somewhat recent history and the superior spiritual qualities of Rembrandt's artistic expression and even further back into the realm of antiquity and prehistory to the heroic, myth-inspired mentality of the artist's Germanic forefathers and their ancestors. Through the influence of Volkish ideas and the indigenous myths and legends of his homeland Nolde was able, in a truly Jungian sense, to extend his own individual consciousness beyond the boundaries of a specific historical moment to realize a spiritual bond with the collective experiences and aspirations of the many generations before him that had lived out their lives upon his homeland.

Conclusion

Despite his descriptions to the contrary, Nolde's reputation increased steadily within artistic circles in Germany in the years after 1916, during which he painted the magnificent landscapes and other works in this period of self-imposed isolation. The controversies surrounding Nolde's expulsion from the Berlin Secession gradually lost their hold on the public mind and despite his seclusion, Nolde exhibited widely during these years. In 1927, a major retrospective exhibition with over two hundred of the artist's paintings was organized by Rudolf Probst in Dresden on the occasion of Nolde's sixtieth birthday, and the exhibit then traveled to several other German cities. Nolde journeyed to Dresden to attend the opening ceremonies and was greatly moved by the entire experience.[1] The previous year, he had been awarded an honorary doctorate by the University of Kiel, and in 1931 he was elected to the Prussian Academy of Art. In 1933 Nolde was offered a chair previously held by Max Slevogt and the presidency of the Staatliche Kunstschule in Berlin, but the appointment was never realized as the National Socialists came to power in that year.[2]

The 1920s also witnessed extensive published appreciations of Nolde's art. In 1921 Max Sauerlandt's monograph on the artist appeared. As much as any of Nolde's contemporaries, Sauerlandt recognized the artist's desire to express the strong mystical attraction he felt for his homeland soil. Sauerlandt realized, furthermore, to what extent this emotional bond between the artist and his native soil determined the entire tenor of Nolde's creative development. "It would appear," he wrote, "that his development . . . has been achieved completely independent of the external events of his life, existing at first in a subterranean state, in the subconscious, until the inhibiting barrier falls away and the mysterious accumulated energy breaks through to the surface in a full, broad stream of creativity."[3] In conceiving of Nolde's creative process as an artistic equivalent of a natural phenomenon, Sauerlandt perceived the potential for important symbolic expression within Nolde's art where man is closely allied with the processes of nature on an emotional and psychological level. Sauerlandt interpreted the recurrence of specific images and emotions in Nolde's art as a system of "personal hieroglyphics" which conveyed the heroic, epic quality within the paintings.[4]

Although he does not directly express it in such terms, it would appear from the focus of his discussion that Sauerlandt was aware, to some degree, of Nolde's attempts to express a mythic consciousness in his art.[5]

Rudolf Probst, who organized the Nolde retrospective in 1927, had published an important article on Nolde at the beginning of the decade which provides further insight into the contemporary understanding of Nolde. Like Sauerlandt, Probst recognized the elemental, myth-oriented qualities of Nolde's art and the creative bond between the artist and his homeland whose forces "gave form to life itself."[6] Probst believed this aspect of Nolde's art, the ability to tap the hidden regions of nature where this creative energy was buried, was the decisive factor that differentiated Nolde from the culture of the present age and its materialistic political ideologies which no longer recognized "the awareness of unique, human existence." Probst believed this factor also removed the artist from the company of other Expressionist painters who, although they too sought to experience the elemental, chaotic nature of life, lacked Nolde's "degree of passion and the certainty of a primal order of things."[7] In this respect, Nolde's art was more than the measure of current conflicts in contemporary life. His timeless art expressed eternal conflicts of life and celebrated the "Passion of nature."[8]

After 1933 the tone of public and critical reaction to Nolde and his art changed drastically. The next twelve years were some of the most trying of Nolde's life. In 1935 he was struck with a serious illness. After several months in a Hamburg hospital his ailment was diagnosed as stomach cancer, and the artist underwent major surgery. He spent the winter in Switzerland recuperating from the operation, but no sooner had he recovered than a far more serious threat to his existence surfaced. Soon after coming to power, the National Socialists had begun a campaign against "cultural Bolshevism" and its expression in the arts. At the beginning of this propaganda battle, Nolde had been singled out by the Nazis as a prime representative of the decadent tendencies within modern German art, his art was prominently featured in the official 1937 Nazi exhibition of "Degenerate Art." After the exhibition, the government began to confiscate all his works not in private collections and to remove his paintings and graphics from the various German museums where they were on public display. In all, 1,052 works by Nolde in German museums were confiscated by 1940. In 1941 the Reichskammer further demanded that Nolde turn over the entire artistic production of the past two years. On August 23 of that year he received a judgment from the Reichskammer based on their evaluation of the works he had sent them. Because he had obviously failed to adhere to the clearly outlined "directions for future artistic conduct and goal orientation in responsibility to *Volk* and *Reich*," Nolde was to be forbidden from that date on to paint or practice any other related artistic activities. Of the works that he had turned over to them, fifty-four were not returned to the artist, but were handed over instead to the police authorities. The *Malverbot* was enforced over the next three years by

regular visits to Seebüll by the Gestapo. As early as 1937, Nolde had begun to paint a collection of watercolors which he called "unpainted pictures." He continued to paint in this medium after being forbidden to paint since the watercolors, unlike oil paintings, did not leave a telltale odor which could be detected by the periodic visitors from the Gestapo. Over 1,300 of these "unpainted pictures" are still extant.[9]

Unlike so many of his fellow artists, Nolde chose not to emigrate in the years after the Nazis came to power. He and Ada did not wish to leave their beloved Seebüll and move back across the Danish border to the region that had been so utterly transformed by the drainage projects and all the other "improvements." Undoubtedly Nolde was also initially fascinated by the rhetoric of the National Socialists which, with its emphasis on a purification and revival of the German spirit, must have sounded awfully familiar and attractive to the artist. Even after being branded "degenerate" by the Nazis, Nolde persisted in his attempts to explain the intentions of his art and his entire career to the government officials who persecuted him. After the "Degenerate Art" exhibition, Nolde wrote to Joseph Goebbels personally demanding that his paintings already confiscated by the Nazis to that date (July 2, 1938) be returned to him. "I also request, most honored Herr Minister," Nolde continued, "that the defamation raised against me cease. This I find especially cruel, particularly since even before the National Socialist movement I, virtually alone among German artists, fought publicly against the foreign domination of German art, against the corruption of art dealers and against the intrigues of the Liebermann and Cassirer era. . . . When National Socialists also labeled me and my art 'degenerate' and decadent I felt this to be a profound misunderstanding because it is just not so. My art is German, strong, austere, and sincere."[10]

Nolde's arguments were unconvincing, however, and the attacks against him continued. After he was forbidden to paint, Nolde made one final attempt to clear his name and reputation. In May of 1942 he traveled to Vienna in hopes of appealing his case before Baldur von Schirach. The final realization of the tremendous evil inherent within the Nazi program and the incredible destruction of World War II weighed heavily on Nolde during those years. To comprehend what he was witnessing Nolde searched for some fatal flaw within the German character itself. "The German people," he wrote in his autobiography, "have been endowed with the lowest and the highest qualities, with the most gruesome instincts but also with a most noble spirituality. It is a wide range, probably wider than that of any other people—and, as a terrible consequence, furious struggles within and without, revolutions and wars."[11] In these moments of despair Nolde returned to his ancient dream of a true revival of the German spirit to replace the degradation of that spirit which was taking place. "Dare one assume that out of all this pain, out of the deepest depths there might possibly develop a fresh, young German spirituality? . . . And what if we had won the war? Germany's spirituality—her most beautiful attribute—would have been utterly eradicated."[12]

Nolde emerged from the war years as a major figure in German art. He was widely honored with honorary appointments, exhibition prizes, medals and orders. Amidst this tumult of praise and celebration, Ada died in November of 1946 after years of illness which had kept her virtually bedridden. In the face of this loss and the complete loneliness which it brought, Nolde remarried two years later. His twenty-six year old bride, Jolanthe Erdmann, was the daughter of his good friend, the pianist Eduard Erdmann. Nolde continued to paint in oil until 1952, translating many of the compositions of his "unpainted pictures" onto canvas, and he worked in watercolor almost until the day of his death on April 13, 1956.

Even the most perceptive of Nolde's admirers and appreciators during his lifetime did not fully recognize the extent to which his art was indebted to the ideas and attitudes that were part of the system of ideas we know today as Volkish thought. That ideology was still in the process of developing and changing into the 1920s, and the nature of its development and the broad range of ideas it encompassed were too complex to be totally comprehended by any contemporary observer. Only in the years since 1945 has extensive historical research and analysis resulted in a more complete understanding of the movement which contained so many diverse ideas and proponents. If Nolde's attempts to reconcile the basis of his art with the Nazis' cultural program cannot be entirely excused, it can certainly be explained as an almost inevitable mistake, for the Nazi ideologists adapted much of the structure of Volkish thought (and only part of its substance) into their own system for a rebirth of the German nation.[13] In his own deeply felt longing for a regeneration of the German spirit and the birth of a new German art, Nolde recognized the similarities between his own ideas and their transformed reappearance in the Nazi rhetoric, but he was no doubt guilty of being blind at least initially to the great and terrible difference between his motivations and those of the Nazis.

As has been stressed in this study, Nolde did not follow a strict program outlined by any of the proponents of Volkish thought. He was attracted to certain of their ideas and images that struck a sympathetic chord within him. Nolde's art is not an essential part of Volkish thought but rather a development out of it. He fused the ideas and attitudes he encountered within the Volkish system with his own experiences and ideas to create a style unique among the artists of the Expressionist generation. What Nolde gained from his contact with Volkish thought was a focus for many ideas and emotions he had felt since childhood about the nature of the individual, his place in society, his spiritual relationship with his native landscape and his cultural past and the role of the creative individual, the artist, in transmitting these ideas and attitudes to a larger audience in the hope of directing its future. Volkish thought also provided Nolde with an acceptable structure, a dynamic vision of the landscape in cosmic terms in which the individual could participate as a member of a greater spiritual community with a sense of certainty and purpose. The tendency within the artist to express

his strongly felt religious longings within his experience of the natural landscape and his ability to translate these experiences into powerful, monumental visions were strengthened by the encounter with Volkish ideas. The confirmation of so many of his own attitudes and emotions regarding the current decline of German culture and the need for a new artistic expression to transform this situation into a revival of the German spirit was quite significant for Nolde's intellectual and artistic development. It instilled in him a belief in the validity of his own personal feelings as the expression of the convictions of a large segment of the German population and provided him with an understanding of his own art as a continuation of a long tradition of deeply spiritual art created by the Northern European artists of the past whom he admired so strongly.

In many respects, Nolde's art marked the end of that tradition of Northern European art, at least among the generations of European artists who succeeded him. Despite his desire to be among the vanguard of a new German art of the future, Nolde shunned followers and students, preferring to follow the path of his art alone and in the solitude which was so important to him. This new German art, he believed, would not arise from a strict, programmatic style, but would develop from the inner necessities and the creative vision of the individuals who contributed to it. The importance of Nolde's art therefore is in its achievement itself. Nolde was able to draw upon the ideas, attitudes and emotional longings expressed by Volkish writers, who were basically conservative and even reactionary in nature and unformed and inconsistent in their expression, and fuse these elements within his own personality. As a result, much of what he expressed in public statements and in his writings retains the conservative and often confused qualities of its Volkish sources. More importantly, however, in part from these same sources, Nolde succeeded in creating a unique vision that was powerful, intense and essentially modern in its emphasis on re-establishing a mystical relationship of the individual with his surroundings and a new capacity for the central role of a mythical attitude in the modern world.

In this sense the art of Emil Nolde is a major part of a greater tradition in the development of early modern art and is representative of the hopes and desires of the many young artists and intellectuals of his generation who rejected the outmoded theologies and the secular beliefs and customs of a materialistic society in search of a new system of spiritual values which would provide a foundation for their new, enthusiastic view of the world. The fact that these paintings and graphic works continue to exert a powerful and evocative emotional impact on the viewer is perhaps the strongest evidence for the success of Emil Nolde's achievement.

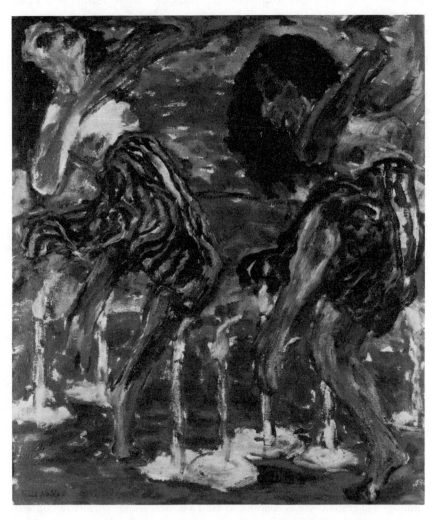

Figure 1. *Candle Dancers,* 1912, oil on canvas
100.5 × 86.5 cm
(Seebüll, Nolde Foundation)

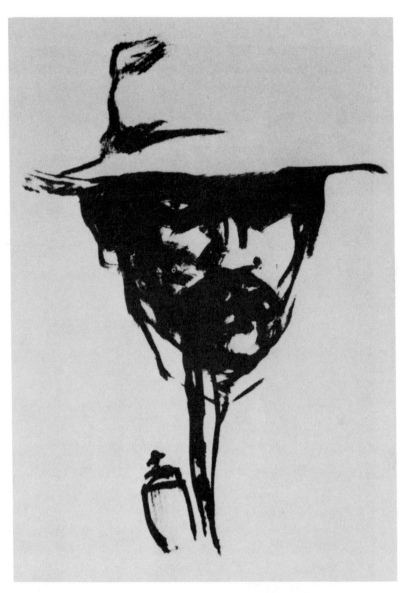

Figure 2. *Self-Portrait with Pipe*, 1907, lithograph
40 × 28.5 cm
(Schiefler L5)

Figure 3. *Marsh Landscape: Evening*, 1916, oil on canvas
73.5 × 100.5 cm
(Basel, Kunstmuseum, Öffentliche Kunstsammlung)

Figure 4. *Sunrise*, ca. 1894, watercolor with gouache
8.4 × 10.2 cm
(Seebüll, Nolde Foundation)

Figure 5. *Sun Worshiper*, 1901, ink sketch
9.5×12.1 cm
(Seebüll, Nolde Foundation)

Figure 6. *Mask of Energy,* 1896, India ink with white highlights
51.2 × 38 cm
(Seebüll, Nolde Foundation)

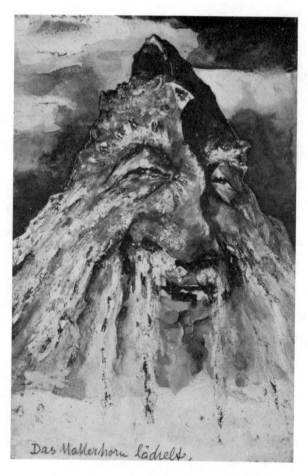

Figure 7. *The Matterhorn Smiles*, 1894, postcard
14.9 × 10.5 cm
(Seebüll, Nolde Foundation)

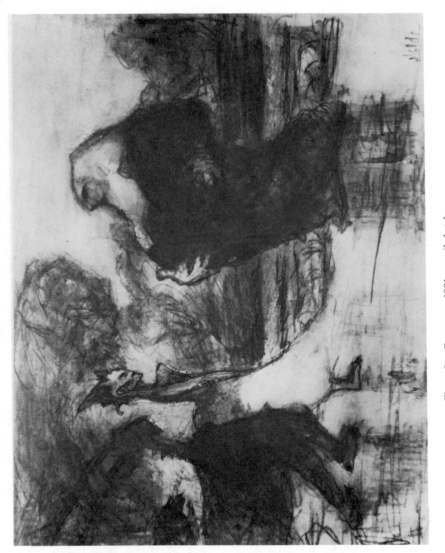

Figure 8. *Encounter*, 1901, pencil sketch
dimensions unknown
(Bern, formerly collection of Hans Fehr)

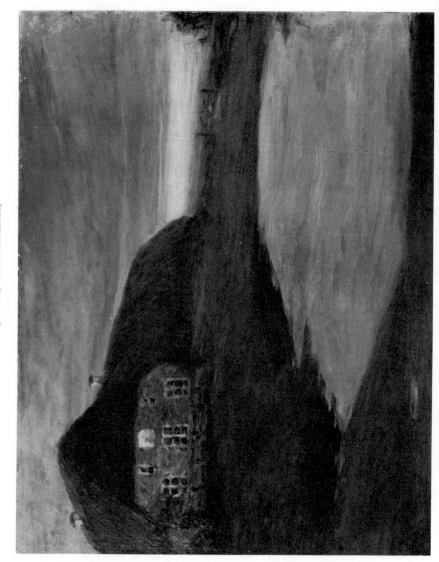

Figure 9. *Home*, 1901, oil on canvas
56.5 × 70 cm
(Seebüll, Nolde Foundation)

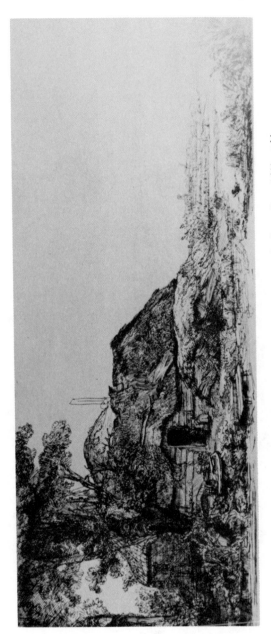

Figure 10. Rembrandt van Rijn, *Landscape with Cottage and a Large Tree*, 1641, etching
12.5 × 32.0 cm

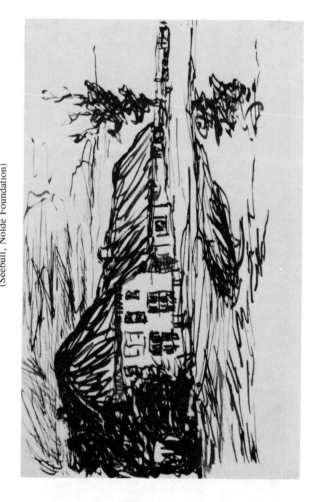

Figure 11. *Home*, 1900, ink sketch
8.8 × 13.7 cm
(Seebüll, Nolde Foundation)

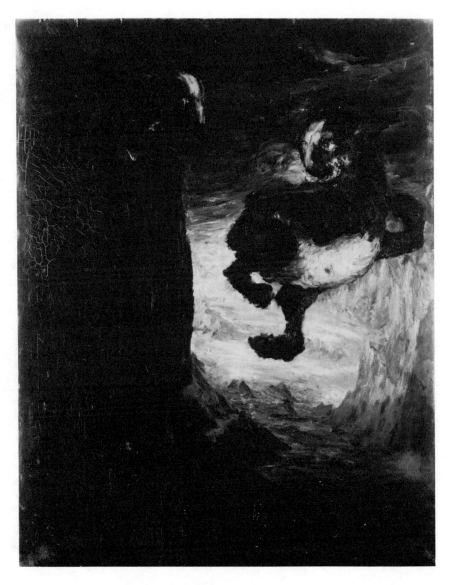

Figure 12. *Before Sunrise*, 1901, oil on canvas
83 × 64 cm
(Seebüll, Nolde Foundation)

Figure 13. *Day of Harvest*, 1904, oil on canvas
73 × 92 cm
(Cambridge, Mass., collection Andreas Kohlschütter-Fehr)

Figure 14. *The Last Supper*, 1909, oil on canvas
86 × 108 cm
(Copenhagen, Statens Museum for Kunst)

Figure 15. *Spring Indoors*, 1904, oil on canvas
88 × 73 cm
(Seebüll, Nolde Foundation)

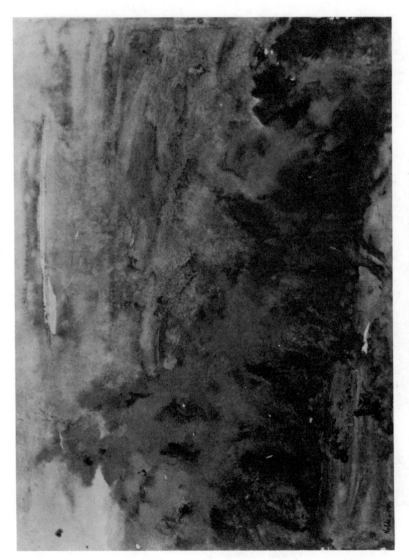

Figure 16. *Cospeda, Trees in March*, 1908, watercolor
36.1 × 49 cm
(Seebüll, Nolde Foundation)

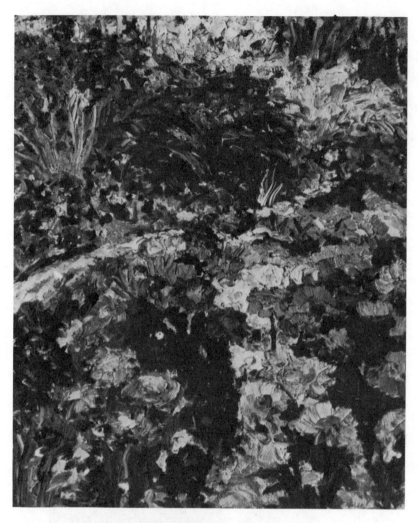

Figure 17. *Anna Wied's Garden*, 1907, oil on canvas
60 × 50 cm
(private collection)

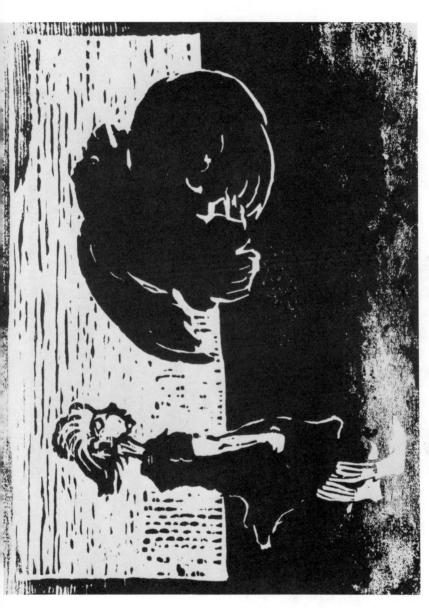

Figure 18. *The Big Bird*, 1906, woodcut
16.2 × 21.1 cm
(Schiefler H9/II)

Figure 19. Philipp Otto Runge, *The Hülsenbeck Children*, 1805, oil on canvas
131.5×143.5 cm
(Hamburg, Kunsthalle)

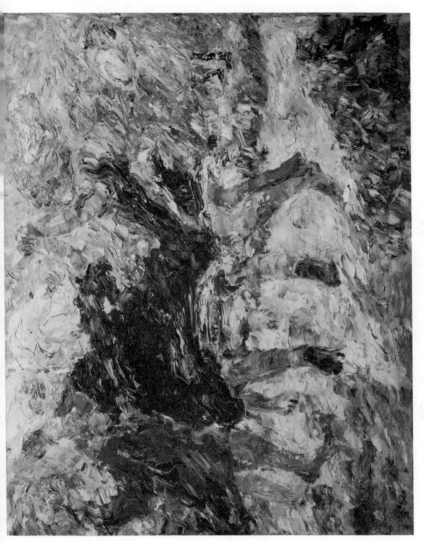

Figure 20. *Wildly Dancing Children*, 1909, oil on canvas
28¾ × 34⅝ in
(Kiel, Kunsthalle)

Figure 21. *Hamburg, Pier (Harbor)*, 1910, etching
31.0×41.1 cm
(Schiefler R139/III)

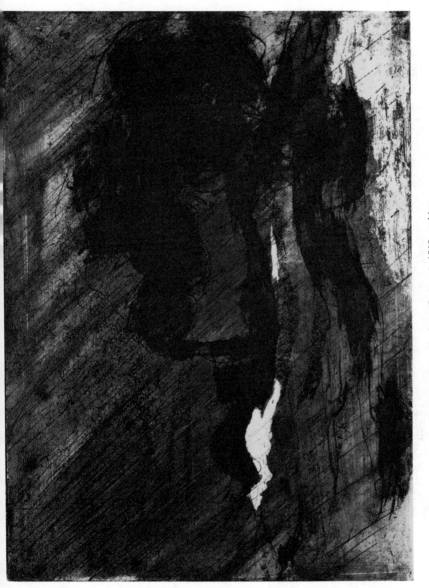

Figure 22. *Tugboat (Steamer)*, 1910, etching
30.5 × 40.5 cm
(Schiefler R135/IV)

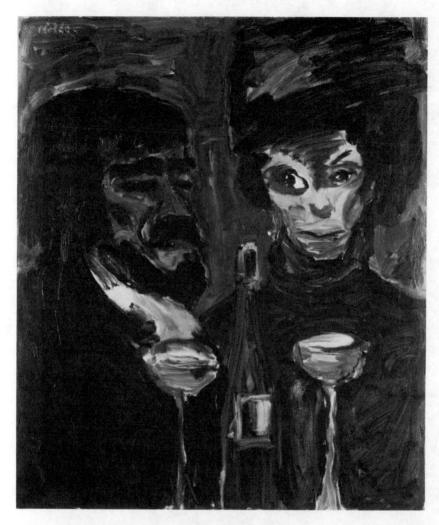

Figure 23. *Slovenes,* 1911, oil on canvas
79.5 × 69 cm
(Seebüll, Nolde Foundation)

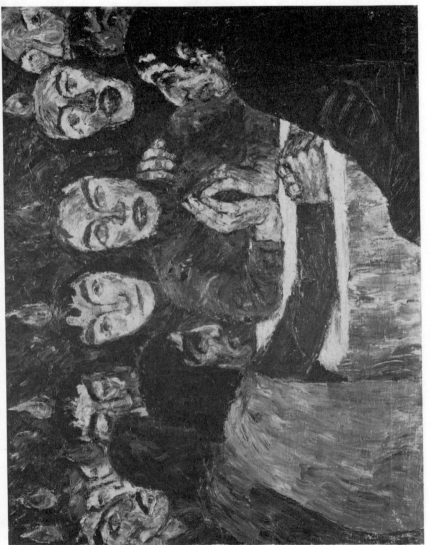

Figure 24. *Pentecost*, 1909, oil on canvas
83 × 100 cm
(Bern, private collection)

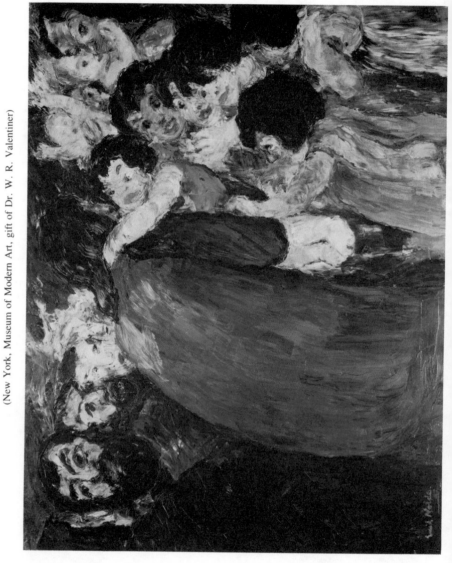

Figure 25. *Christ among the Children*, 1910, oil on canvas
86.8 × 106.4 cm
(New York, Museum of Modern Art, gift of Dr. W. R. Valentiner)

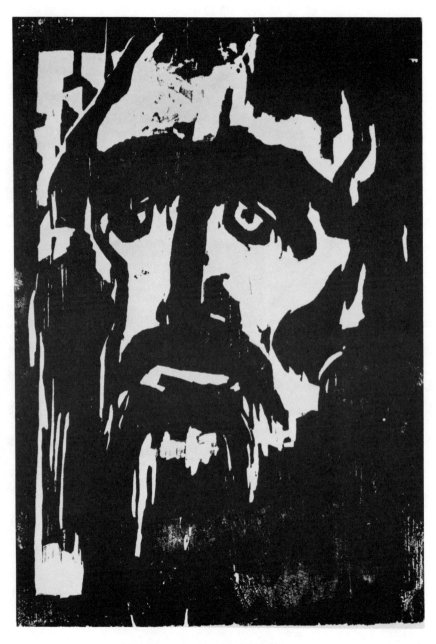

Figure 26. *Prophet*, 1912, woodcut
32.4 × 22 cm
(Schiefler H110)

Figure 27. *Three Russians*, 1915, oil on burlap
28¾ × 39½ in
(Boston, collection Mr. and Mrs. David Bakalar)

Figure 28. *Tropical Sunrise*, 1914, oil on canvas
70.3 × 104.5 cm
(Seebüll, Nolde Foundation)

Figure 29. Caspar David Friedrich, *Large Enclosure near Dresden*, 1832, oil on canvas
73.5 × 103 cm
(Dresden, Staatliche Kunstsammlungen, Gemäldegalerie Neue Meister)

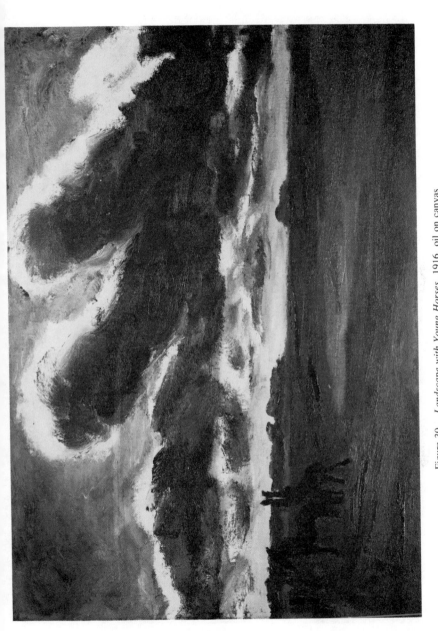

Figure 30. *Landscape with Young Horses*, 1916, oil on canvas
73.5 × 100.5 cm
(Seebüll, Nolde Foundation)

Figure 31. *Landscape, Hallig Hooge,* 1919, watercolor
34 × 48.7 cm
(Seebüll, Nolde Foundation)

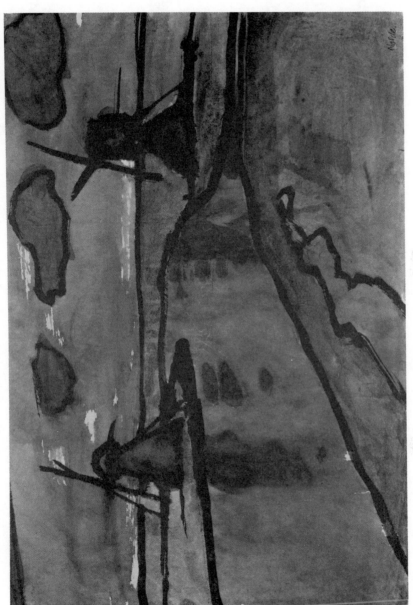

Figure 32. *Windmills*, watercolor
34 × 47.7 cm
(Seebüll, Nolde Foundation)

Figure 33. Rembrandt van Rijn, "Het Molentje" Seen from the Amsteldijk, ca. 1655, pen and
bistre wash
10.5 × 18.8 cm
(Oxford, Ashmolean Museum)

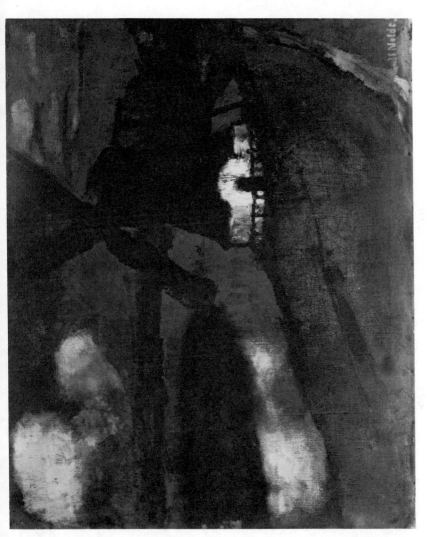

Figure 34. *Windmill*, 1924, oil on canvas
73 × 88.7 cm
(Seebüll, Nolde Foundation)

Figure 35. Rembrandt van Rijn, *The Windmill*, 1641, etching
14.4 × 20.7 cm

Figure 36. *Sultry Evening*, 1930, oil on plywood panel
73 × 100.5 cm
(Seebüll, Nolde Foundation)

Figure 37. *Northern Windmill*, 1932, oil on canvas
28¾ × 34⅝ in
(Munich, Bayerische Staatsgemäldesammlungen)

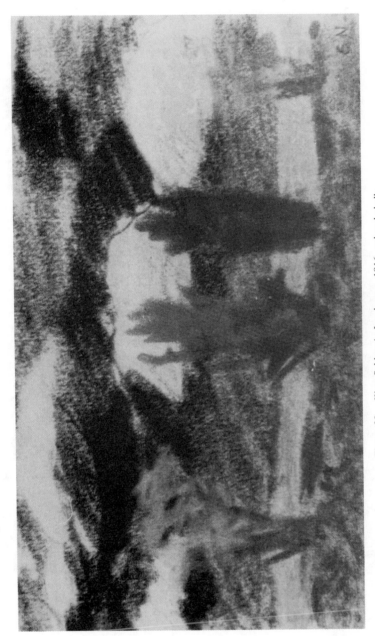

Figure 38. *West Schleswig Landscape*, 1916, colored chalk
(Seebüll, Nolde Foundation)

Figure 39. *Frisian Farm on a Canal*, 1935, oil on canvas
73.5 × 88.5 cm
(Seebüll, Nolde Foundation)

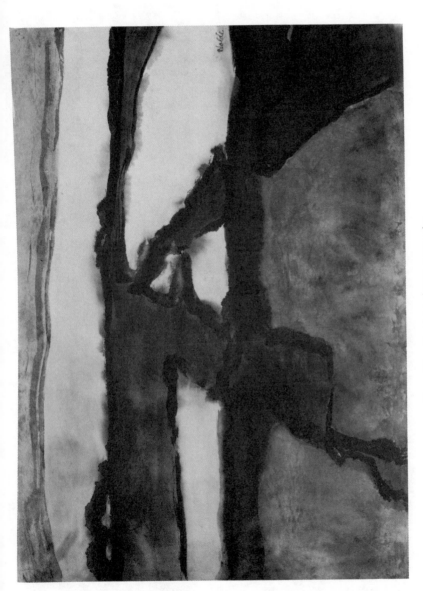

Figure 40. *Marsh Landscape*, watercolor
35.4×47.2 cm
(Seebüll, Nolde Foundation)

Figure 41. *Evening Landscape, North Frisia,* watercolor
36.3 × 47.1 cm
(Seebüll, Nolde Foundation)

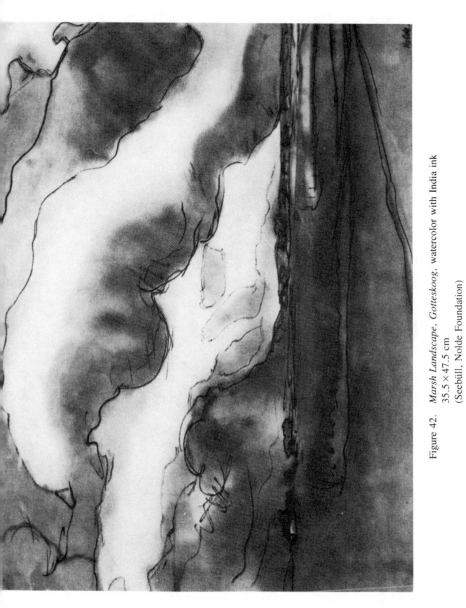

Figure 42. *Marsh Landscape, Gotteskoog,* watercolor with India ink
35.5×47.5 cm
(Seebüll, Nolde Foundation)

Figure 43. *Red and Violet Clouds*, watercolor
36.9 × 50.6 cm
(Seebüll, Nolde Foundation)

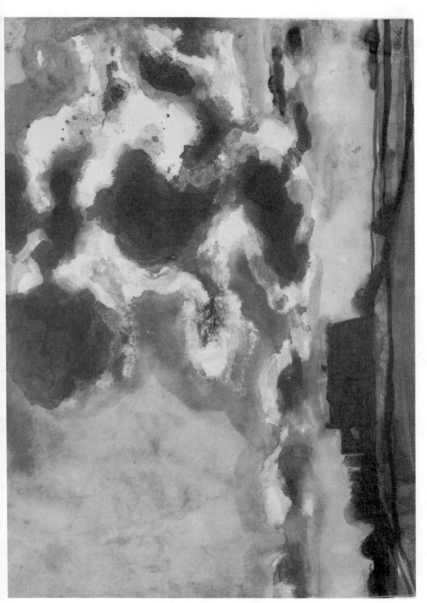

Figure 44. *Seebüll with Cloudy Skies*, after 1927, watercolor
33.6 × 46.1 cm
(Seebüll, Nolde Foundation)

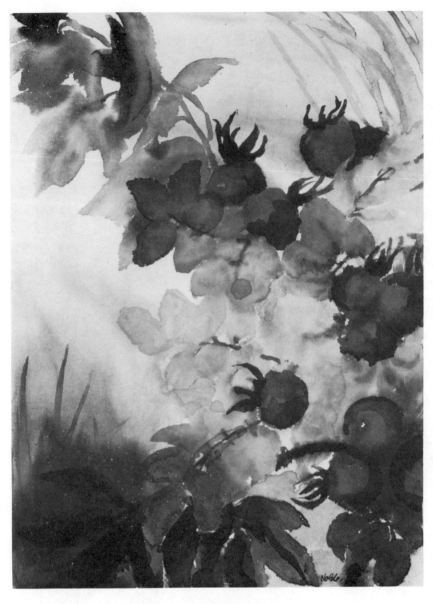

Figure 45. *Ripe Hawthorns,* watercolor
45.6 × 33.9 cm
(Seebüll, Nolde Foundation)

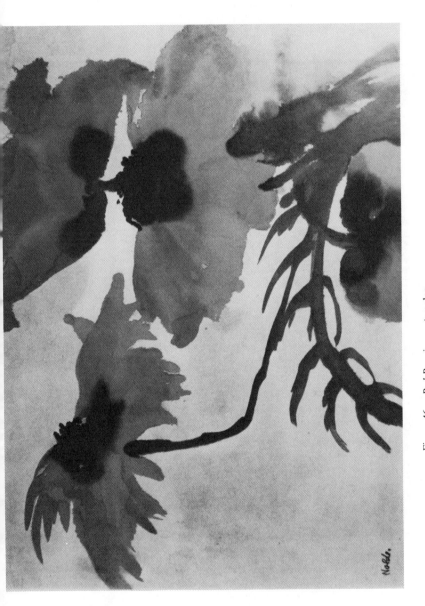

Figure 46. *Red Poppies*, watercolor
13 × 18 in
(San Francisco, collection Mr. and Mrs. Hans Popper)

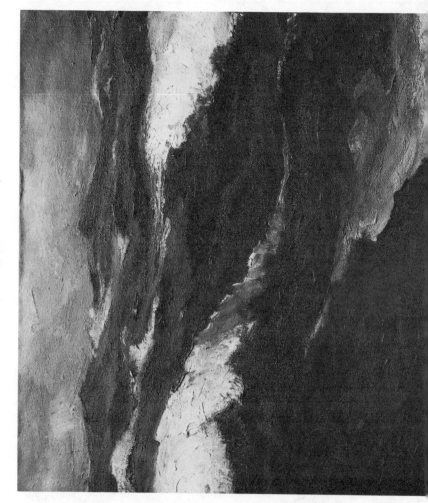

Figure 47. *The Sea III*, 1913, oil on canvas
34 × 39⅜ in
(Seebüll, Nolde Foundation)

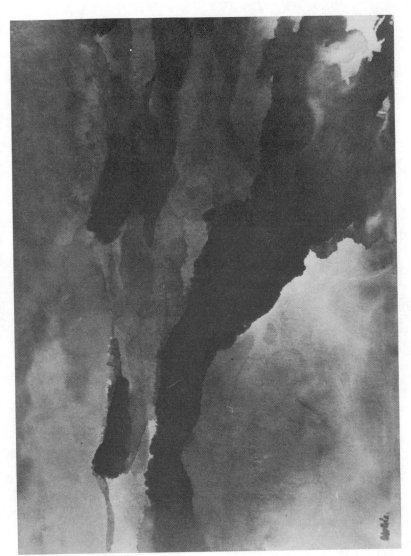

Figure 48. *High Seas*, watercolor
34.5 × 45.9 cm
(Seebüll, Nolde Foundation)

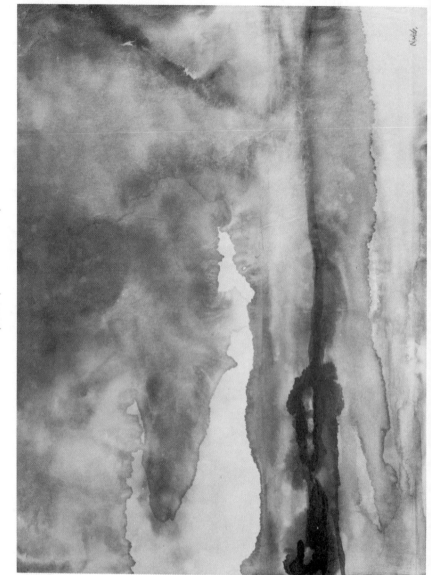

Figure 49. *Flood*, watercolor
35.5 × 47.1 cm
(Seebüll, Nolde Foundation)

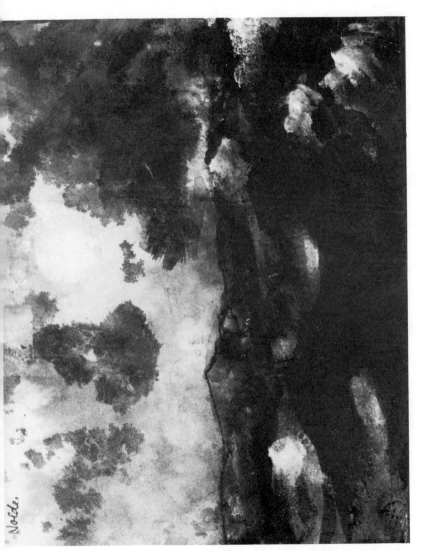

Figure 50. *Sea with Red Sun*, 1938–45, watercolor
18 × 22.8 cm
(Seebüll, Nolde Foundation)

Notes

Introduction

1. Peter and Linda Murray, *A Dictionary of Art and Artists,* 3rd ed., Harmondsworth: Penguin Books, 1972, p. 144. Nolde's painting also embodies certain attitudes which can be interpreted by the cultural historian as representative of this age. For example, Gordon Craig recognizes in Nolde's *Candle Dancers* a sense of impending doom, an expression of the worship of uncontrollable power which was so characteristic of the Expressionist artist. (Gordon A. Craig, *Germany 1866–1945,* New York: Oxford University Press, 1978, p. 221.)

2. See Richard Hamann and Jost Hermand, *Expressionismus,* Berlin: Akademie-Verlag, 1975, pp. 28–29, 62 and passim for examples of this type of evaluation and analysis.

3. Friedrich Nietzsche, *The Birth of Tragedy and the Genealogy of Morals,* trans. Francis Golffing, Garden City, N.Y.: Doubleday & Co., 1956, p. 27. I have introduced Nietzsche into the discussion at this early point because his thoughts on irrationality (at least as they were interpreted by Nolde's generation) were cardinal to the formation of the climate of restlessness and dissatisfaction which pervaded pre-1914 Germany. See Chapter 1 for further discussion.

4. Ibid., p. 23.

5. Rudolf Probst, "Emil Nolde," *Neue Blätter für Kunst und Dichtung,* vol. 2 (1920), 208–9.

6. Ibid., p. 207.

7. Ibid., p. 208.

8. *Briefe und Tagebücher von Paula Modersohn-Becker,* ed. Sophie Dorothee Gallwitz, 5th ed., Munich: Kurt Wolff Verlag, 1922, p. 111. Letter of May 27, 1900.

9. *August Macke. Franz Marc. Briefwechsel,* ed. Wolfgang Macke, Cologne: DuMont Schauberg, 1964, pp. 30–31. Letter of June 7, 1912.

10. Walter H. Sokel, *The Writer in Extremis: Expressionism in Twentieth-Century German Literature,* Stanford: Stanford University Press, 1959. Chapters 4, 5 and 6 deal with each of these themes.

11. Frederick S. Levine, *The Apocalyptic Vision: The Art of Franz Marc as German Expressionism,* New York: Harper & Row, 1979, p. 3.

12. Levine, *The Apocalyptic Vision,* p. 4.

13. The basic studies are George L. Mosse, *The Crisis of German Ideology: Intellectual Origins of the Third Reich,* New York: Grosset & Dunlop, 1964, and Fritz Stern, *The Politics of Cultural Despair: A Study in the Rise of the Germanic Ideology,* Garden City, N.Y.: Doubleday

& Co., 1965 (original edition: Berkeley: University of California Press, 1961). Stern refers to the ideology as "Germanic" rather than "Volkish" which Mosse uses. After World War I when the various movements coalesced into a single unit, its members referred to themselves as *"deutsch-völkisch."* Levine, *The Apocalyptic Vision*, pp. 9–11, mentions the major proponents of Volkish thought in the 1890s in the context of their participation in the general sense of discontent and cultural despair that characterized German intellectual life in that decade.

14. Stern, *The Politics of Cultural Despair*, p. 173.

15. Emil Nolde, *Jahre der Kämpfe, 1902–1914*, Berlin: Rembrandt Verlag, 1934, p. 198.

16. Ibid., p. 160.

17. Michael Hamburger, *From Prophecy to Exorcism: The Premisses of Modern German Literature*, London: Longmans, Green & Co., Ltd., 1965, pp. 1–2.

18. Quoted in Hamburger, *Prophecy to Exorcism*, p. 3.

19. J. P. Stern, *Re-interpretations: Seven Studies in Nineteenth-Century German Literature*, London: Thames and Hudson, 1964, p. 227.

Chapter 1

1. Quoted in Golo Mann, *The History of Germany since 1789*, New York: Praeger, 1968, pp. 278–79.

2. Rainer Maria Rilke, *Worpswede* (1902) in: *Sämtliche Werke*, vol. 5, Frankfurt/M: Insel Verlag, 1965, pp. 10–11.

3. These conclusions concerning the psychological and spiritual state of modern man, only implied in Rilke's essay on the Worpswede painters, are fully explored in *The Notebooks of Malte Laurids Briggs*, a novel which Rilke began two years after the Worpswede essay.

4. *Friedrich Hölderlin. Eduard Mörike: Selected Poems*, trans. Christopher Middleton, Chicago: The University of Chicago Press, 1972, p. 137. First and third stanzas are quoted.

5. Mann, *The History of Germany since 1789*, p. 203.

6. Elizabeth Gilmore Holt, ed., *From the Classicists to the Impressionists: Art and Architecture in the 19th Century*, Garden City, N.Y.: Doubleday & Co., 1966, pp. 63–64. The passage is from Wackenroder's collection of essays, *Effusions from the Heart of an Art-Loving Monk*, published posthumously in 1799.

7. Friedrich Ratzel, "Die deutsche Landschaft," *Deutsche Rundschau*, vol. 88 (July–September 1896), 347.

8. Cf. Otto Gmelin, "Landschaft und Seele," *Die Tat. Monatsheft für die Zukunft deutscher Kultur*, vol. 17, no. 1 (April 1925), 33.

9. (Julius Langbehn), *Rembrandt als Erzieher. Von einem Deutschen*, 21st ed., Leipzig: C. L. Hirschfeld, 1890, p. 77.

10. See Stern, *The Politics of Cultural Despair*, p. 170, footnote. The use of the term was widespread for over a generation, but its meaning was relatively secure. Not only Langbehn and his circle, but Rilke (*Briefe*, vol. 2 (1914–26), Rilke-Archiv edition, Wiesbaden: Insel Verlag, 1950, p. 483) also used the term. These qualities were also recorded in descriptions by German visitors to America during this period. Passing through Chicago in 1904, the sociologist Max Weber reflected on the interactions of a "maddening mixture of peoples"—"the Greek shining the Yankee's shoes for 5¢, the German acting as his waiter, the Irishman managing his politics

and the Italian digging his dirty ditches. With the exception of some exclusive residential districts, the whole gigantic city, more extensive than London, is like a man whose skin has been peeled off and whose entrails one sees at work." (*From Max Weber: Essays in Sociology,* ed. and trans. H. H. Gerth and C. Wright Mills, New York: Oxford University Press, 1946, p. 5.)

11. For this summary of the political situation in Schleswig-Holstein from 1848 to 1920, I have relied on relevant discussion in Mann, *The History of Germany since 1789,* and chapters 9 and 10 in Otto Brandt, *Geschichte Schleswig-Holstein,* 6th rev. ed. by Wilhelm Klüver, Kiel: Walter C. Mühlau Verlag, 1966. Lawrence D. Steefel, *The Schleswig-Holstein Question,* Cambridge, Mass.: Harvard University Press, 1932, is still the most complete study of the complicated role played by Schleswig-Holstein in German and international politics during the period 1850–66.

12. See Mosse, *The Crisis of German Ideology,* chapter 1, especially pp. 13–24, for a full discussion of the development of Volkish ideas out of Romanticism and the role played by the many travelogues published after the middle of the century in disseminating these ideas and attitudes.

13. Theodor Mügge, *Streifzüge in Schleswig-Holstein und im Norden der Elbe,* vol. 1, Frankfurt/M.: Literarische Anstalt, 1846, pp. 5–10.

14. Mosse, *The Crisis of German Ideology,* pp. 19, 23–34.

15. Ibid., pp. 19–20. This growing political conservativism in Germany in the middle nineteenth century was associated with certain developing theories of racial superiority as well as with Volkish-oriented nationalism. By the end of the century these three tendencies had been combined by most Volkish proponents to form a fully developed ideology. Cf. Adolf Bartels, *Der völkische Gedanke. Ein Wegweiser,* Weimar: Fritz Fink Verlag, 1923, p. 21, who maintains that Riehl and Gustav Freytag, the popular novelist of the 1860s and 1870s, were important contributors to the Volkish movement "even though they do not clearly profess a racial attitude." Georg Lukacs points out that much of the racial theory in the middle decades of the nineteenth century in Europe can be seen as an attempt to seek a racial basis for maintaining social class distinctions, i.e., that the aristocracy was descended from a conquering race and the peasantry was descended from a subverted race. (Georg Lukacs, *Die Zerstörung der Vernunft. Der Weg des Irrationalismus von Schelling zu Hitler,* Berlin: Aufbau-Verlag, 1955, pp. 526–27.) Riehl sought to justify similar sentiments, not by resorting to racial differences but through "natural evidence." He associated the idea of the forest with the aristocracy and public property and the field with the bourgeoisie and private ownership. In arguing for the necessity of the forest as a wilderness and a source of strength to society (renewal of vital social forces), Riehl is actually setting up a defense of the feudal social structure by association. (Riehl, *Land und Leute,* pp. 54 ff.)

16. Consider for example Hansen's dedication in the introduction: "Whoever loves his people (*Volk*), he must also wish that that *Volk* recognize itself, as well as its land and attractions, its property, its past and present, language and customs, laws and regulations, church and school, raw materials and artistic products, its needs and goals for the future and that, avoiding stupefying, embittering prejudice and particularism, it will come to comprehend the new age and associate itself with her more noble strivings. . . . For these ideological and energetic patriots is this book written." (A. U. Hansen, *Characterbildern aus den Herzogthümeren Schleswig, Holstein und Lauenburg,* Hamburg: Gustav Carl Würger, 1858, pp. vi–vii.)

17. Hansen, *Characterbildern,* pp. 64–66.

18. See Mosse, *The Crisis of German Ideology,* pp. 67–87, for the fullest examination of this Nordic mania from the 1880s until the Nazi period. The obvious inspiration and direct influence of Richard Wagner and his work must also be mentioned in this context.

19. A late example of this more nostalgic approach to the passing of traditional, rural customs and the transformation of the landscape itself is Theodor Möller's *Das Gesicht der Heimat: Natur- und Kulturbilder aus Schleswig-Holstein (The Face of Our Homeland. Images of Nature and Culture from Schleswig-Holstein),* first published in 1912. This is a slim volume and about half of the page space is taken up by photographic illustrations of landscapes, farmhouses, interiors, and other scenes. Möller frequently quotes earlier writers like Mügge or Claus Harms. In the introduction, he states his attitude toward the subject, which is one of mournful regret, and his reasons for writing the book—to record the scenes for posterity before they are eradicated once and for all. Another example of this early travel literature, Ernst Willkomm, *Wanderungen an der Nord- und Ostsee (Ramblings along the North and Baltic Seas,* 1850) was not available to me.

20. Claus Harms, ed., *Schleswig-Holsteinischer Gnomon: Ein allgemeines Lesebuch. Insonderheit für die Schuljugend,* 2nd ed., Kiel: Schwer'sche Buchhandlung, 1843, pp. 136–37. Excerpted from Rougemont's *Geography of Mankind.*

21. Harms, *Schleswig-Holsteinischer Gnomon,* p. 141.

22. Ernst Weymar, *Das Selbstverständnis der Deutschen: Ein Bericht über den Geist des Geschichtsunterrichts der höheren Schulen im 19. Jahrhundert,* Stuttgart: Ernst Klett Verlag, 1961, p. 151.

23. The best study to date of both Lagarde and Langbehn is found in Stern, *The Politics of Cultural Despair.*

24. Ibid., p. 25.

25. Ibid., p. 57; Paul de Lagarde, *Deutsche Schriften,* 4th ed., Munich: J. F. Lehmanns Verlag, 1940, p. 325. The essay in which this passage is found is "Noch einmal zum Unterrichtsgesetze," written in 1881.

26. Stern, *The Politics of Cultural Despair,* p. 59; Lagarde, *Deutsche Schriften,* p. 184. The essay from which this passage is quoted is "Über die gegenwärtige Lage des Deutschen Reiches," written in 1875.

27. Representing this point of view, the historian George Steinhausen accused Lagarde and his followers of contributing to the "de-humanization" of culture during the Wilhelmine Era rather than opposing it as they believed they were doing. (Georg Steinhausen, *Deutsche Geistes- und Kulturgeschichte von 1870 bis zur Gegenwart,* Halle: Max Niemeyer, 1931, p. 308.)

28. Stern, *The Politics of Cultural Despair,* p. 32.

29. Ibid., pp. 67–68; Lagarde, *Deutsche Schriften,* pp. 68–69. The essay in which these points are made is "Verhältnis des deutschen Staates zu Theologie, Kirche und Religion," written in 1859. The anti-Semitism implicit in this attitude is discussed in a later chapter.

30. Stern, *The Politics of Cultural Despair,* p. 77; Lagarde *Deutsche Schriften,* p. 278. From "Die Religion der Zukunft" (1878).

31. Ibid., p. 77; Lagarde, *Deutsche Schriften,* p. 273.

32. Stern, *The Politics of Cultural Despair,* pp. 123–33.

33. Ibid., p. 138.

34. Ibid., p. 132.

35. Ibid., p. 152, note.

36. Ibid., p. 131.

37. Ibid., pp. 199–200.

38. Ibid., p. 203.

39. Cornelius Gurlitt, *Die deutsche Kunst seit 1880: Ihre Ziele und Taten,* 4th rev. ed., Berlin: Georg Bondi, 1924, p. 344. Konrad Lange's *Die künstlerische Erziehung der deutschen Jugend,* Darmstadt; Arnold Bergstraesser, 1893, was the earliest serious attempt to apply Langbehn's ideals to art education.

40. Stern, *The Politics of Cultural Despair,* p. 192.

41. (Langbehn), *Rembrandt als Erzieher,* p. 24.

42. Ibid., p. 15.

43. Ibid., p. 87. Some fifty years earlier at the end of the Romantic period, Carl Gustav Carus, a student of Caspar David Friedrich, had postulated a similar correspondence between objects and climactic changes in the landscape and various states of the soul in his *Nine Letters on Landscape Painting* (C. G. Carus, *Briefe über Landschaftsmalerie, Geschrieben in den Jahren 1815–1835,* 2nd ed., Leipzig: Gerh. Fleischer, 1835, pp. 44–53; see also Holt, *From the Classicists to the Impressionists,* pp. 89–90, and Lorenz Eitner, ed., *Neoclassicism and Romanticism, 1750–1850. Sources and Documents,* vol. 2, Englewood Cliffs, N.J.: Prentice-Hall, 1970, pp. 47–52.)

44. (Langbehn), *Rembrandt als Erzieher,* p. 91.

45. Mosse, *The Crisis in German Ideology,* pp. 41–42. Cf. (Langbehn), *Rembrandt als Erzieher,* p. 98. "Whoever does not recognize the divine in nature, is not seeing nature correctly either." This is a patently Romantic concept! See, for example, Robert Rosenblum, *Modern Painting and the Northern Romantic Tradition: Friedrich to Rothko,* New York: Harper & Row, 1975, pp. 17–23, and passim, and M. H. Abrams, *Natural Supernaturalism: Tradition and Revolution in Romantic Literature,* New York: W. W. Norton and Co., 1971, pp. 97–117 and passim. This point will be discussed in more detail in later chapters regarding Nolde's own religious view of the landscape and its manifestations in his landscape paintings.

46. (Langbehn), *Rembrandt als Erzieher,* p. 19. Later Volkish writers like Adolf Bartels, also a native of Schleswig-Holstein, promoted Langbehn's concept of Volkish art. Bartels, however, infused it with an extreme racial quality that was not emphasized by Langbehn. (Adolf Bartels, *Rasse und Volkstum: Gesammelte Aufsätze zur nationalen Weltanschauung,* 2nd rev. ed., Weimar: Alexander Duncker Verlag, 1920, pp. 14–18, 46–47.)

47. Stern, *The Politics of Cultural Despair,* p. 158.

48. (Langbehn), *Rembrandt als Erzieher,* p. 16.

49. Ibid., p. 24.

50. Ibid., p. 20.

51. Stern, *The Politics of Cultural Despair,* p. 190, and (Langbehn), *Rembrandt als Erzieher,* p. 234.

52. (Langbehn), *Rembrandt als Erzieher,* pp. 234–35.

53. Ibid., p. 236.

54. Ibid.

174 *Notes for Chapter 2*

55. Ibid., pp. 236–37.

56. Ibid., p. 237.

57. Langbehn's image of Schleswig-Holstein and *Niederdeutschland* as a repository of Volkish energy and creativity did persist. It was especially cultivated after World War I by the Volkish publisher Eugen Diederichs and his monthly periodical, *Die Tat*, which regularly contained articles dealing with aspects of this region; for example, Christian Jensen, "Niederländisch-Nordfriesische Beziehungen," *Die Tat*, vol. 8, no. 12 (March 1917), 1104–12, and the entire March 1924 issue (*Schleswig-Holsteinisches Sonderheft*, vol. 15, no. 12).

58. (Langbehn), *Rembrandt als Erzieher*, p. 328.

59. Ibid., p. 325. This passage is partially translated in Stern, *The Politics of Cultural Despair*, p. 169.

60. Stern, *The Politics of Cultural Despair*, pp. 345–46.

61. Ibid., p. 23.

62. Ibid., p. 24.

63. Ibid., p. 140.

64. Mosse, *The Crisis of German Ideology*, p. 65. These incomplete adaptions, misunderstandings and even intentional misinterpretations of Nietzsche's writings are as important to the influence exerted by Nietzsche in the early twentieth century as was the actual philosophy contained in these writings. See Mosse, pp. 205–12, and Hamburger, *From Prophecy to Exorcism*, pp. 29–53, for examinations of some of these misinterpretations and their influence.

65. Ibid., p. 26. Nolde records a section of a conversation with a friend which is almost identical with this passage. It will be discussed in detail in the next chapter.

66. (Langbehn), *Rembrandt als Erzieher*, p. 12. In this passage Langbehn recognizes these "supremely Germanic qualities" not only in the paintings of Rembrandt, but also in the music of Beethoven. Nietzsche, in discussing Dionysiac ritual, also turns to Beethoven as a modern example: "If one were to convert Beethoven's 'Paean to Joy' into a painting, . . . one might form some apprehension of Dionysiac ritual." (*The Birth of Tragedy*, p. 23.) He later defines the qualities of Dionysiac music as "the heart-shaking power of tone, the uniform stream of melody, the incomparable resources of harmony" all controlled by "the desire to express the very essence of nature symbolically." (Ibid., p. 27.)

67. Nolde records that Nietzsche's *Zarathustra* was one of the four great creations of Nordic culture. The other three were the Eddas, Grünewald's Isenheim altarpiece and Goethe's *Faust*. (Emil Nolde, *Jahre der Kämpfe*, Berlin: Rembrandt Verlag, 1934, p. 175.)

Chapter 2

1. *Festschrift für Emil Nolde anlässlich seines 60. Geburtstages*, Dresden: Neue Kunst Fides, 1927, p. 26. A rather unsuitable English translation of this appreciation appeared in *Arts*, vol. 30, no. 2 (November 1955), 15.

2. Emil Nolde, *Reisen. Ächtung. Befreiung. 1919–1946*, Cologne: DuMont Schauberg, 1967, p. 60.

3. These four volumes are the major source of biographical information on Nolde. A second, revised edition of *Das eigene Leben* (Flensburg, Christian Wolff, 1949), as well as original editions of the other three volumes and a one-volume abridged edition of all four volumes (*Mein Leben*, Cologne: DuMont Schauberg, 1976), were available to me. See the postscript by Martin Urban in *Mein Leben*, pp. 421–22, for the publication history of the various volumes.

4. Emil Nolde, *Das eigene Leben, 1867–1902*, 2nd ed., pp. 12–13. For a discussion of the characteristic father-son conflict of this period and its manifestation in Expressionist drama, see Richard Samuel and R. Hinton Thomas, *Expressionism in German Life, Literature and Theatre 1910–1924* (1939), Philadelphia: Albert Saifer, 1971, pp. 29–33.

5. Nolde, *Das eigene Leben*, p. 14. See Mosse, *The Crisis of German Ideology*, p. 154, for a discussion of the study of *Heimatkunde* at this time and its Volkish overtones.

6. Weymar, *Das Selbstverständnis der Deutschen*, p. 156.

7. Ibid., pp. 156–57.

8. Nolde, *Das eigene Leben*, p. 56.

9. Weymar, *Das Selbstverständnis der Deutschen*, p. 168, n. 55.

10. The entire passage is quoted in Weymar, pp. 169–71. This penchant for describing the ideal German character in terms of the qualities of the ancient Germans was as prevalent and as respectable in a scholarly sense in the 1920s as it was in Daniel's day. See, for example, Wilhelm Brepohl, "Der nordische Mensch, sein Lebensgefühl und seine Heimat," *Die Tat*, vol. 17, no. 1 (April 1925), 23–32, where a character study similar to Daniel's is put forth using similar sources.

11. Weymar, *Das Selbstverständnis der Deutschen*, pp. 179–81.

12. Ibid., p. 167.

13. Stern, *The Politics of Cultural Despair*, p. 106.

14. Lagarde's ideas of educational reform found their fullest application in the educational theories put forth by Ludwig Gurlitt after the turn of the twentieth century in his various writings. See Mosse, *The Crisis of German Ideology*, pp. 158–59, for a discussion of Gurlitt's contribution.

15. Weymar, *Das Selbstverständnis der Deutschen*, pp. 164–65.

16. Nolde, *Das eigene Leben*, p. 64.

17. Ibid., pp. 65–69. A small exhibition catalogue, *Emil Nolde in Flensburg*, Flensburg: Städtischer Museum, January 8–29, 1967, covers this period in more detail than I wish to here.

18. Konrad Lange, *Die künstlerische Erziehung der deutschen Jugend*, Darmstadt: Arnold Bergstraesser, 1893, pp. 53–54.

19. Lange, *Die künstlerische Erziehung*, pp. 140–41, 143–44.

20. Ibid., p. 188.

21. Quoted in Peter Selz, *Emil Nolde*, New York: Doubleday, 1963, p. 51.

22. Nolde, *Das eigene Leben*, pp. 99–100.

23. Ibid., p. 200.

24. Mosse, *The Crisis of German Ideology*, pp. 14–16, 26.

25. Nolde, *Das eigene Leben*, pp. 141–42.

26. Rosenblum, *Modern Painting and the Northern Romantic Tradition*, pp. 132–33.

27. The Volkish sun worshipers even had a resident artist, Fidus (Hugo Höppener), whose art served as a model for later depictions of the ritual by Nazi artists. For examples of this aspect of Volkish thought, see Mosse, *The Crisis of German Ideology*, pp. 58–60, 71–72. The view of the Nordic man as a being "drawn to the sun" abounds in Volkish writings, for example,

Ratzel, "Die deutsche Landschaft," pp. 350–51, or Brepohl, "Der nordische Mensch, sein Lebensgefühl und sein Heimat," pp. 30–31. The major monograph on Fidus is Janos Frescot et al., *Fidus 1868–1948. Zur aesthetischen Praxis bürgerlicher Fluchtbewegungen,* Munich: Rogner and Bernhard, 1972.

28. Nolde, *Reisen. Ächtung. Befreiung,* p. 57.

29. Nolde, *Das eigene Leben,* p. 175. The existence of a pendant drawing, *Mask of Indolence,* however, does suggest that Nolde was thinking in more general terms of depicting states of being.

30. Ibid., p. 185.

31. Fritz Novotny, *Painting and Sculpture in Europe 1780–1880,* Harmondsworth, Middlesex, England: Penguin Books, 1960, p. 298.

32. Rosenblum, *Modern Painting and the Northern Romantic Tradition,* pp. 133–35.

33. Nolde, *Das eigene Leben,* pp. 254–55.

34. Rosenblum, *Modern Painting and the Northern Romantic Tradition,* p. 133.

35. Nolde, *Das eigene Leben,* pp. 191–92.

36. Ibid., p. 207.

37. See Eitner, *Neoclassicism and Romanticism,* vol. 2, pp. 42–47.

38. Nolde, *Das eigene Leben,* p. 208.

39. Ibid., pp. 217–18.

40. Ibid., pp. 269–70. In Paris, Nolde had admired the ability of Goya and Rembrandt to find inspiration "in the darkest regions." (Ibid., p. 245.)

41. Ibid., p. 281.

42. Stern, *The Politics of Cultural Despair,* pp. 147–52, and Olaf Klose and Eva Rudolph, *Schleswig-Holsteinisches Biographisches Lexikon,* vol. 3, Neumünster: Karl Wachholtz Verlag, 1974, pp. 220–23.

43. Stern, *The Politics of Cultural Despair,* p. 150.

44. Nolde, *Das eigene Leben,* p. 285.

45. The letter of August 7, 1901, is reprinted at the end of Nolde, *Reisen, Ächtung, Befreiung,* p. 173.

46. Emil Nolde, *Briefe aus den Jahren 1894–1926,* ed. Max Sauerlandt, Berlin: Furche-Kunstver-lag, 1927, pp. 35–36.

47. The letter is translated in Werner Haftmann, *Emil Nolde. Unpainted Pictures,* New York: Abrams, 1971, pp. 30–31.

48. Hans Fehr, *Emil Nolde. Ein Buch der Freundschaft,* Cologne: DuMont Schauberg, 1957, pp. 23–24.

49. Nolde, *Das eigene Leben,* p. 189.

50. Ibid., p. 292.

51. Ibid., p. 294. Nolde does not give the dates for either event, and there is some disagreement among various sources. Werner Haftmann (*Emil Nolde,* New York: Abrams, n.d. (1959), p. 41) gives 1901 as the year for both. Hans Fehr (*Emil Nolde,* p. 34) says Emil and Ada were married in Copenhagen in 1902.

Chapter 3

1. Stern, *The Politics of Cultural Despair*, pp. 156–57, footnote.

2. Ibid., p. 158.

3. Nolde, *Jahre der Kämpfe*, p. 94.

4. Ibid., p. 185. Translated in Victor H. Miesel, ed., *Voices of German Expressionism*, Englewood Cliffs, N.J.: Prentice-Hall, Inc., 1970, p. 37.

5. Nolde, *Jahre der Kämpfe*, p. 185. Translated in Herschel B. Chipp, ed., *Theories of Modern Art*, Berkeley: University of California Press, 1968, p. 148.

6. Nolde, *Jahre der Kämpfe*, p. 229.

7. Nolde, *Reisen, Ächtung, Befreiung*, p. 35.

8. (Langbehn), *Rembrandt als Erzieher*, p. 19.

9. Ibid., p. 209.

10. Nolde, *Jahre der Kämpfe*, pp. 14–17.

11. Ibid., p. 18.

12. Ibid., p. 19.

13. Ibid., p. 21.

14. Ibid., pp. 28–31.

15. Ibid., p. 52.

16. Ibid., pp. 61–63.

17. Ibid., pp. 75–79, and Haftmann, *Emil Nolde*, p. 41.

18. Ibid., p. 79. The numbers following the title *Phantasien* refer to their catalogue number in Schiefler's volumes. See bibliography.

19. Ibid., p. 81.

20. Ibid., p. 87.

21. Nolde, *Jahre der Kämpfe*, pp. 90–91. The full text of the letter is translated in Selz, *German Expressionist Painting*, p. 84.

22. Nolde, *Jahre der Kämpfe*, p. 91.

23. Ibid., p. 92.

24. Selz, *German Expressionist Painting*, p. 78.

25. Ibid., p. 79.

26. Miesel, *Voices of German Expressionism*, p. 16. This passage is from Kirchner's *Chronik der Brücke*, written in 1913.

27. Nolde, *Jahre der Kämpfe*, p. 92.

28. Ibid. Schmidt-Rottluff also recognized that Nolde's reasons for leaving the *Brücke* were the result of deeper differences of personality. See Selz, *German Expressionist Painting*, p. 120.

29. Haftmann, *Emil Nolde*, pp. 41–42.

30. Ibid., p. 88. Translated in Selz, *Emil Nolde*, p. 60. Munch also engaged in similar practices, placing his finished canvases outside before the oils had dried completely and allowing the elements to work on them for several days. See J. P. Hodin, *Edvard Munch*, New York: Praeger, 1972, p. 202.

31. Ibid., pp. 93–94.

32. Flowers play an important role in Philipp Otto Runge's unfinished *Times of Day* series. See Rosenblum, *Modern Painting and the Northern Romantic Tradition*, pp. 47–48, and Runge's own statement in a letter to Ludwig Tieck that "with regard to all flowers and trees it becomes clearer to me and always more certain, how in each is contained a certain human spirit, concept, or feeling, and it is very clear to me that it must have originated in Paradise." A translation of the entire text of this letter appears in Holt, ed., *From the Classicists to the Impressionists*, pp. 78–81.

33. Rosenblum, *Modern Painting and the Northern Romantic Tradition*, pp. 136–37.

34. Ibid., pp. 178–80.

35. Will Grohmann, *Paul Klee*, New York: Abrams, n.d. (1958), p. 181. A translation of the full text of Klee's *Creative Credo* can be found in Miesel, *Voices of German Expressionism*, pp. 83–88.

36. Selz, *German Expressionist Painting*, p. 121, note 4.

37. Hugh Honour, *Romanticism*, New York: Harper & Row, 1979, p. 313. Honour discusses the Romantic image of the child in this section of his book, pp. 311–15.

38. See Rosenblum, *Modern Painting and the Northern Romantic Tradition*, pp. 52–53, for further discussion of this painting.

39. Stern, *The Politics of Cultural Despair*, pp. 168–69.

40. William Butler Yeats, "Among School Children," in *The Norton Anthology of English Literature*, vol. 2, ed. M. H. Abrams et al., New York: W. W. Norton & Co., Inc., 1968, p. 1588.

41. Nolde, *Jahre der Kämpfe*, p. 114.

42. Karl Müllenhoff, ed. *Sagen, Märchen und Lieder der Herzogtümer Schleswig, Holstein und Lauenberg* (1845), rev. ed. by Otto Mensing, Schleswig: Julius Bergas Verlag, 1921, p. xxiii.

43. These objects are reproduced in various sources including the exhibition catalogue, *Plastik und Kunsthandwerk von Malern des deutschen Expressionismus*, Schleswig: Schleswig-Holsteinisches Landesmuseum, August 28–October 2, 1960; Hamburg: Museum für Kunst und Gewerbe, October 14–November 3, 1960.

44. Nolde, *Jahre der Kämpfe*, p. 99.

45. Ibid.

46. Ibid., p. 100.

47. Selz, *Nolde*, p. 52.

48. Nolde, *Jahre der Kämpfe*, p. 137.

49. Otto Gmelin, "Landschaft und Seele," p. 39.

50. Ibid.

51. Nolde, *Jahre der Kämpfe*, pp. 102–5. This translation by Ernest Mundt appears in Chipp, ed., *Theories of Modern Art*, pp. 146–47. I have substituted "fervor" for "tenderness" as the translation of the German *"Innigkeit"* because I feel this comes closer to Nolde's intentions in the context of this passage and certainly closer to what is actually depicted in the painting.

52. See Holt, ed., *From the Classicists to the Impressionists*, p. 79, and Mosse, *The Crisis of German Ideology*, pp. 15–17, 25.

53. Selz, *Nolde*, p. 19. Selz points out that the faces of the disciples were probably modeled on Nolde's studies of North Frisian farmers. Compare, for example, the profile face of the disciple at the far right center with the woodcut head *Serf* of 1912 (Sch. H117) or the head of the disciple just to the left of Christ and across the table from Him with the woodcut head *Knight* of 1906 (Sch. H31).

54. Nolde, *Jahre der Kämpfe*, p. 105.

55. Ibid., pp. 105–6. The translation quoted here is again that of Ernest Mundt (Chipp, ed., *Theories of Modern Art*, p. 147).

56. Ibid., p. 107. Translated in Chipp, ed., *Theories of Modern Art*, p. 149.

57. Ibid., p. 106. See Chipp, ed., *Theories of Modern Art*, p. 147.

58. Ibid., p. 107, See Chipp, ed., *Theories of Modern Art*, p. 148.

59. Nolde mentions in the first volume of his autobiography an evangelical movement which swept through Schleswig-Holstein in the last decade of the nineteenth century, gathering members of Nolde's own family in its wake. Although the nature of his personality at the time did not permit him to participate in this fervent revival of faith, Nolde was not entirely unsympathetic to its effects. (*Das eigene Leben*, p. 137.)

60. Nolde, *Jahre der Kämpfe*, p. 108. See Chipp, ed., *Theories of Modern Art*, p. 105.

61. Stern, *The Politics of Cultural Despair*, p. 68.

62. Ibid., pp. 77–78.

63. Ibid., pp. 114–28. In this chapter, Stern outlines the nature of Lagarde's influence after his death and the growing acceptance of his ideas on two fronts in accordance with a "hard" or "soft" interpretation of Lagarde's writings.

64. (Langbehn), *Rembrandt als Erzieher*, p. 25. See Chapter 1 of the present study for the relevant description of Langbehn's appreciation of Rembrandt's religious nature.

65. Nolde, *Jahre der Kämpfe*, p. 190.

66. Ibid., p. 225.

67. Ibid., pp. 173–74. This translation is found in Miesel, *Voices of German Expressionism*, p. 33.

68. Carl Georg Heise, "Emil Nolde. Wesen und Weg seiner religiösen Malerei," *Genius*, vol. 1, no. 1 (1919), p. 26. The particular phrasing of Heise's praise in this passage and elsewhere in the article would suggest that he consulted Nolde personally about the facts and the artist's intentions as they related to the paintings discussed.

69. Nolde, *Jahre der Kämpfe*, p. 26.

70. Selz, *Emil Nolde*, pp. 26–27, note 18.

71. Selz, *German Expressionist Painting*, p. 122.

72. Selz, *Emil Nolde*, p. 27.

73. G. F. Hartlaub, *Kunst und Religion,* Leipzig: Kurt Wolff Verlag, 1919, p. 86.

74. Ibid., p. 87.

75. Ibid.

76. Nolde, *Jahre der Kämpfe,* p. 141. Nolde records the comment in Liebermann's Berlin dialect: "Wenn det Bild ausjestellt wird, lege ick mein Amt nieder." There is some disagreement concerning the exact exhibition, 1909 or 1910, for which the *Pentecost* was refused. Werner Haftmann believes Nolde submitted it to the jury in 1909 (*Emil Nolde,* p. 41) Nolde implies it was sent in 1910, and there is no official list of what works were rejected by the juries during those years.

77. Ibid.

78. Nolde included the text of the last half of the letter dated December 10, 1910, in his autobiography (*Jahre der Kämpfe,* pp. 142–43). Scheffler reprinted the first part of the letter ("Erklärung," *Kunst und Künstler,* vol. 9 (January 1911), 210–11). The entire text, which is addressed to the editor, reads:

> I thank you for reproducing two of my drawings in *Kunst und Künstler* (p. 152 of the journal). It has been some years since you promised to bring out an article on me, but I can forgive you for that because I know under what difficult circumstances you edit *Kunst und Künstler* and how much you must publish your views under [outside] influence. For the words which accompanied the reproductions you must certainly not expect that I give you any thanks, for under the pretense of being benevolent you have actually written as negatively as possible about me and the other [artists] discussed. We know well that a new art journal will defend our views, as well as *Kunst und Künstler* supports the views and interests of the artists of the old school, where everything stands more or less under the sign "Liebermann." It is the case with the clever, old Liebermann as it has been with many a clever man before him: he doesn't know his limits. His most important life's work: his agitating efforts for the Secession and the artistic point of view for which it strove, scribbled and quarreled; he now seeks to rescue it and becomes nervous and rambling in the process. He tries to achieve the same thing with his art. He sees to it that as much as possible is written and published about himself, he acts, paints and exhibits as much as he can. The result of this is that the youngest generation [of artists], sick and tired of this, can and will no longer bear to look at his works, that they recognize how calculated all this is, how weak and *kitschig* is not only his recent work, but much of his earlier work. The critics will soon come to the same conclusion, then public opinion will follow and so the art house of Liebermann, founded on such insufficient quality, will disappear. One can hardly understand, that he did not rid himself years ago of everything that exhausted his energy to live entirely from his art—but the reason for that is inherent in this (i.e. his art). He himself hastens the inevitable; we young artists can calmly watch this happen.

Scheffler's editorial comments to this letter were predictable and understandable. He strongly denied that his journal was influenced by Liebermann or any other authority beyond "the authority of good art." That Liebermann and his art embodied the highest principles of the "good art" was beyond debate and therefore he was asked by the editor from time to time to express his opinions in the journal. According to Scheffler, Nolde was never promised an article in his journal. Scheffler could not resist criticizing Nolde for constantly referring to his cause as that of the young German artists. "One must be quite naive to include oneself as a forty-three year old in the ranks of youth." Finally, Scheffler accused Nolde himself of being self-serving and commercially motivated in his actions regarding the Liebermann letter. Nolde,

of course, denied this (*Jahre der Kämpfe,* p. 144), but his true motivations as he described them were not always clearly perceived by his fellow artists. In a letter of June 1, 1912, to August Macke, Franz Marc wrote, "I'm curious about Nolde," and went on to admit a bit of uncertainty concerning Nolde's commercial motives. "Is he just a clever publicist?" Marc conjectures. (Wolfgang Macke, ed., *August Macke. Franz Marc. Briefwechsel,* Cologne: DuMont Schauberg, 1964, pp. 130–31.)

79. Nolde, *Jahre der Kämpfe,* p. 146. The entire Liebermann incident covers pp. 143–50 in this volume.

80. Selz, *Emil Nolde,* p. 28.

81. Paul Ortwin Rave, *Kunstdiktatur im dritten Reich,* Hamburg: Verlag Gebruder Mann, 1949, p. 74. Nolde became a member of the NSDAP in North Schleswig upon its formation. Rave does not give the year.

82. Otto Rank, *Beyond Psychology* (1941), quoted in Ernest Becker, *Escape from Evil,* New York: The Free Press, 1975, p. 91.

83. Mosse, *The Crisis of German Ideology,* pp. 88–89.

84. Ibid., p. 15.

85. Ibid., pp. 27–29.

86. This view of the Jewish people was a major contributing factor to the growth of anti-Semitism in late nineteenth-century Germany. See Stern, *The Politics of Cultural Despair,* p. 376, note 9, for the most important studies of this phenomenon in English. To this list can be added a recent book by George Mosse, *Germans and Jews* (New York, 1970).

87. Nolde, *Jahre der Kämpfe,* p. 122. In the context of the discussion from which this passage is taken, Nolde is referring to artistic as well as sexual interactions when he warns against racial intermixing.

88. Adolf Hitler, *Mein Kampf,* trans. Ralph Mannheim, Boston: Houghton Mifflin Company, 1943, p. 285.

89. Ibid., p. 296.

90. Nolde maintained that the works of art he produced in New Guinea were uninfluenced by the native art, that, for example, the wooden statuettes he carved there "remained in emotion and execution as active Nordic German as the Old German carved statues are—and I myself am." (*Jahre der Kämpfe,* p. 177.)

91. Ibid., p. 124.

92. See his letter of September 14, 1911, to Gustav Schiefler (*Jahre der Kämpfe,* pp. 186–87). Nolde's problems with the Nazi government will be discussed in the conclusion of this study, but it is worth noting here that, had he been sufficiently aware of the political climate in 1934 and had he chosen to do so, Nolde could have emphasized his struggles with Liebermann and Paul Cassirer as a racial conflict rather than defending himself against the charges of anti-Semitism. If he had taken this course whether he really believed it to be the case or not, the second volume of his autobiography might have found more favor with the Nazi censors. That he did not paint the scene this way and even included in this volume rather tolerant statements about Jews and other "inferior" races suggests that the nature of Nolde's racial thought was in this respect very different from the racism officially espoused by the National Socialists.

93. Ibid., p. 159.

94. Ibid., pp. 234–35. The last three paragraphs are translated in Miesel, *Voices of German Expressionism*, pp. 40–41. The emphasis is my own. The year Nolde gives is important. It is one of the few times he includes a date as a reference in a passage describing a particular mental state. The period around 1912 was a fateful time for many German artists of the Expressionist generation, especially for Marc and Kandinsky whose apocalyptic vision was even more developed than Nolde's. It was also a turning point for Expressionist literature. See Michael Hamburger's essay, "1912," in *Reason and Energy: Studies in German Literature*, London: Routledge & Kegan Paul, 1957, pp. 213–36, which deals with this period in German literature.

95. (Langbehn), *Rembrandt als Erzieher*. The passages in the order they appear are taken from pages 176, 207, 175, 286 and 329, respectively.

96. Ibid., p. 109. Miesel includes a similar passage in his anthology (*Voices of German Expressionism*, p. 40).

97. Ibid., pp. 213–14. The almost untranslatable *Helldunkel*, referring to the dark, but glowing quality of Rembrandt's paintings and their strong contrast in light and dark, is the same term used repeatedly by Langbehn in his appreciation of Rembrandt (*Rembrandt als Erzieher*, pp. 89–90). For a discussion of the *Sonderbund* exhibition, see Selz, *German Expressionist Painting*, pp. 241–49.

98. Nolde describes his desire to be left alone to paint in virtually the same manner in a later passage (Emil Nolde, *Welt und Heimat. Die Südseereise 1913–1918* (1936), Cologne: DuMont Schauberg, 1965, p. 139).

99. Nolde, *Jahre der Kämpfe*, pp. 161–62.

Chapter 4

1. Nolde, *Jahre der Kämpfe*, pp. 172–74. This translation is from Chipp, ed., *Theories of Modern Art*, pp. 150–51.

2. Ibid.

3. Nolde in ibid., p. 177. This translation is from Miesel, *Voices of German Expressionism*, pp. 35–36.

4. Sauerlandt, ed., *Nolde, Briefe*, pp. 102–3. A letter of April 14, 1914, written just before his departure back to Europe.

5. Nolde, *Welt und Hiemat*, p. 10. The sensitive, but seemingly objective description of a North Schleswig farmhouse with all its traditional furnishings contained in this passage recalls similar passages in Mügge's proto-Volkish travelogue of Schleswig-Holstein and the attitude of nostalgic regret at the passing of these traditional articles corresponds to the "soft" Volkish complaints voiced by Möller and other Volkish writers. See Chapter 1 for a more detailed discussion of these writers. Nolde was undoubtedly influenced in his awareness and appreciation of these folk artifacts through his own family history and especially through the strong interests of his brother, Hans, in this area of *Heimatkunde*.

6. Ibid., p. 11.

7. Ibid., pp. 15–48, and Nolde's map of the trip, p. 129. See Selz, *Emil Nolde*, p. 33, for a summary of the itinerary.

8. Ibid., p. 48.

9. Ibid., pp. 145–46.

10. Ibid., pp. 57–58. The actual sketching trip which resulted in the finished oil painting is described on page 67.

11. Nolde, *Welt und Heimat,* pp. 48, 57–58, 65, 106–7.

12. Ibid., p. 88

13. Ibid., pp. 124–25.

14. Riehl, *Land und Leute,* pp. 53–73.

15. Nolde, *Welt und Heimat,* pp. 146–47.

16. Selz, *Nolde,* p. 33.

17. C. G. Jung, *Symbols of Transformation: An Analysis of the Prelude to a Case of Schizophrenia* (1912), 2nd ed., trans. R. F. C. Hull, Princeton: Princeton University Press, 1956 (Bollingen Series, XX), p. xxiv.

18. Nolde, *Welt und Heimat,* p. 123. He concludes this passage, which includes a description of a dance ritual in Mandalay, with the sentence: "We experienced the concealed, trembling mysticism, the throbbing heart of Asia."

Chapter 5

1. Nolde, *Welt und Heimat,* p. 137.

2. Ibid., pp. 139–40, and Nolde, *Jahre der Kämpfe,* p. 197.

3. Nolde, *Welt und Heimat,* p. 138.

4. Nolde, *Jahre der Kämpfe,* pp. 215–16.

5. Nolde, *Welt und Heimat,* p. 139. "The task which lay before me was so distant and difficult that it would require every ounce of strength and spirit if I could hope in any way to become an artist of the highest measure as it was whispered to my soul in these splendid hours" (p. 148).

6. Nolde, *Jahre der Kämpfe,* p. 184.

7. Friedrich's painting is discussed in Rosenblum, *Modern Painting and the Northern Romantic Tradition,* pp. 97–98.

8. For example, Nolde, *Welt und Heimat,* p. 138.

9. Gmelin, "Landschaft und Seele," p. 33.

10. (Langbehn), *Rembrandt als Erzieher,* pp. 87–88.

11. Nolde, *Welt und Heimat,* p. 147.

12. Karl Ludwig Schneider, "Das Bild der Landschaft bei Georg Heym and Georg Trakl," in Hans Steffen, ed., *Der deutsche Expressionismus. Formen und Gestalten,* Göttingen: Vanderhoeck & Ruprecht, 1965, p. 46.

13. Ibid., p. 47.

14. The entire poem is translated by R. S. Hillyer in Oluf Friis, ed., *A Book of Danish Verse,* New York: The American-Scandinavian Foundation, 1922, pp. 14–21.

15. Nolde, *Welt und Heimat,* pp. 11–12; Nolde, *Reisen. Ächtung, Befreiung,* p. 13.

16. See Chapter 1 of this study.

17. Nolde also completed this composition in a lithographic version (Sch. L82) of the same year.

18. Brandt, *Geschichte Schleswig-Holstein*, pp. 267–72.

19. Selz, *Emil Nolde*, p. 42.

20. Nolde, *Welt und Heimat*, p. 160.

21. Ibid., pp. 10–11, Nolde, *Jahre der Kämpfe*, p. 110, and Nolde, *Reisen. Ächtung, Befreiung*, p. 52.

22. Nolde, *Jahre der Kämpfe*, pp. 111–12.

23. Nolde, *Reisen. Ächtung, Befreiung*, pp. 50–51.

24. Sauerlandt, ed., *Nolde, Briefe*, p. 175.

25. Nolde, *Reisen. Ächtung, Befreiung*, pp. 82–83.

26. Ibid., p. 37.

27. See Chapter 2, note 54, of this study.

28. Mosse, *The Crisis of German Ideology*, pp. 14–15, 26–27.

29. See Gmelin, "Landschaft und Seele," p. 36, and Chapter 1, note 73, and Chapter 2 of this study.

30. Nolde, *Jahre der Kämpfe*, p. 110.

31. Nolde, *Reisen, Ächtung, Befreiung*, p. 52.

32. Quoted in Haftmann, *Emil Nolde, Unpainted Pictures*, opposite plate 24.

33. See the previous discussion in Chapter 2.

34. Rilke, *Worpswede* (1902), pp. 26–27.

35. Schneider, "Das Bild der Landschaft by Georg Heym und Georg Trakl," p. 51.

36. This experience is conveyed in the poem "Die Fläche" ("The Plains") quoted by Schneider. The first stanza reads:
 > Wo sich der kahlen Ebene kahler Rand
 > Verliert in blasser Himmel Einerlei,
 > Brennen drei Wolken wie in einer Hand,
 > Die vor sich trägt der Toten Fackeln drei.

 The repetition of "*kahl*" (barren) and references to emptiness and death in the description of the landscape combine to create an image of metaphysical dread.

37. M. H. Abrams, *Natural Supernaturalism: Tradition and Revolution in Romantic Literature*, New York: W. W. Norton and Co., Inc., 1971, p. 68.

38. Rosenblum, *Modern Painting and the Northern Romantic Tradition*, passim.

39. Ibid., p. 15.

40. Abrams, *Natural Supernaturalism*, pp. 97–98.

41. "Duality has always held an important place within my paintings and also in my graphics." (Nolde, *Jahre der Kämpfe*, p. 181.) "I often think about the dual nature of the individual, that union of opposites whose struggles and mutual friction generate the heat that gives rise to art." (Quoted in Haftmann, *Unpainted Pictures*, opposite plate 34.)

42. Abrams, *Natural Supernaturalism*, pp. 98 ff.

43. (Langbehn), *Rembrandt als Erzieher*, p. 90.

44. Rosenblum, *Modern Painting and the Northern Romantic Tradition*, p. 14.

45. "The unconscious consists, among other things, of remnants of the undifferentiated archaic psyche. . . . The unconscious . . . is universal; it not only binds individuals together into a nation or race, but unites them with the men of the past and with their psychology." (Jung, *Symbols of Transformation*, pp. 176–77.) Langbehn and other Volkish writers held beliefs similar to this, but used the terms "spirit" or "soul" in place of "unconscious."

46. See C. G. Jung, "The Phenomenology of the Spirit in Fairy Tales," in C. G. Jung, *Psyche and Symbol*, ed. Violet S. de Lazlo, Garden City, N.Y.: Doubleday Anchor Books, 1958, pp. 61–112, for an example of the application of modern-day depth psychology to the analysis of traditional fairy tales in an attempt to explore the mythic consciousness as it is revealed in these tales.

47. A letter of October 14, 1919. Quoted in Urban, *Emil Nolde. Landschaften*, pp. 30–31.

48. Mircea Eliade, *Patterns in Comparative Religion*, trans. Rosemary Sheed, Cleveland: World Publishing Co., 1963, p. 38.

49. Nolde, *Jahre der Kämpfe*, p. 113.

50. Eliade, *Patterns in Comparative Religion*, pp. 302–3.

51. Juan Eduardo Cirlot, *A Dictionary of Symbols*, 2nd ed., trans. Jack Sage, New York: Philosophical Library, Inc., 1972, p. 104.

52. Selz, *Emil Nolde*, p. 49.

53. Jung, *Symbols of Transformation*, pp. 100–101, 225.

54. Eliade, *Patterns in Comparative Religion*, pp. 192–93.

55. Ibid., pp. 259–60, and especially p. 314.

56. Nolde, *Jahre der Kämpfe*, p. 96. Partially translated in Selz, *Emil Nolde*, p. 38.

57. Nolde, *Reisen, Ächtung, Befreiung*, pp. 104–9. These weeks on Sylt were another period of intense creative activity for the artist, accompanied by an agitated mental state and visionary experiences.

58. Nolde, *Welt und Heimat*, p. 161.

59. See Eliade, *Patterns in Comparative Religion*, pp. 210–11, for discussion of deluge symbolism which is universal to almost all cultures and mythologies. Peter Selz also realizes the concept of regeneration as a major factor in Nolde's attraction to the sea. (*Emil Nolde*, p. 38.)

60. According to C. G. Jung, in legends and myths such funnels of wind often signify a fructifying agent, conveyed in part through their tubular, phallic form. See Jung, *Symbols of Transformation*, p. 100.

61. Eliade, *Patterns in Comparative Religion*, p. 212.

62. Cf. Jung, *Symbols of Transformation*, pp. 121–22, 209. Jung understands the mythological symbolism of the sun on the one hand as a representation of "the creative power of our own soul, which we call libido," and furthermore as a transformation of the overwhelming biological importance of the sun as the course of all life.

63. Nolde, *Welt und Heimat*, p. 145.

64. For Nolde's statement, see Chapter 2 of this study. Robert Rosenblum discusses the nature of this Postromantic solar imagery in Van Gogh and Munch and the conceptual and visual connection of their beliefs with Nolde's sun compositions in *Modern Painting and the Northern Romantic Tradition*, pp. 119–20, 133.

65. Max Sauerlandt, *Emil Nolde,* Munich: Kurt Wolff Verlag, 1921, p. 13.

66. Nolde, *Jahre der Kämpfe,* p. 113.

67. Ibid., p. 223. This statement recalls Lagarde's desire "to bind and liberate my *Volk.*"

68. Sauerlandt, ed., *Nolde. Briefe,* p. 163. Letter of May 17, 1923.

69. Ibid., pp. 165–66. Letter of October 20, 1923.

Conclusion

1. Nolde, *Reisen, Ächtung, Befreiung,* p. 87.

2. Haftmann, *Emil Nolde,* p. 43.

3. Sauerlandt, *Emil Nolde,* pp. 15–16.

4. Ibid., p. 59.

5. Elsewhere Sauerlandt mentions the "spiritual and human affinity" between Rembrandt and Nolde, but he is no more specific than this. See Max Sauerlandt, *Die Kunst der letzten 30 Jahre* (1935), reprinted and slightly abridged in *Emil Nolde. Seebüll III,* Flensburg: Christian Wolff, 1961, pp. 58–59.

6. Rudolph Probst, "Emil Nolde," p. 207.

7. Ibid., p. 208.

8. Ibid., p. 209. Another critic, Hildebrand Gurlitt, the son of Cornelius Gurlitt, also recognized this unique quality of Nolde that removed him from the present age. "Nolde has what is missing in our age: he is basically always simple and unpretentious, he is close to the animals and plants which others only hope to be." ("Zu Emil Noldes Aquarellen," *Kunst für Alle,* vol. 44, no. 2 [November 1928], 42.)

9. See Werner Haftmann, *Emil Nolde. Unpainted Pictures,* for an insightful examination of motifs of these watercolors and the circumstances surrounding the creation of these remarkable paintings, the last major phase of Nolde's creative activity. These circumstances of Nolde's personal and professional life after the *Malverbot* also provided Siegfried Lenz with a model for the character of Max Nansen, the artist who had to carry out his painting in constant secrecy under the watchful eyes of local authorities, in *The German Lesson* (1968).

10. The entire letter is translated in Miesel, *Voices of German Expressionism,* pp. 209–10, from which these excerpts are taken. Nolde also mentions in this letter as proof of his sincerity that he joined the North German branch of the Nazi party as part of the German minority residing in North Schleswig after it was ceded to Denmark. Actually, the group that Nolde probably joined in the early 1920s was a booster organization of German-speaking members residing in the newly acquired Danish territory whose original purpose was to foster German culture and represent the interests of the region's German minority and whose activities were only nominally political until the group joined with the North German Nazi party in 1940. (See Selz, *Emil Nolde,* p. 70.)

11. Nolde, *Reisen, Ächtung, Befreiung,* p. 130. Translated in Miesel, *Voices of German Expressionism,* p. 210.

12. Ibid., pp. 131–32. Translated in Miesel, *Voices of German Expressionism,* p. 211.

13. For a full analysis of this final phase in the development of Volkish thought, see Stern, *The Politics of Cultural Despair,* pp. 231–325, and Mosse, *The Crisis of German Ideology,* pp. 237–310.

Bibliography

Citations marked with an asterisk contain extensive bibliographies that are pertinent to the specific area.

Texts and Statements by Nolde

Nolde, Emil. *Briefe aus den Jahren 1894–1926.* Ed. Max Sauerlandt. Berlin: Furche-Kunstverlag, 1927.
———. *Das eigene Leben. 1876–1902.* Berlin: Julius Bard Verlag, 1931. 2nd ed., Flensburg: Christian Wolff, 1949. 4th ed., Cologne: DuMont Schauberg, 1974.
———. *Jahre der Kämpfe. 1902–1914.* Berlin: Rembrandt Verlag, 1934. 2nd rev. ed., Flensburg: Christian Wolff, 1958. 3rd ed., Cologne: DuMont Schauberg, 1971.
———. *Welt und Heimat. Die Südseereise. 1913–1918.* (1936). Cologne: DuMont Schauberg, 1965. 2nd ed., 1971.
———. *Reisen. Ächtung. Befreiung. 1919–1946.* Cologne: DuMont Schauberg, 1967. 3rd ed., 1978.
———. *Mein Leben.* Cologne: DuMont Schauberg, 1976. 2nd ed., 1977. A one-volume, abridged version of the four-volume autobiography.
———. Scheffler, Karl. "Erklärung." *Kunst und Künstler,* 9 (1911), 210–11. Text of Nolde's letter attacking Liebermann, published along with a defense of Liebermann by Scheffler and a notice of Nolde's expulsion from the Berlin Secession.

Books on Nolde

Fehr, Hans. *Emil Nolde. Ein Buch der Freundschaft.* Cologne: DuMont Schauberg, 1957.
Festschrift für Emil Nolde anlässlich seines 60. Geburtstages. Dresden: Neue Kunst Fides, 1927. Introduction by Rudolph Probst.
Gosebruch, Martin. *Emil Nolde. Aquarelle und Handzeichnungen.* 6th ed., Munich: Bruckmann, 1979.
Haftmann, Werner. *Emil Nolde.* New York: Abrams, n.d. (1959).
———. *Emil Nolde. Unpainted Pictures.* New York: Abrams, 1971.
Hentzen, Alfred. *Emil Nolde. Das Abendmahl.* Stuttgart: Reklam, 1964.
Hoffmann, Rudolf. *Holzschnitte von Emil Nolde.* Vol. 1. Bremen: Hertz, 1947. Introduction by Werner Haftmann.
———. *Holzschnitte von Emil Nolde.* Vol. 2. Bremen: Hertz, 1948. Introduction by Werner Haftmann.
Pois, Robert. *Emil Nolde,* Lanham, Md.: University of America Press, 1982.
Sauerlandt, Max. *Emil Nolde.* Munich: Kurt Wolff, 1921.
———. *Die Kunst der letzten 30 Jahre.* 1935; rept. slightly abridged in *Emil Nolde. Seebüll III.* Flensburg: Christian Wolff, 1961. Three lectures on Nolde given at the University of Hamburg in 1935.

Schiefler, Gustav. *Emil Nolde. Das graphische Werk.* New ed. by Christel Mosel. 2 volumes, Cologne: DuMont Schauberg, 1967.

Schmidt, Paul Ferdinand. *Emil Nolde.* Berlin: Klinkhardt & Biermann, 1929. Volume 53 of *Junge Kunst.*

*Selz, Peter. *Emil Nolde.* New York: Doubleday and Co., 1963. Published in conjunction with Nolde retrospective at the Museum of Modern Art, New York.

Urban, Martin. *Emil Nolde. Aquarelle und Handzeichnungen.* 4th ed., Seebüll: Stiftung Ada und Emil Nolde, 1975.

————. *Emil Nolde. Blumen und Tiere. Aquarelle und Zeichnungen.* 2nd rev. ed., Cologne: DuMont Schauberg, 1972.

————. *Emil Nolde. Landschaften. Aquarelle und Zeichnungen.* 2nd ed., Cologne: DuMont Schauberg, 1977.

————. *Emil Nolde. Ungemalte Bilder 1938-1945.* 2nd rev. ed., Seebüll: Stiftung Ada und Emil Nolde, 1973.

————, et al. *Emil Nolde. Graphik aus der Sammlung der Nolde-Stiftung.* 2nd ed., Seebüll: Stiftung Ada und Emil Nolde, 1979.

Articles of Nolde; Exhibition Catalogues

Däubler, Theodor. "Emil Nolde." *Das Kunstblatt,* no. 4 (April 1917), 114–15.

Emil Nolde. Hannover: Kestner Gesellschaft, 1948. Introduction by Alfred Hentzen.

Emil Nolde. Zürich: Kunsthaus, 1958. Introduction by Alfred Hentzen.

Emil Nolde. Ölgemälde. Aquarelle. Zeichnungen. Hannover: Kunstverein, 1961. Introduction by Gert von der Osten.

Emil Nolde. Aquarelle und Handzeichnungen. Essen: Museum Folkwang, 1967. Text by Martin Urban.

Emil Nolde in Flensburg. Flensburg: Städtischer Museum, 1967.

Emil Nolde. Aquarelle und Zeichnungen. Bremen: Kunsthalle, 1971. Texts by Jürgen Schultze and Annemarie Winter.

Emil Nolde. Masken und Figuren. Bielefled: Kunsthalle, 1971. Texts by Martin Urban and Klaus Hoffman.

Emil Nolde. Gemälde, Zeichnungen und Druckgraphik. Cologne: Wallraf-Richartz-Museum, 1973.

Emil Nolde. Gemalde. Aquarelle. Graphik. Belgrad: Museum of Modern Art, 1978. Introduction by Martin Urban.

Gedächtnisausstellung Emil Nolde. Hamburg: Kunstverein, 1957. Text by Alfred Hentzen.

Graphische Ausstellung Emil Nolde. Berlin: J. B. Neumann, Graphisches Kabinett, 1916.

Gurlitt, Hildebrand. "Zu Emil Noldes Aquarellen." *Kunst für Alle,* 44, no. 2 (November 1928), 41–42.

Heise, Carl Georg. "Emil Nolde. Wesen und Weg seiner religiösen Malerei." *Genius,* 1 (1919), 18–32.

Jens, Walter. "Der Hundertjährige; Festvortrag zur Feier des 100. Geburtstages von Emil Nolde am 7. August 1967 in Seebüll." Seebüll: Stiftung Ada und Emil Nolde, 1967.

Liden, Elisabeth. "Nolde's polyptych 'Life of Christ.'" *Artis,* no. 1 (1970), 19–26.

Probst, Rudolf. "Emil Nolde." *Neue Blätter für Kunst und Dichtung,* 2 (1920), 207–9.

Sauerlandt, Max. "Emil Nolde." *Zeitschrift für bildende Kunst,* n.s. 25, vol. 49, no. 7 (1913–14), 181–92.

Schiefler, Gustav. "Emil Nolde." *Zeitschrift für bildende Kunst,* n.s. 19, no. 2 (1907), 25–32.

Verzeichnis der Aquarelle von Emil Nolde. Berlin: Galerie Ferdinand Möller, 1928. Introduction by Hildebrand Gurlitt.

Werner, Alfred. "Nolde—German Expressionist." *American Artist,* 27 (January 1963), 38–43.

Studies of Expressionist Art and Literature

Bahr, Hermann. *Expressionismus*. Munich: Delphin, 1914.

Edschmid, Kasimir. *Uber den Expressionismus in der Literatur und des neuen Malerei*. Berlin: Erich Reiss, 1919.

Ettlinger, L. D. "German Expressionism and Primitive Art." *Burlington Magazine,* 110 (April 1968), 191–201.

Expressionism: A German Intuition 1905–1920. New York: The Solomon R. Guggenheim Museum, 1980.

Gallwitz, Sophie Dorothee, ed. *Briefe und Tagebücher von Paula Modersohn-Becker*. 5th ed., Munich: Kurt Wolff Verlag, 1922.

Gordon, Donald E. "Content by Contradiction." *Art in America,* 70, no. 11 (December 1982), 76–82.

————. "Expressionism: Art by Antithesis." *Art in America,* 69, no. 3 (March 1981), 99–111.

Hamann, Richard and Jost Hermand. *Expressionismus*. Berlin: Akademie-Verlag, 1975.

Hartlaub, Gustav Friedrich. "Die Kunst und die neue Gnosis." *Kunstblatt,* 1 (1917), 166–79.

————. *Kunst und Religion*. Leipzig: Kurt Wolff Verlag, 1919.

**Index Expressionismus*. Ed. Paul Raabe. 18 volumes. Nendeln, Liechtenstein: Kraus-Thomson Organization Limited, 1972.

*Levine, Frederick S. *The Apocalyptic Vision: The Art of Franz Marc as German Expressionism*. New York: Harper & Row, 1979.

Macke, Wolfgang, ed. *August Macke. Franz Marc. Briefwechsel*. Cologne: DuMont Schauberg, 1964.

Miesel, Victor H., ed. *Voices of German Expressionism*. Englewood Cliffs, N.J.: Prentice-Hall, Inc., 1970.

Myers, Bernard S. *The German Expressionists: A Generation in Revolt*. New York: Praeger, 1966.

Plastik und Kunsthandwerk von Malern des deutschen Expressionismus. Hamburg: Museum für Kunst und Gewerbe, 1960. Introduction by Martin Urban.

Raabe, Paul, ed. *The Era of German Expressionism*. Woodstock, N.Y.: Overlook Press, 1974.

Rilke, Rainer Maria. *Worpswede*. Volume 5. *Sämtliche Werke*. Frankfurt/M.: Insel Verlag, 1965.

Samuel, Richard and R. Hinton Thomas. *Expressionism in German Life, Literature and the Theatre 1910–1924*. 1939; rpt. Philadelphia: Albert Saifer, 1971.

Sauerlandt, Max. *Im Kampf um die moderne Kunst: Briefe 1902–1933*. Ed. Kurt Kingelstedt. Munich: Langen-Müller, 1957.

Schneider, Karl Ludwig. "Das Bild der Landschaft bei Georg Heym und Georg Trakl." *Der deutsche Expressionismus. Formen und Gestalten*. Ed. Hans Steffen. Göttingen: Vanderhoeck & Ruprecht, 1965, pp. 44–63.

*Selz, Peter. *German Expressionist Painting*. Berkeley: University of California Press, 1957.

Sokel, Walter H. *The Writer in Extremis: Expressionism in Twentieth-Century German Literature*. Stanford: Stanford University Press, 1959.

Vogt, Paul. *Expressionism: German Painting 1905–1920*. New York: Abrams, 1980.

*————. *Geschichte der deutschen Malerei im 20. Jahrhundert*. Cologne: DuMont Schauberg, 1972.

Walden, Herwarth. *Expressionismus*. Berlin: Sturm Verlag, 1918.

————. *Die neue Malerei*. Berlin: Sturm Verlag, 1919.

Worringer, Wilhelm. "Kritische Gedanken zur neuen Kunst." *Genius* (1920), 221–36.

Related Art History—Modern Art and Modern German Art

Chipp, Hershel B., ed. *Theories of Modern Art*. Berkeley: University of California Press, 1968.

Einstein, Carl. *Die Kunst des 20. Jahrhunderts*. 3rd ed., Berlin: Propyläen Verlag, 1931.

Finke, Ulrich. *German Painting from Romanticism to Expressionism*. London: Thames and Hudson, 1974.

German Art of the Twentieth Century. New York: Museum of Modern Art, 1957. Introduction by Andrew Carnduff Ritchie.

Goldwater, Robert. *Primitivism in Modern Painting*. 1938; rev. ed., New York: Vintage Books, 1967.

Gurlitt, Cornelius. *Die deutsche Kunst seit 1800: Ihre Ziele und Taten*. 4th rev. ed., Berlin: Georg Bondi, 1924.

Haftmann, Werner. *Painting in the Twentieth Century*. 2 volumes. New York: Praeger, 1960.

Holt, Elizabeth Gilmore, ed. *From the Classicists to the Impressionists: Art and Architecture in the 19th Century*. Garden City, N.Y.: Doubleday & Co., 1966. Volume 3 of *A Documentary History of Art*.

Honour, Hugh. *Romanticism*. New York: Harper & Row, 1979.

Maas, Max Peter. *Das Apokalyptische in der modernen Kunst: Endzeit oder Neuzeit. Versuch einer Deutung*. Munich: F. Bruckmann, 1965.

Novotny, Fritz. *Painting and Sculpture in Europe 1780–1880*. Harmondsworth, Middlesex, England: Penguin Books, 1960.

Rosenblum, Robert. *Modern Painting and the Northern Romantic Tradition: Friedrich to Rothko*. New York: Harper & Row, 1975.

Shapiro, Theda. *Painters and Politics: The European Avant-Garde and Society 1900–1925*. New York: Elsevier, 1976.

Winkler, Walter. *Psychologie der modernen Kunst*. Tübingen: Alma Mater Verlag, 1949.

Worringer, Wilhelm. *Abstraction and Empathy: A Contribution to the Psychology of Styles*. Trans. Michael Bullock. New York: International Universities Press, 1953.

Modern European and German History and Literature

Abrams, Meyer H. *Natural Supernaturalism: Tradition and Revolution in Romantic Literature*. New York: W. W. Norton and Co., 1971.

*Andrews, Wayne. *Siegfried's Curse: The German Journey from Nietzsche to Hesse*. New York: Atheneum, 1972.

Brandt, Otto. *Geschichte Schleswig-Holstein*. 6th rev. ed. by Wilhelm Klüver. Kiel: Walter G. Mühlau Verlag, 1966.

*Craig, Gordon A. *Germany 1866–1945*. New York: Oxford University Press, 1978.

Hamburger, Michael. *From Prophecy to Exorcism: The Premises of Modern German Literature*. London: Longmans, Green & Co., Ltd., 1965.

———. *Reason and Energy: Studies in German Literature*. London: Routledge & Kegan Paul, 1957. Longmans, Green & Co., Ltd., 1965.

Heller, Erich. *The Artist's Journey into the Interior and Other Essays*. New York: Random House, 1965.

———. *The Disinherited Mind: Essays in Modern German Literature and Thought*. New 3rd ed., New York: Barnes & Noble, 1971.

Holborn, Hajo. *A History of Modern Germany. Volume 3 (1845–1940)*. New York: Alfred Knopf, 1969.

Lukacs, Georg. *Die Zerstörung der Vernunft: Der Weg des Irrationalismus von Schelling zu Hitler*. Berlin: Aufbau-Verlag, 1955.

Mann, Golo. *The History of Germany since 1789*. New York: Praeger, 1968.

Martini, Fritz. *Deutsche Literatur im bürgerlichen Realismus 1848–1898*. 2nd rev. ed., Stuttgart: J. B. Metzlersche Verlagsbuchhandlung, 1964.

Mönch, Walter. *Deutsche Kultur von der Aufklärung bis zur Gegenwart*. Berlin: Max Hueber Verlag, 1962.

Rave, Paul Ortwin. *Kunstdiktatur im dritten Reich*. Hamburg: Verlag Gebruder Mann, 1949.

Rehder, Helmut. *Die Philosophie der unendlichen Landschaft: Ein Beitrag zur Geschichte der romantischen Weltanschauung*. Halle: Max Neimeyer, 1932.

Samuel, Richard and R. Hinton Thomas. *Education and Society in Modern Germany.* London:
Routledge & Kegan Paul, Ltd., 1949.

Steeful, Lawrence D. *The Schleswig-Holstein Question.* Cambridge: Harvard University Press, 1932.

Steinhausen, Georg. *Deutsche Geistes- und Kulturgeschichte von 1870 bis zur Gegenwart.* Halle:
Max Niemeyer, 1931.

Stern, J. P. *Re-interpretations: Seven Studies in Nineteenth-Century German Literature.* London:
Thames and Hudson, 1964.

Tuchman, Barbara W. *The Proud Tower: A Portrait of the World before the War 1890–1914.* New
York: The Macmillan Company, 1966.

Wulf, Josef. *Die bildenden Künste im dritten Reich: Eine Dokumentation.* Gutersloh: Sigbert Mohn
Verlag, 1953. Volume 1 of *Kunst und Kultur im Dritten Reich,* ed. Josef Wulf.

German History and Literature—Volkish Orientation, Sources and Studies

Bartels, Adolf. *Rasse und Volkstum: Gesammelte Aufsätze zur nationalen Weltanschauung.* 2nd rev.
ed., Weimar: Alexander Duncker Verlag, 1920.

————. *Der völkische Gedanke: Ein Wegweiser.* Weimar: Fritz Fink Verlag, 1923.

Butler, Rohan. *The Roots of National Socialism 1783–1933.* London: Faber & Faber, 1941.

Gerstenhauer, Max Robert. *Der völkische Gedanke in Vergangenheit und Zukunft.* Leipzig: Armanen-
Verlag, 1933.

Gmelin, Otto. "Landschaft und Seele." *Die Tat. Monatsheft für die Zukunft deutscher Kultur,* 17,
no. 1 (April 1925), 32–42.

Hansen, A. U. *Characterbildern aus den Herzogthümeren Schleswig, Holstein und Lauenberg.*
Hamburg: Gustav Carl Würger, 1858.

Harms, Claus, ed. *Schleswig-Holsteinischer Gnomon: Ein allgemeines Lesebuch. Insonderheit für
die Schuljugend.* 2nd ed., Kiel: Schwer'sche Buchhandlung, 1843.

Jahn, Friedrich Ludwig. *Deutsches Volksthum.* 1810; new ed., Leipzig: Wilhelm Rein, 1813.

Kamphausen, Alfred. *Schleswig-Holstein: Land der Küste. Landschaft. Geschichte. Kultur. Kunst.*
Nuremberg: Glock & Lutz, 1968.

Lagarde, Paul de (Paul Bötticher). *Deutsche Schriften.* 4th ed., Munich: J. F. Lehmanns Verlag, 1940.

(Langbehn, Julius). *Rembrandt als Erzieher. Von einem Deutschen.* 21st ed., Leipzig: C. L.
Hirschfeld, 1890.

————. *Rembrandt als Erzieher.* Introduction by Benedict Momme Nissen. 50th ed., authorized
rev. ed., Leipzig: C. L. Hirschfeld, 1922.

————. *Der Rembrandtdeutsche. Von einem Wahrheitsfreund.* Dresden: Glöss, 1892.

Lange, Konrad. *Die künstlerische Erziehung der deutschen Jugend.* Darmstadt: Arnold Bergstraesser,
1893.

Laquer, Walter. *Young Germany.* New York: Basic Books, 1962.

Mohler, Arnim. *Die konservative Revolution in Deutschland 1918–1932.* Stuttgart: Reclam, 1950.

Möller, Theodor. *Das Gesicht der Heimat: Natur- und Kulturbilder aus Schleswig-Holstein.* 1912;
4th ed., Kiel: Schleswig-Holsteinische Verlagsanstalt, 1922.

*Mosse, George L. *The Crisis of German Ideology: The Intellectual Origins of the Third Reich.*
New York: Grosset & Dunlop, 1964.

Mügge, Theodor. *Streifzüge in Schleswig-Holstein und im Norden der Elbe.* 2 volumes. Frankfurt/M.:
Literarische Anstalt, 1846.

Müllenhoff, Karl, ed. *Sagen, Märchen und Lieder der Herzogtümer Schleswig, Holstein und Lauen-
berg.* 1845; rev. ed. by Otto Mensing, Schleswig: Julius Bergas Verlag, 1921.

Rapp, Adolf. *Der deutsche Gedanke: Seine Entwicklung im politischen und geistigen Leben seit
dem 18. Jahrhundert.* Bonn & Leipzig: Kurt Schroeder, 1920. Volume 8 of *Bücherei der Kultur
und Geschichte,* ed. Sebastian Hausmann.

Ratzel, Friedrich. "Die deutsche Landschaft." *Deutsche Rundschau.* Ed. Julius Rodenberg. 88 (July–
Sept. 1896), 346–67.

————. "Reisebeschreibungen." *Deutsche Rundschau,* 95 (1898), 183–211.

Riehl, Wilhelm Heinrich. *Land und Leute.* 1853; 5th ed., Stuttgart: J. G. Cotta, 1861.

————. *Von deutscher Landes- und Volkskunde.* Breslau: Ferdinand Hirt, n.d. (after 1925).

*Stern, Fritz. *The Politics of Cultural Despair: A Study in the Rise of the Germanic Ideology.* 1961; rpt., Garden City, N.Y.: Doubleday & Co., 1965.

Weymar, Ernst. *Das Selbstverständnis der Deutschen: Ein Bericht über den Geist des Geschichtsunterrichts der höheren Schulen im 19. Jahrhundert.* Stuttgart: Ernst Klett Verlag, 1961.

Miscellaneous—Philosophy, Psychology, Ethnological Studies, Cultural History

Eliade, Mircea. *Patterns in Comparative Religion.* Trans. Rosemary Sheed. Cleveland: World Publishing Co., 1963.

Jung, Carl Gustav. *Symbols of Transformation: An Analysis of the Prelude to a Case of Schizophrenia* (1912). 2nd ed., trans. R. F. C. Hull. Princeton: Princeton University Press, 1956. Bollingen Series, volume 20.

Klose, Olaf and Eva Rudolph. *Schleswig-Holsteinisches Biographisches Lexikon.* Neumünster: Karl Wachholtz Verlag, 1974.

Nietzsche, Friedrich. *The Birth of Tragedy and the Genealogy of Morals.* Trans. Francis Golffing. Garden City, N.Y.: Doubleday & Co., 1956.

Otto, Rudolf. *The Idea of the Holy* (1917). Trans. John W. Harvey. New York: Oxford University Press, 1958.

Reich, Wilhelm. *The Mass Psychology of Fascism* (1933). New York: Orgone Institute Press, 1946.

Weber, Max. *The Sociology of Religion* (1922). Trans. Ephraim Fischoff. Boston: Beacon Press, 1963.

Whitehead, Alfred North. *Religion in the Making.* New York: Macmillan, 1926. (The Lowell Lectures, 1926.)

Index